POWER
MARKETING,
SELLING,
and PRICING

A Business Guide for
Wedding and Portrait Photographers

Second Edition

Mitche Graf

AMHERST MEDIA, INC. ∎ BUFFALO, NY

Dedication

I would like to dedicate this book to one of the greatest men I have ever met, Pat Wright. Although he is no longer with us, he left behind a legacy that will not soon be forgotten. As my stepfather, my supporter, and my friend, he showed me the value of not only a hard days' work, but also the importance of taking time to enjoy the precious moments life has to offer.

By example, he taught me to take my work seriously, but to take myself lightly. His playful spirit will forever be an integral part of my daily life, and his gentle approach to loving others will always help guide me in each of my relationships. I am honored to have known such a tender and loving man.

Copyright © 2009 by Mitche Graf.
All rights reserved.

Published by:
Amherst Media, Inc.
P.O. Box 586
Buffalo, N.Y. 14226
Fax: 716-874-4508
www.AmherstMedia.com

Publisher: Craig Alesse
Senior Editor/Production Manager: Michelle Perkins
Assistant Editor: Barbara A. Lynch-Johnt
Editorial Assistance: John S. Loder, Carey A. Maines, C. A. Schweizer

ISBN-13: 978-1-58428-246-4
Library of Congress Card Catalog Number: 2008926666

Printed in Korea.
10 9 8 7 6 5 4 3 2 1

Table of Contents

"How can you immediately begin to create value (perceived or real) in your products that motivates people to want to do business with you?"

"Do you just hand your clients a piece of paper with your wedding or portrait prices on it?"

"What is your mark-up factor? How did you decide what to charge for each of your products and services?"

Introduction

I am excited to spend some time with you, and I hope you are just as excited to immerse yourself in the business side of your business. The fact that you are investing your time in this book shows that you are one of the few who will make a difference in our industry. I welcome and congratulate you!

In today's overcrowded marketplace, we have more choices and are faced with more decisions than ever before. How do we decide what we should spend our hard-earned money on? In 1980 there were 400 mutual funds; today there are over 10,000. In 1980 alone, 1,500 new grocery products hit the shelves; this year there will be over 15,000. With all these choices, you have to offer something the buyers in your target demographic can't get from anyone else. You need a marketing game plan that is brilliant in its simplicity.

The journey you are about to take is going to change your life forever. While that's a big statement, I guarantee that if you take the marketing principles outlined here seriously, you will tap into a better way of looking at your business and a better quality of life. And that's important. After all, photography is not who we are, it's only what we do.

Motivations

What is the number-one reason for starting your own business? Is it the joy of being a self-employed entrepreneur and an ability to dictate your own hours? Is it the money? The ability to dream your own dreams and reach for the stars? Is it the ability to "breathe life" into your own business creation and watch as it grows and becomes more profitable and successful over time?

Actually, each of these ideals prompt people to put everything on the line and start their own business. However, the number-one reason is that we have a passion for what we do.

I assume that since you are reading this book, you are a professional photographer or are committed to becoming one. That said, I suspect you are technically proficient and can take pretty good pictures. Therefore, this book doesn't cover posing, lighting, camera equipment, or the latest advances in digital technologies. Instead, it is dedicated to getting you fired up and excited about what I call the "fun stuff."

You will tap into a better way of looking at **your business** and a better quality of life.

During our time together, I'll challenge your mind, get your creative juices flowing, and turbocharge your studio in fresh, innovative ways. I'll teach you how to make your phone ring and make more money, and that will give you more time off to do the things that are most important to you. As a result, you'll enjoy a renewed vigor in your personal life.

It's easy to fall into that old management trap and get caught up in the day-to-day business details. We end up running our studios instead of designing our lives. We answer phones, retouch images, order supplies, clean the bathroom, and mow the lawn. Before we know it, we are working seven days a week, sixteen hours a day—week after week, month after month. We don't have time for our families, to drop a fishing line in the water, to hit that golf ball up and down the fairway, or to watch our favorite show on the weekend. The things that are most important to us start slowly slipping away, and we become a slave to our business rather than its master.

If you are like most other professional photographers, you are looking for effective and innovative marketing

techniques that will take your business to the next level of sales and profitability and give you the freedom to attain your goals in life. This book will teach you dynamic, profit-oriented methods not only to compete in the battle for customers but also to win the marketing war! The strong will survive, and the weak will perish. Which will you be?

About the Power Corners

Between the chapters in this book, you'll find sections called "Power Corners." When I began to write this book, I knew I wanted not only to share with you the thoughts that were rattling around in my brain but also to bring you ideas and inspirations from the best marketers our industry has to offer. I proceeded to assemble a team of photographers and marketers who were willing to open up and talk about their lives, both personal and professional. Some of these interviews were done via telephone, others were done through e-mail, and still others were conducted in person.

Each person was presented with basically the same set of questions and they responded in their own unique ways. You will notice, however, that even though the answers, approach to life, and perspectives are all a little different, there is a common thread that ties them all together. They individually believe that life is to be lived to its fullest and photography is but a means to that end.

These contributors are marketers first and photographers second. They do not let their business get in the way of their lives—and there is definitely a lesson for us all in that example. Effective marketing allows you to have a life outside of photography.

The strong will survive, and the weak will perish. Which **will you be**?

Besides wanting to find out what makes them tick professionally, I wanted to dig deeper and discover who they are as human beings. They all were good sports about it. In fact, the time I spent talking with each of these successful photographers was perhaps the best education I have received in this industry. It motivated and inspired me, and it confirmed in my mind that successful people have many things in common.

I know you will enjoy the nuggets of wisdom they have to share with you—so let's get started right away! The first "Power Corner" begins on the next page.

About the Author

Internationally acclaimed photographer, educator, and best-selling author Mitche Graf has become one of the most sought-after speakers in the industry, with a fun and creative style that has catapulted his program onto the international scene. He brings more than twenty-five years of dynamic sales and marketing experience and ten years of studio experience to these energetic seminars and workshops, which he has presented in nearly every state and in nine countries. Additionally, his articles appear on a regular basis in the pages of *Rangefinder* magazine, *Professional Photographer, Image Maker,* and several other industry publications.

Mitche has been involved in many exciting business ventures, from a used bike parts business he ran from his garage in the seventh grade, to a cribbage-board manufacturing company, to a limousine business, to a restaurant, to a portable hot tub rental business, to a drive-through espresso business, to a photography studio, and many more. From this, he has learned that the basic principles of marketing are the same whether you are selling meat, corn, bricks, potatoes, or photography.

He firmly believes that life is meant to be lived, not endured, and that taking control of your business can help you achieve all your other goals in life. (For him, that means enjoying the outdoors, gardening, playing guitar, really good wine, great music, reading, barbequing, and spending lots of time with his family.)

Whether you live in a small town or a metropolitan area, you will find in this book the techniques you need to maximize your success—in both your business and your life. For more information on Mitche Graf or his educational products and services, please visit www.powermarketing101.com.

Power Corner

Focus on . . .
John Hartman

John has his business and his life figured out! He has kept a fresh attitude during his thirty-year photographic career by building a business that serves him, rather than the other way around.

This arrangement affords him time to help other photographers by producing business-building seminars (the John Hartman Marketing Boot Camp), creativity-enhancing products (Quick-Mats™ digital matting system), digital workflow solutions (QuickProofs™), and marketing and sales systems (SeniorMarketing™). His famous "Marketing Boot Camps" are an absolute must for anyone looking to gain a complete understanding of what marketing entails.

For more information on John's educational materials and seminars, visit www.jhartman.com.

Mitche: **What is the biggest challenge facing our industry in the coming years?**

John: The electronic revolution is changing our whole business model. The way we shoot, present our images, sell, and produce photographs will never be the same. Similarly, the methodologies we use to locate, sell, and manage our customers have never been more complex. The challenges can be met by flexible, forward-thinking, customer-driven studios. Those that cannot or will not adapt to these changes will eventually die, most likely sooner rather than later.

Describe your marketing philosophy.

Marketing is simply a communication system to drive clients into your studio. The best marketing creates the maximum number of qualified customers at the lowest possible cost and effort per total sales. Note that I did not simply say the lowest possible cost. Marketing that brings in a high response might be expensive to produce, but because the response rate is so high, the result is a very low marketing cost as a percentage of total sales.

To illustrate, one photographer among my senior marketing clients spent $1,200 on a postcard mailing that produced eight phone inquires, resulting in three confirmed portrait bookings. Those three sessions brought in a total of $2,258 in sales. His marketing cost as a percentage of sales was a rather dismal 53 percent and, in his opinion and mine, certainly not worth his time and effort.

He then switched to a more comprehensive mailing strategy—an eight-page sales letter with an eight-page color catalog mailed in a 9x12-inch envelope. Printing and mailing costs for this package were just over $5,300. He mailed to the same list and this time booked 154 sessions with total sales of $109,494. His marketing costs as a percentage of sales was under 4.8 percent.

At first, he was petrified of spending $5,300 at his printer and post office ("I could've bought a new digital camera and a couple of lenses for that!"), but his spectacular results helped to change his attitude. Good marketing is not an expense; it's an investment. For him, every dollar spent returned $20.00. At that rate, how much would he have been willing to invest? As much as possible!

Another portion of my thinking about marketing is that it should be a tool to keep your studio running as close to full capacity as possible, for as long as you deem necessary. If you have a large staff that likes to get a paycheck every week, you may deem fifty-two weeks a year to be necessary. If you're a mom-and-pop studio and like time off, you may be able to earn a good living working hard just twenty to twenty-five weeks a year.

Regardless, marketing keeps your schedule from being a hit-or-miss affair. If you are as busy as you want to be, with no holes in your schedule, then your marketing is working. If you aren't shooting as many weeks a year as you'd like, or if your schedule has 9:30 a.m., 1:00 p.m., and 4:30 p.m. appointments with nothing in between, then your marketing probably needs some fine-tuning.

What do you feel are the most important attributes of a "Power Marketer"?

The Power Marketer understands what marketing is and what it can do for his or her studio. A key attribute of the Power Marketer is the ability to see the big picture while being able to focus on details of the here and now (hence my self-portrait). Power Marketers constantly test new

marketing ideas against old, proven ones and don't change until they have found ones that work better, faster, cheaper or with greater yield. Most photographers jump willy-nilly into a new marketing idea they haven't even tested, often abandoning the successful marketing they had been using. The Power Marketer knows that marketing that works should only be substituted with marketing that works better. And the most powerful of Power Marketers will often use these new marketing ideas in tandem with their old ones, rather than substituting them. Doing this allows each studio to build business in its own way, and to compound their marketing results.

Do you feel that Power Marketers are born, or are they self-taught?
Some people have the gift of interpersonal communication, which is often called "born salesmanship." To some extent this is true, but born salespeople do not necessarily make born Power Marketers. Marketing is both an art and a science that requires several abilities and skills.

First is the ability to provide products and services for which customers are willing to pay the price you need to maintain your standard of living—and make sure you're still in business tomorrow. It's not impossible to market a bad product, but it makes the task much more difficult, especially if you rely on repeat business.

Second is the ability to realize that without a customer, you do not have a photography studio, but merely an art gallery. The only way to create customers is through marketing. And the more effective your marketing is, the faster your business grows, and ultimately the faster you will achieve the lifestyle you desire.

Third, Power Marketers understand the reasons that customers do business with them, and from those reasons they develop their hook or unique selling propositions (USPs) to market to their new prospective clients. They constantly query their clients on why they chose their studio over others and then promote those reasons in their marketing. They don't waste marketing space tooting their own horns, but rather, they place a high priority on packing as many customer benefits into their marketing effort as possible. They fully understand that people don't buy photography; they buy the benefits that photography brings them, whatever they may be.

What are the most important things in your life? How does your marketing come into play with them?
My family, my God, my friends, and my personal development as a contributing human being in the days allotted to me on terra firma are my life priorities. Smart marketing has allowed me time and resources to spend on them, instead of being a slave to my business.

How important is it to you to have the proper balance between your personal and professional life?
Most people spend a good portion (if not all) of their life buying money with their time. Some people tire of this early and learn it is much more efficient to buy time with your money. I do this by delegation. I know what the value of my time is, and if there is someone who is willing to do a job that needs to be done at a lower cost, then I buy that time from them. The more I can delegate, the more personal time I have. You rarely "save" money by doing it yourself if you factor in the value of your time.

What would you recommend to someone looking to take their marketing to the next level?
First, marketing is not a one-shot affair. Its effectiveness can only be measured with repeated efforts and exposures to a targeted prospective clientele. People are not always ready to buy at the exact instant your marketing reaches them. But given enough exposure to your message, they will buy from you when the need finally arises.

Good marketing is not an expense; it's an investment.

Second, don't overlook the most obvious and valuable marketing resource you possess: your current customer base. It costs about twenty times more to acquire a new customer than it does to reactivate an old one. For some reason many photographers think their first-time customers are finished buying from them. Nothing could be farther from the truth; they can buy more (up-sell or re-order from existing files), they can buy again (resell or update session), or they can buy something else (cross-sell

or migrate to a new product line). These people have already done business with you; they like what you do, they understand your fee structure. Provide good WIIFM (what's-in-it-for-me) reasons to spend money with you again and, more often than not, they will.

What is your "hook"?

For my photography clients, it's "You get a comfortable and enjoyable session, flattering photographs, and finished image products you will be proud to hang in your home and give to friends and loved ones—guaranteed."

For my photographer clients, it's "We provide marketing, sales, management and digital workflow solutions that bring additional sessions, higher sales, and time savings all out of proportion to their investment."

What marketing campaign or concept has been the most productive and successful for you?

Far and away, the best marketing vehicle I have used is direct mail. I've had a single portrait mailing to 4,000 prospects bring in over $200,000 in sales in one six-week period. One direct mail piece to photographers resulted in over $33,000 in sales in a single morning. I designed, printed, and sent a mailing to several hundred of my past portrait clients that resulted in over $6,000 in credit card deposits within forty-eight hours of the mailing.

No other marketing I've used even comes close to this kind of response . . .

No other marketing I've used even comes close to this kind of response. I continue to test Internet marketing, rep marketing, and joint ventures with other businesses, but for fast, immediate sales, direct mail is still king.

What about the least successful?

Yellow pages advertising. I tracked results three years running and found that although the ad produced many inquiries, most were unqualified price shoppers who spent lots of time asking questions but rarely were converted into paying customers. Not only was the actual dollar investment of the ad wasted, so was a large amount of staff time. In not one of those three years did the sales from those yellow pages ad clients pay for the ad. Dropping to a simple line listing was an easy sell to the ad rep.

What do you do for fun?

I have a loving wife and three sons who require (and receive) lots of my attention. Luckily we all share interesting passions: music (I'm a former professional drummer), gourmet cooking, biking, and downhill skiing. My personal passions are fast cars and investing (you need the latter in order to do the former). And of course I still love to pick up a camera and shoot just for me.

The time spent studying and emulating successful marketing ideas is the most valuable investment you can make in your business. Take away all my photography skills, my Photoshop knowledge, my entire studio, but let me keep my marketing skills, and I'll have it all back in no time. Take away my marketing skills and I'll be stuck at the bottom of the barrel until the bankruptcy court finally calls.

What's the best experience you have had in your life?

Besides being present at the births of my three sons, it was pretty cool to step out of a 40-foot stretch HumVee limo with the Blue Man Group, my staff and seven photographers/musicians in front of the Luxor in Las Vegas (to the cheers and camera flashes of several hundred students posing as "fans") at Boot Camp in 2002. They pulled off the entire evening including a huge party and my getting to play with the band, without me having a clue. That evening I learned the depth of the camaraderie that exists in this industry, and what a privilege it is to be a part of it.

Who are your biggest inspirations in your life as a photographer/teacher/entrepreneur?

Paul Castle taught me that it's about business, not about photography. Don Feltner showed me how to build that business faster than I ever dreamed possible. Charles Lewis gave me the inspiration to grow outside of my box. Earle Nightengale proved it's not what happens, but what you do about it that matters. Jay Abraham has to be the most creative thinker in the business world. My wife Kathy, who always reminds me that it's nice to be important, but it's more important to be nice!

1. The Wonderful World of Power Marketing

So, what does the word marketing mean to you? Simply defined, it means letting potential customers know who you are, what you do, and why they should spend their hard-earned money on your product/services. While the concept is a simple one, many businesspeople put little effort into achieving these goals. They open their doors in the morning and wait for clients to come through the door. Well, I prefer to have control over my business, and I believe you do, too.

To succeed in this industry, you'll need more than a love of photography. You must have a basic understanding of the laws of business and a marketing plan that's second to none. It also demands initiative, self-discipline, and a tremendous amount of mental energy drawn from the depths of your creative being. Small business owners have gigantic challenges to face each and every day, whether it be the increasing costs of doing business, more competition for consumer dollars, regulations from the government, or the need to find the energy to keep your nose to the grindstone when things get tough.

I don't know about you, but I'm self-employed so that I can have more time off and the financial means to fully appreciate that time. And that's where marketing comes in. Having a solid marketing plan will allow you to do the things in life that are most important to you.

You always hear people talking about managing time. Well, you can't *manage* time, you can only decide how to *spend* your time. We sometimes forget that running a successful studio requires a lot more than the day-to-day routine; it requires the vision as well—the stuff from which dreams are made. It's almost mystical as it drives us each and every day to get up and do a better job than we did the day before. It's what we have that others lack.

Whether you live in a thriving metropolis or in a small town, having a well-defined marketing plan is vital to your professional success. Did you know that every ten seconds in this country there is a business that folds up its tent and goes home? That's an amazing statistic! In five years, four out of five photographers probably won't be around. And guess what most of those photographers don't have? You guessed it—a marketing plan.

I established my business in a small town, like many of you. The town has a population of about 2,400 people. It is predominantly a timber town, which means that we have a very high unemployment rate of anywhere from 14 to 18 percent. This in and of itself creates a new set of obstacles and problems for the small business owner. Entrepreneurs are faced with more and more challenges and obstacles every day. There are times you just want to beat your head against the wall and chuck it all in. That's because we allow our businesses to control us instead of us controlling our business. We need to work hard, play hard, love our families, and love our friends. The rest will fall into place.

Having a solid marketing plan will allow you to do the things in life that are **most important** to you.

Here's the question: If you only had a limited amount of time left to live, would you work less than you do now? Would you play more? Would you spend more time with loved ones?

I hate to be the bearer of bad news, but things are not getting any easier for professional photographers. Whether you realize it or not, you already have a marketing plan. It begins the first time someone hears your name, sees your signs, hears your voice on the phone, or walks into your place of business. Marketing is how you create value for yourself and for your products. It creates a demand for

your product long before the phone ever rings or the client walk in the door.

It has been said that the sales process ends when the client writes you a check. Well, everything that happens up to that point determines how large that check will be. That's where the marketing comes in. The better the job we do in marketing, the bigger that check is going to be. Marketing is not rocket science, but the lack of a well-planned strategy is one of the biggest reasons why studios fail. The best product doesn't always win the race. The best marketer does.

You are better off being a top-notch marketer and a good photographer than the reverse. My money is on the

Everything prospective customers see impact what they will be willing to spend. Photographs by Christa Hoffarth.

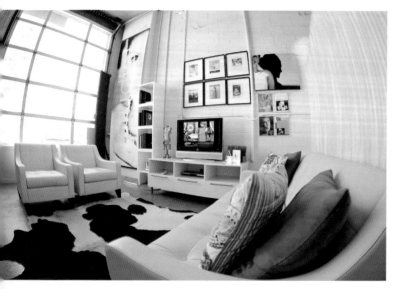

marketer every time! In photography, people buy because they want to feel good about themselves. They need to be convinced that we offer something special that will add value to their lives.

What is "Power Marketing"?

So, what is Power Marketing? Actually, it's the exact opposite of passive marketing. It demands your personal, proactive involvement and is very systematic. If you want to be a successful Power Marketer, you must be willing to roll up your sleeves, jump in the trenches, and get a little dirty! Sounds like fun, doesn't it? It really can be if you understand the philosophy behind it and can see the benefits you will reap over the long haul.

I once knew a man who owned a successful pet-product manufacturing company, and it seemed no matter what pet store I went into, his product was on the shelf. The packaging was professional looking and colorful, the price was fair, and it was something every pet owner used. What better combination, huh? My opinion of the product was so high that I figured his warehouse was full of brand new, high-tech equipment, the employees dressed in freshly pressed uniforms, and the offices lined with expensive oak furniture.

I remember walking into his building for the first time and feeling my jaw drop to the floor. The building was actually an oversized garage, there were only three employees (most of the work was contracted out) and the "executive office" was a remodeled bathroom with little room to sit. There were file cabinets everywhere (organized alphabetically of course), a small coffee table with one magazine, and two chairs. It was a very clean and organized office, but it was tiny!

I couldn't believe such a "big" company was operating out of such a small area. When I asked him how he had made his company so successful though he was working with so little, his answer was short and to the point— "Marketing, marketing, marketing!" Although he didn't believe in excessive spending, he spared no expense when it came to presenting a professional image to his customers. Everything from the way his secretary answered the phone, to his elegant letterhead, to the way he packaged and presented his product was top-notch. He settled for nothing but the best, and nothing was left to chance.

I remember him telling me that image was the most powerful marketing element, and the only thing that mattered was what the customer thought. His marketing plans were written out a year in advance, and he could show you the results from each and every idea he ever tried—good or bad. If something didn't work, he would either rework it and try it again or move on to something else until he got it right!

The last time I talked with him, his annual sales were over $10,000,000. There is something to this thing they call marketing.

The Power Marketing Self Test

Before you dive in with both feet, you need to take inventory of your current marketing efforts. So, let's begin with a quick Power Marketing self-test. I can hear the gasping out there, but don't worry—there are no wrong answers to this test, it's just information about your business (and the more information you have, the better prepared you will be when it comes to planning and initiating a Power Marketing campaign).

Now, you may not have answers to all of the questions in the following test. Don't worry. Simply providing any answers you can will help you to lay the foundation for a new way of thinking. Creating a marketing plan is similar to building a house: A good contractor would never build a house on unstable ground or without pouring the concrete first.

A solid marketing foundation is necessary in order to reap positive results and attain the goals we have set for ourselves. I do my best not to let my business run my life. I used to work six to seven days per week, fourteen hours per day, but I realized life is way too short and precious, and I needed to rearrange my priorities.

The reason I run my own business and work hard is to have financially secure time off! Isn't this a goal we all should have, to be able to enjoy the fruits of our labor? Sure, there are times we need to spend long hours at work—occasionally for days on end. Then, there are times we can put a big X through an entire Friday on the calender and take a three-day or even a four-day weekend, or even an entire week!

So grab your favorite beverage and a pen and notepad. Unplug the phone, put some relaxing music on, then sit

"I only hope that we don't lose sight of one thing . . . that it was all started by a mouse." —Walt Disney

Since 1928 when Steamboat Willie debuted the name, the Walt Disney Company has always stood for excellence. Whether it's the newest cast member or one with over forty years of experience, all the employees are passionate about making magic happen. As a photographer for the Walt Disney Company, that magic takes place each and every day I come to work!

Walt Disney and Mickey Mouse are arguably the most widely recognized names in the world, and the mere mention of their names creates a spark to our imagination and brings a smile to our faces.

Over the past 100 years, Walt Disney has had themes such as "Remember the Magic," "100 Years of Magic," and now "Where Magic Lives." When a bride and groom come to us to photograph their wedding day, they expect us to capture some of that magic, just for them. Ever since they were little girls playing dress-up, they imagined the glass coach, the handsome prince, and the beautiful castle as the ideal place for their own wedding. Let me tell you, when they hire a Walt Disney photographer to photograph their wedding, that's pressure! Their wedding must be as magical as the fairy tale the bride has imagined.

I have been a photographer at Walt Disney World for ten years. In that time I have photographed approximately 3,500 weddings, 1,200 Magic Kingdom Bridal Portraits and an equal number of family portraits, conventions, and commercial assignments. I constantly need to remind myself that it is the client's first time to be exposed to the Magic Kingdom, even though I have taken tens of thousands of exposures.

We need to constantly expand our knowledge and imagination if we expect to continue to exceed the expectations of our brides and grooms.

Walt Disney also said, "All you have to do is own up to your ignorance honestly, and you will find people who are eager to fill your head with information." And might I add imagination!

—Mike Strickland
Director of Photographers, Walt Disney Co.

back, close your eyes, and relax for a few seconds before we begin.

All right, here we go . . .

1. What do your current marketing efforts consist of (e.g., yellow pages, direct mail, newspaper, magazine, or television ads, mall displays, vendor networks, senior referral programs, etc.)?
2. Do you have a way of tracking the results of your current programs? What is it?

3. Do you consistently develop a list of goals before you begin a new program? How do you do it? How do you measure their effectiveness?

4. What have you tried in the past that didn't attain the desired results? Why?

5. What programs in the past exceeded your desired results? Why?

6. Do you have a plan for your upcoming marketing programs? What are your plans?

7. Have you identified the goals and objectives of those programs? What are they?

8. What types of marketing are your competitors using that seem to be successful? Why?

9. Do you have a budget set each and every month for marketing? How much is it?

10. What makes clients come to your business instead of to other studios in your area?

11. What makes them go to your competitors instead?

12. As a consumer, what would you look for from a professional photographer? Do you offer those things?

13. What are your three biggest strengths as a business owner? As a photographer?

14. What are your three biggest weaknesses as a business owner? As a photographer?

15. Do you set aside time each and every day to work on the essence of your business and to develop new ways to improve it? If not, what time of day would work best if you were to start this tomorrow?

Well, how did you do? Did you have a pretty good idea of how to answer each question, or did a few of them give you pause for thought? Remember, there are no right or wrong answers, only information. I challenge you to ask yourself not only these questions, but to come up with some of your own questions about your business and your effectiveness as a marketer. A top-notch Power Marketer is constantly reviewing, analyzing, and adjusting their techniques to achieve their maximum potential and to get the most out of their employees and their business. Only you have that ultimate responsibility; if you don't do it, nobody else will.

Whether you have been in the industry for several years or have recently decided to jump in with both feet, you probably realize that it takes guts and determination to own and operate a business. If it were easy, everyone in the world would do it. Simple, it's not. It requires a very special person who is willing to take risks, commit themselves to a cause, and to fight the daily battles in order to win the war. Most importantly, you must be willing to do whatever it takes to become successful. You are obviously one of the chosen few!

If I were to list all the issues that contribute to business failure, it would fill this entire book. Of course, you can find thousands of books on hundreds of subjects pertaining to business at your local library, through mail-order catalogs, or through the Internet. Many offer good information, but many do not. I know of only one absolute fact when it comes to operating a business: there is not another business exactly like yours in the entire world, and only you can decide what information is beneficial and what isn't. The following chapters will help you to tailor your marketing efforts to meet your personal goals and enhance your unique business.

But first, let's look at some suggestions from another Power Marketer . . .

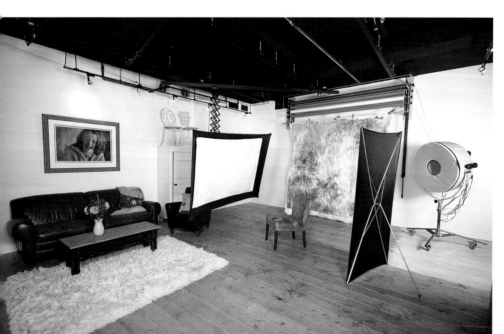

A clean, attractive shooting area will make clients feel comfortable—and make you look like the kind of consummate professional who's worth every penny they'll spend on their images.

Mitche: **What do you feel is the biggest challenge facing the industry?**

Michael: I don't see many challenges. I've gotten to the point of nirvana; I can do anything I want to do. Quite frankly, after you've put your mind to work over twenty years and you've boot-strapped everything, you can face so many challenges. You just look at what's next. You know, "What do I want to do next?"

What are your core marketing concepts?

Marketing is the engine of a business. When I want business, I market. When business goes down, I market. When my numbers aren't where they should be, it's because I didn't do my marketing. Over the years I've found out what fuel works best, and what's the best octane.

Important attributes of a Power Marketer?

Learning how to network. Learning how to get in touch with people that can help your business grow. Learning which people they are. Learning your target market. What is your target market? Who they are? And finding who you want to deal with—then learning how to talk with people and talking to the ones who can put you in touch with the end result that you're looking for.

What are the most important things to you? How does your marketing come into play?

Quality of life is everything to me. And how does marketing relate to that? The better I market, the better quality of life I have. You have to learn how to do business, but once that's all done, what makes it all function is the marketing. It all starts with marketing. The phone doesn't ring unless you've asked for business. The definition of marketing, in my opinion, is asking for more business. And after you've learned that, then the question becomes how to ask for the best quality of business.

How do you balance everything?

I just work until I'm tired of working, and then I do something else. It's all about quality of life. First of all, do I get eight to ten hours of sleep? Yes, because that's part of the quality of life. The reason I chose photography is that I don't have to get up at 6:00 or 7:00 a.m. I don't do that. I wake up at 8:00 or 9:00 a.m., and I gently get up

Power Corner

Focus on . . .
Michael Redford

If you want energy, spend some time studying with Michael Redford! His powerful presence and witty sense of humor will stimulate your out-of-the-box thinking and give you a new zest for life. In the early '80s, Michael began developing his marketing techniques (now revered as state of the art). Soon, utilizing the marketing systems and sales strategies discussed in-depth during his seminars, he had turned a small studio into a portrait "super studio" grossing over $1,200,000 per year. Michael has blazed the marketing trail and has taken many arrows over the years. He now has the tried-and-true map to portrait studio success and to maintaining his quality of life. For more information on his seminars and educational materials, visit www.redfordseminars.com.

and go about working. And when I'm done working for the day and I've accomplished all that I have to respond to, I go and do my social stuff.

What would you recommend to someone who is looking to take their marketing to the next level?

Define whom you really want to work with. Do you want to work with a couponer, or do you want to work with upscale people who have expendable income, are easier to work with, and for whom money is secondary in the game? I've found that after it's all said and done I'm going to take the same amount of pictures and I'm going to do the same amount of hours, so I might as well do it with people who can afford more—and there's much more profit involved there. You've got to go for the profit level that gets you the quality of life that we've talked about. And, dealing with coupons is going to eat you up. I mean, that's what the department stores are for. They're for the couponers. You're for the higher-end clients who want to have a little bit more expendable income and who appreciate what we do.

What is your hook?

It's the image that I've created. The hook nowadays is that the name has been created, it's just living up to it daily. I've been very successful in integrating the systems necessary to live up to the image.

Would you call it a designer brand?

It absolutely is. It's just all about quality service and a creative look. It's all based on very good photography, by the way. Everything I have is truly first of all based on good photography and then from that point on it's good customer service. Then it's good marketing to keep them coming. The marketing is first, but you have to have a good, quality brand. You can market until you're blue in the face, but if you can't take good pictures, that ain't going to work. It's all got to be congruent.

What has been the most successful marketing philosophy, concept, or campaign that you've ever had in the years that you've been in the industry?

A country club promotion where we go to the country club and offer them good, high-end executive portraits of their leaders. We initially photograph the board and the president and then invite the other members to call Redford Photography. We often have family portraits created at this location or at our studio. We put their names on the bottom of an 8x10-inch print. We put that print into an

It all starts with marketing. The phone doesn't ring unless you've **asked for business.**

album, and on the front cover it says The Golf Club at Nevelwood (or whatever country club we're working with). We buy everything for the photography of the presidents and all the board members. At the same time, though, that country club is turning me on to other business because of the complimentary service I provide.

My point is, it's a very, very good networking idea. It drives as many families to try your studio as you think you could possibly handle each year. Now we're working with two country clubs, and I'm a little scared that it's almost

too much. The first country club we did has 600 members, and we did eighty members the first year, and now I've got two of those. I mean, I don't know if I can handle all the business they can throw at me.

How many shooters do you have?

Four. I photograph children and families. I have another gentleman who does all the high school seniors and the weddings. My wife does the children and families with me, and then my other son does the high school seniors that the other gentleman can't.

You don't photograph any seniors yourself?

No. Only in emergencies. I'll do twenty or thirty a year. We do about 600 to 650 seniors. I'll do twenty or thirty of those simply because my photographers are sick or out of the studio. Of the 650 seniors, you're going to have ten or twenty who need special treatment. I'm totally capable of doing it, but I don't wish to do it. I'd rather use the time on the boat!

Is there an experience that you've had that just stands head and shoulders above everything else?

I have a friend who's a billionaire—one of the world's richest men. I get to work with him all the time; I'm his photographer. I'm around Jerry Seinfeld and people like that, because he is . . . well, he's a billionaire, so he has private parties with people like Jerry Seinfeld, Bill Cosby, Jeff Foxworthy—the biggest of the big. I even met Robin Williams! These people are brought in for private parties of fifty to sixty people, and I get to rub elbows and take pictures of these people, and it's just really, really fun stuff!

Who are your biggest inspirations?

I've got to say Jesus Christ because I am a Christian, and I truly believe that he is the strength. Walt Disney for sure. Sam Walton, Ted Turner, people like that. These are people who just came from nothing and worked to have everything through their sheer understanding of capitalism, of trading services, and the sheer understanding of looking through all the red tape, seeing exactly what needed to be done, and doing it.

2. Developing Your Marketing Strategy

Before you can develop a marketing plan, you have to know what it is you want out of life—and I don't just mean setting goals for your business, but striking a balance between the energy you devote to your business and the time that you take for yourself. What is it you want out of your life personally? Time with your family, time to travel, or for your gardening, reading, or other hobbies and passions you may have? Be specific: Do you hope to spend more time listening to some really good music, watching old movies, wetting a fishing line, taking in an art show, reading the funny pages, or golfing?

Taking It All in Stride

To achieve balance between your professional and personal life, you've got to take your job seriously but take yourself lightly. It's called having a sense of humor! And having a sense of humor is not something that we are born with. It is a set of developed skills that allows us to keep flexible in the face of stress and change—and it really has nothing to do with telling jokes, even though most people associate having a good sense of humor with just that.

Do you think you can tell a good joke? More than likely, you don't. Only about 2 percent of the population can remember punch lines and tell a good joke.

On the other hand, do you feel you have a good sense of humor? There are people in this wonderful world of ours who go through life with a case of terminal professionalism. You know the type: "If I'm going to be successful, I must be hard-driving, hardheaded, and serious. I don't have time to laugh and play around. Leave me alone; I'm having a really good bad day!"

Those are the kind of people who end up with nervous breakdowns, end up dead, or worse yet end up old, bitter, cantankerous photographers! We need to enjoy the simple things in life: a newborn baby, a sunny day, a home run in the bottom of the ninth, a great drive off the tee!

Having a sense of humor won't solve the world's problems, but it sure makes it easier to get through the tough days that pop up every now and then. Such an outlook has the magical ability to sustain life. When people are on their deathbeds, they don't say they wished they owned more toys or had more money. They say things like, "I wish I would have worked less and played more."

Part of the reason we find it difficult to keep it light sometimes is the world we live in is full of stress. Stress isn't something new to mankind; our world is in a constant state of change, which is what causes stress. The vast majority of what we know about the world today has been learned in the last twenty years. In the past decade or so

Good marketing is not an expense; it's an investment.

there have been 500,000 new commercials on TV and 10,000 new shopping malls. The Internet as we know it has sprung into existence, and the wonderful world of digital photography has come into being. No wonder we have such a difficult time keeping it light in the face of such radical changes in our world. But you know what? Life is a matter of perspective, and our thoughts can keep us healthy or can make us ill. It's all up to us.

Know Yourself and Your Priorities

Being successful has nothing to do with how much money you make, how many weddings you shoot, or how many sessions you photograph. It's all about proper balance in your life, or what I call perspective. We all need to be reminded from time to time that life is short, fragile, and precious. We need to remember that the job of photog-

rapher is only a job. Success is a constantly evolving journey, not merely a destination. You set your sights on the future to map out your goals in your personal life, just as you do for your business with a good marketing plan.

You must have a vision of where you want to go. After all, we drive with our focus in the distance, not on the highway as it passes beneath us. Remember Alice in Wonderland? When Alice was walking through Wonderland, she came to a fork in the road and met the Cheshire cat. She asked, "Which road do I take?" and the Cheshire cat said, "Well, where do you want to go?" Alice responded, "I don't know," and the Cheshire cat said, "Then any road will get you there."

Know Your Clients and Their Priorities

When I was in seventh grade, I had a business that I ran out of my garage. If you needed a bicycle chain or seat or tire, chances were I had it! If I didn't, I would trade with the guy down the street to get one. At the time I didn't really understand any of the dynamics of marketing, but I sure seemed to have a lot of kids coming over!

Understanding **who you are** is essential to developing a successful marketing plan.

Saturday mornings were the best; all of the neighborhood kids would ride their bikes up and down the street and would stop in to see what the "hot special" was for the day. The best deal I ever made was trading a set of blue handle grips for a dollar and a 45 record. I remember playing that record until the grooves wore out!

I used to take bicycle chains and horns to school to show my friends and classmates. Mondays were always good because a lot of kids received their allowance over the weekend. Sometimes I would get a special order for a banana seat or a sissy bar and would have to trade with someone else to be able to fill the order. In junior high there were a lot of guys who had so-called bike businesses, so I usually found the requested item.

There definitely wasn't much money to be made, but looking back, I learned an important marketing principal:

In order to be successful with any business, you need to understand your potential customers and then develop a strategic plan that attracts them to you. This is probably the most basic definition for the word marketing.

In the real world of business, things are a bit more difficult than they were when I was a kid, but the rules are the same. Before you can develop a marketing strategy, you need to follow certain steps.

First, realize that understanding who you are is essential to developing a successful marketing plan. The self-test you took earlier likely resulted in some self-discovery. Having an intimate understanding of what makes you tick is not only important to your business, but it is important in your life. Knowing your strengths and weaknesses, as well as what challenges and excites you, will help you to be the best you can be.

Recharge Your Personal Batteries

This is where quiet time comes in, because we all get into the 9-to-5 mentality and can become mere observers of our businesses. This outlook taxes your energy level and it doesn't allow you to focus on the real issue, which is how to make your business more profitable. Nor does it free your mind to allow the expansive thinking that separates "good" from "great."

Let's compare your studio to a car with a full tank of gas. At the beginning of a trip you feel pretty good driving down the road and looking at all the sites. You're excited and enthused about your journey and not too concerned with what lies down the road. As the miles go by, the needle starts to drop on your fuel gauge, and you start thinking about filling up. But the next gas station isn't for another hundred miles, so you continue driving. If you don't get gas soon, you will end up stranded on the side of the road! Now, would you let your gas tank get so low you run the risk of running it dry in the middle of nowhere? Likely not. So why would you allow your business to run for long periods of time without adding fuel to its tank?

The fuel for your business comes in the form of your creative juices and mental energy. No one has as much desire to make your studio succeed as you do. The challenge is in figuring out a way to look at your business from an outsider's point of view. What we would like people to

think of us, and what they actually do think of us, are often vastly different. We may have the best intentions, but for whatever reasons the message doesn't come across the way we intended. We all probably have a few stories to tell.

I have a couple of friends who were in the photography business for over twenty years. They had become weary after all those years of keeping their noses to the grindstone, and they decided to close down their studio and go to work for someone else. After a while, they realized that working for someone else was not their cup of tea, and they reopened their studio. But before they did, they had plenty of opportunity to research new and different ways of photographing, selling, packaging, and just about everything related to running their businesses. This actually began to become quite enjoyable for them, and before long, they had developed a head of steam that has allowed them to totally and completely reinvent the way their studio operates. What a joy it has been to watch as their new studio has grown from the bottom up all over again, and as they have discovered new and exciting ways of conducting their business. It's almost like they are going into business for the very first time, and it's because they allowed themselves the creative freedom to brainstorm for a breakthrough!

Is this something that sounds intriguing to you? Do you have the desire to reinvent your business and replenish your creative juices? Brainstorming will give you the opportunity!

Be Objective in Analyzing Your Business

The most valuable asset you can have as a Power Marketer is an objective perspective of your business. In a sense, you need to put your entire business on a table in front of you, then stand on a chair and look down upon it. Here is a simple test you can take to help identify some objective details about your business. Grab a pen and paper and grade yourself on a scale of 1 to 10 (1 being totally unacceptable, 10 being perfect). Are you ready?

1. I am totally satisfied with my staff and feel they are doing the best they can do.
2. I feel my staff is happy and content with their jobs.
3. I have a good understanding of my customer base.
4. I am satisfied with my current suppliers and know I am getting the best possible service, quality, and price.
5. I believe my studio front, gallery, and portrait park (or any other studio area that is visible to clients) are the best they can be.
6. I am satisfied with my current level of sales and profit.
7. I have a thorough understanding of my competition and know their strengths and weaknesses.
8. I feel the products and services I offer are complete, my prices fair, and my profit margins acceptable.
9. I am confident that my ordering procedures and inventory levels are under control.
10. I am aware of my strengths and weaknesses and can list them on paper.

Now, let's see how you did. Add up the ten individual scores to see how you stack up.

90–100—Great job! You obviously are in touch with the pulse of your business.
80–89—You have a pretty good understanding of your business, but realize there is room for improvement.
70–79—Things are becoming overwhelming to you, and you are searching for answers.
60–69—Your business is getting out of control and you are probably considering joining a monastery.
59 and below—You are wondering why in the world you got into this industry in the first place.

There are no pass or fail marks, only a better understanding of your business. We need to have a starting point, and now you know where yours is. If you scored lower than you had hoped, don't get discouraged. You just have more opportunities for growth and profitability!

Making Progress

Now that you have a fair idea of your business's strengths and weaknesses, it's time to look at some of the areas in which your business can be improved, no matter your score on the previous quiz.

Understanding Your Customers. We all know that our customers are, without a doubt, our most important

Marketing is essentially a way of asking for business. That's what makes the phone ring. Photography and design by Chatsworth Portrait Studio.

assets. Whether you are just getting started in the photography industry and have a small customer base or have worked to develop one that is extremely large, it is vital that you understand everything you can about them. The value of this information will be obvious when you sit down to plan your first Power Marketing campaign.

There is a small, owner-operated coffee shop. It is located in a tiny town and enjoys a rather lucrative business, offering a wide variety of coffees, fresh bakery items, and a pleasant atmosphere. For many years it has been the cool place to go and hang out. It is constantly packed with patrons. There must be at least ten more coffee shops within a six- or seven-block radius, but this lady's is the best.

One day, I asked the owner what it was that lured the customers into her establishment. She said, "I bet I can tell you the first name and favorite drink of 99 percent of them. I want each person to feel they are my most important customer. Everything I do is with them in mind."

Isn't that a wonderful message? No wonder people come from miles around to sit and visit. She makes them feel like gold. Unfortunately, not everyone has the pizzazz and memory this woman has, but I bet each of us could do a better job of taking care of and listening to our valued customers.

Measuring the Competition. Throughout history, wars have been won and lost by many nations and many types of people. Some wars were fought because of differences in religious beliefs; others fought over territorial dispute; and still others because of the overinflated egos of their leaders. Regardless of the reasons why people fight wars, it's a given that the winner was well aware of their opponent's strengths and weaknesses and was able to adapt their battle plan in order to effectively compete.

One of the biggest fears of any businessperson is the fear of competition, and in photography, competition is everywhere! Whether you realize it or not, though, competition is vital to the success of your business. It requires you to constantly analyze, adjust, and adapt your own business to a changing market. Those who react the most effectively are the ones who end up on top, while those who don't react at all end up in a different industry!

On the flip side, we are all charged with the responsibility to both introduce consumers to and educate them about our industry. In this respect, you are on the same team with every other photographer in your local area, state, and the country. But that's where the friendly competition ends. Beyond that, the consumer is the battlefield, and the name of the game is survival of the fittest. You are in business to generate net profits and provide for your lifestyle choices, just like your competitors.

If I asked you to list three strengths and weaknesses of your biggest competitor, would you be able to? Most of

us are acutely aware of our strengths but won't admit any glaring weakness. That's human nature. In business, however, you must be able to identify the good and bad in your own enterprise, and in others' endeavors as well.

One of the easiest ways to learn about your competition is to go and visit them. Just sit down and have a cup of coffee with them, visit their studios or, better yet, make friends with them. No rule says that you can't get along with other photographers in your area. Invite some of them to your studio and maybe even exchange some helpful ideas on how to make your respective businesses better. Remember that we are all on the same team, and it is important to help each other. You don't have to give away any trade secrets—nor do they—but you may find that you can help each other out in many ways.

The goal in marketing is not to have your competitors fail, but rather to increase your chances of succeeding. If you ask most people, they will tell you marketing is a battle of products and services. In the long run, they figure, the best product will win. Not true! The only things that exist in the world of marketing are perceptions in the minds of consumers. Perception is reality. Everything else is illusion. What the customer perceives as fact is fact.

Identifying Your Hook. So, what is it that you do in your business better than anyone else? What makes you stand out from the crowd and gives the customer a reason to come to you instead of the guy down the block? What is it about your studio that is so compelling that people can't help but want to do business with you? Do you know what it is? Or are you having a little difficulty?

In the world of marketing, we refer to this message that we send to potential clients as a "hook," and it is probably one of the most important assets your business has. Great empires have been built on great messages! If you don't know what yours is, you'll need to grab a pen and paper and spend some quiet time thinking about it. It is important to mention that not everyone can have the same strengths and be best in all categories, but to maximize your position in the market, you should be tops in at least one. Which one? Well, that is up to you to decide.

Once a customer has made up their mind about something, it is nearly impossible to make them believe otherwise. If one of your biggest competitors has spent lots of time, energy, and money to promote their Super Saturday Seventies Portraits, they probably own that category in the consumer's mind. You need to create a category for which you are known as the best.

In my studio, the slogan is, "Elegance, Simplicity, and Sophistication . . . with a little KICK!" Everything I want a prospective client to know about who I am is wrapped up in that tidy package. It communicates the fact that we do very nice, artistic work, but that we do it with a little something extra—some style, some attitude, some pizzazz! This is the message that I want to communicate to my clients about the way I do business, so everything we do from a marketing standpoint reinforces this message.

Several years ago, I had a wedding client who suggested to me that we get a photo of all the groomsmen jumping off a forty-foot cliff into Lake Coeur d'Alene in Northern Idaho. Well, in North Idaho in June, the water temperature is still pretty chilly, but being the kind of guy I am, I whole-heartedly supported the idea. After the wedding was over and the reception was in full swing, the entire wedding party and about half of the guests got into their cars and headed down to the lake. One of the only people who wasn't allowed to come with us was the groom. By this time, he was a husband, and he wasn't allowed to go play with the boys. His wife told him he needed to stay at the reception so he could meet the rest of her family, who had traveled many miles to come to the wedding.

What is it that you do in your business **better** than anyone else?

Well, as we got to the location of the jump, the word had spread quickly that we were doing something spectacular with a bunch of groomsmen, so people from all over the shoreline peppered the side of the mountain to watch the event. Of course, there I was with my tuxedo, tripod, and Mamiya in hand, balancing myself on the side of this cliff with a little help from my assistant. After several minutes of coaching each of the six groomsmen as to where to jump—and who was to jump in what order—so we didn't have a major accident on our hands, I loudly counted to three, and away they went!

Needless to say, the jump went off without a hitch, and to this day I use that photograph in many of my promotional pieces. (Believe it or not, the bridesmaids jumped off the same cliff, but the dresses over their heads didn't make for as good a shot.) Because of that single shot, I have had no less than five other wedding parties "take the plunge" off various cliffs and bridges around the Pacific Northwest. People will call and say, "Aren't you the photographer who takes crazy shots like people jumping off of cliffs?" And of course I say, "Yep, that's me!"

For some reason, people think I am the only photographer who can take a photo of people jumping off of things. And they are willing to pay more for that. I don't have the heart to tell them that any photographer could do it. They think, if you want something crazy and spontaneous, call Graf Creative Group! Remember our slogan: "Elegance, Simplicity, and Sophistication . . . with a little KICK!" You can bet I will ride that marketing wave as long as I can.

Now, most wedding parties don't want to jump off a cliff—or anything else, for that matter—but that single image says to my prospective clients that I am willing to have some fun and try something out of the ordinary. This is just the type of client I want, and it's the exact type of client I attract.

Here is little exercise that will show you the incredible power of a good slogan. See if you can identify the companies behind each one.

SLOGANS
1. Just do it.
2. We try harder.
3. Nothing runs like a Deere.
4. From Sharp minds come sharp products.
5. You're in good hands.
6. Have it your way.
7. We care about the shape you're in.
8. Fresh, hot pizza, delivered in 30 minutes or less. Guaranteed!

COMPANIES
A. Wonderbra
B. Avis
C. Sharp Electronics
D. John Deere
E. Domino's Pizza
F. Allstate Insurance
G. Nike
H. Burger King

I know that most other photographers do fun and creative stuff with their clients all the time, but I am the only one in my market who makes it a point to use those types of images consistently in all of my marketing efforts. We still spend most of our time doing the traditional portraits of mom, dad, grandma, and grandpa looking into the camera smiling, because that's what they buy, but the shots that get us hired in the first place are the fun, crazy, and spontaneous ones. I spend at least ten minutes during each wedding doing off-centered, nontraditional, fun images for my bride and groom. That's what they expect when they hire me, and that's what my studio delivers. So one of the positions or marketing niches that we have developed in our market is the "fun and crazy" position.

Do you have a slogan for your studio? Can you summarize your marketing message and what position you occupy in one sentence (or less)? Creating an effective slogan isn't rocket science, but it does require some of that brainstorming I spoke of earlier. It may also require some quiet time, a pen, a notepad, and a good cup of coffee.

Your slogan doesn't have to be complicated, but it should communicate who you are and what you want your market to know about you. The same is true of your logo. It can be something as simple as your selection of a font, or something with extensive graphics and colors. But whatever it is, it should appeal to the specific demographic you want to attract.

Make sure you are consistent with everything you do, and make an investment in your business cards, your stationery, your signage—anything that projects who you are. Sometimes you need to spend a little money to make a great first impression.

While successful people may not be the very best at what they do, they use top-notch marketing to position themselves in the mind of the consumer as better than the next guy. When you go to a grocery store, do you always buy the best product, or do you choose the one that is most cleverly marketed?

If you look at successful studios around the country, they tend to have several things in common: a staff that is well trained and motivated; a solid customer base; a top-notch image; a creative marketing strategy that generates excitement, lures new customers, and keeps them coming back; and something that separates them from the rest of

the pack. Again, we call this a hook, and it is vital that you have a firm grasp on what yours is. Some examples of a hook are:

- A special black & white technique that you offer your wedding clients
- A popular kids' portrait club that you have been running for several years
- A portrait park that allows families and other clients to be photographed right on the premises
- A special lighting combination you use in your camera room
- Hours of operation unique to your studio (e.g., Saturday/Sunday sessions, evening sessions, holiday availability, etc.)
- Your willingness to go to a location of your client's choice
- The friendliness of your staff
- Your location (whether it be in town or in a country setting)
- Specialization in children, families, seniors, weddings, pets, etc.
- The fact that you photograph weddings with two photographers instead of one

These are only a small handful of possible ideas, and there are literally hundreds more.

Establish a Personal Connection

When it comes right down to it, the client is drawn by your perspective, personality, sense of artistic interpretation, and/or sense of humor. The client is hiring you, regardless of the style of photographs or albums you sell. The bottom line is that the biggest hook you can offer your clients is yourself. All of the fancy equipment, wonderful sets, and expensive lighting won't get you very far if you don't have the personality to sell yourself. If you can establish a personal connection with your client, price becomes secondary, because they are investing in you.

Following this logic, people who recognize they don't have the personality of a salesperson will be well served to hire someone who does. Many photographers are incredible at creating stunning images for their clients and win all sort of awards from their peers for their technical and artistic expertise, but without the ability to sell themselves or promote their businesses, failure is not far behind. Long gone are the days when you could hang out a shingle and people would flock to you simply because you were good. In today's fiercely competitive field of professional photography, only the strong will survive!

I once knew a business owner who had the "me too" syndrome.

Again, you are selling yourself, your personality, and the experience you give people who come into your studio. If they have a positive and pleasant experience and enjoy their time with you, there is great value in that, and they will tell their friends, their neighbors, and their families. They will talk highly of you because they enjoyed themselves, not to mention that your talent will show in the images. People are buying emotion when they purchase photography, and there isn't a lot of common sense that goes into it.

Stand Out From the Crowd

An important factor in determining what it is you do better than anyone else is to make sure someone else doesn't already make that claim. One of the basic rules of marketing is that it's better to be first in your own category than to be second in someone else's. You need to find an area that nobody has taken as their own, and then build on it.

I once knew a business owner who had the "me too" syndrome. He always waited to see what everyone else was doing and then he would do the same thing. Big mistake! Over time, customers became aware he was always copying other people's ideas, and he continued to lose business until he had no choice but to get out of the industry. If he would have focused on his uniqueness, he would still be around today!

I'm going to ask you some questions about category ownership, and I want you to think of the answers:

- What is the top computer company? Which company comes in second place?

What do you offer that makes a prospective client want to open your door instead of heading down the road to the next studio? Photograph by Christa Hoffarth.

- What is the top rental car company? Who's in second place?
- What is the top-selling copy machine? Which manufacturer is in second place?
- What is the top-selling facial tissue? Which is the next best-selling brand?
- What are the two top-selling soft drinks? Name the product in third place.
- Who is the number-one manufacturer of jeans? Which brand is in second place?

While you may have figured out that IBM, Hertz, Xerox, Kleenex, Pepsi and Coke, and Levi's hold the top spots in each respective category, you may have run into trouble recalling the names of the runners-up. Are you starting to get the idea? Nobody cares about or even remembers the guy who comes in second place. I hope you are getting those creative juices flowing and realizing what makes you special and unique to your marketplace.

Establish Program Goals and Objectives

John Wooden, the great coach for the UCLA Bruins, used to sit down before each season and write down a list of goals for himself, then for each player, and for the team.

Periodically during the season he would pull them out and reread them. No other coach in the history of college basketball had as much success as John Wooden, and it wasn't by chance.! His ability to set goals, maximize his resources, adjust his methodology as the season progressed, and follow through until the end, produced championship after championship, year after year.

Athletics teaches us a lot about setting goals and working toward them with diligence. Your business requires the same level of commitment in order to achieve your objectives. In marketing, your goals should be based on three considerations:

1. Are the goals realistic and attainable?
2. Does the program help you achieve your ultimate goals and objectives?
3. Will the results be measurable and trackable?

If you can answer yes to all three questions, then your program has the potential to be successful. It may be worth investigating your idea further.

Now, let's take another little break to hear from another of our Power Corner experts, Don MacGregor.

Mitche: **What is the biggest challenge that faces our industry now and in the future?**

Don: The digital revolution's obviously the key part of the biggest change. With innovative products and software, anybody can get into digital photography. Therefore, our biggest challenge, as professionals, is to set ourselves apart. You've got to really know your lighting, composition, and elegant or very free-flowing posing and be able to put it together exceptionally well. We can no longer rely on the fact that it's some mystical kind of thing, because everybody and everybody's brother is going to have the same cameras that we have. So we've got to become better photographers. A lot of people will almost have to relearn the craft. As wonderful as digital is, it's got some great things we can add into our tool collection, so to speak. But shooting digitally today requires a lot of stronger skills in exposure, for example. It takes a great deal more time. It's a lot more expensive.

What percentage of your clients purchase wall portraits?

100 percent! If we don't sell a 30-inch or larger family portrait, it's because the client is not pre-sold or properly prequalified before they come to place their order. Pre-selling, for me, is helping clients by making their purchasing decisions easier. Sales are not created in a sales room. Sales are created in a mall when you first talk to the client. We do our very best to create a portrait they will want to display as a wall portrait. With a lot of our wall portraits, we do the consultations in the homes. We do the sales in the homes as well. I try to do all the projections right in the client's home. You're helping them put a piece of art on their wall.

Describe your marketing philosophy.

At a conference that I went to many years ago, I learned a saying: "Is the price too high or the purchasing desire not high enough?" I don't think there are any more powerful words in our business than those words. Is the price too high or the purchasing desire not high enough? So, my marketing philosophy is to do whatever I can to create a strong purchasing desire. Utilizing emotional symbolism, in other words, putting something into those images that has a special meaning, is the way to do it.

Power Corner

Focus on . . .
Don MacGregor

Perhaps one of the most passionate and gentle men I have ever met, Don MacGregor gives new meaning to the term "image marketing." I was fortunate to be able to spend some time interviewing him at his photography school on Vancouver Island, British Columbia, and came away revived and filled with a new sense of what my business could become. His total dedication to his craft is one of the main reasons why he has become one of the most successful marketers in all of Canada, and his insights are extremely valuable and informative.

MacGregor Studios, a Vancouver-based studio for almost thirty years, specializes in portrait and wedding photography. Don's creative wedding albums and family portraits have been displayed throughout Canada and the U.S. and are included in the permanent collections of the Canadian and American Professional Photographers Association archives as well as the International Exposition of Photography at Epcot Center.

Don teaches across North America and is well known for his passionate programs. This is a man who absolutely loves photography!

For more on Don's educational materials and workshops, visit www.macgregorstudios.com.

How many mall displays do you have at any given time?

We probably do anywhere from six to ten a year. They're fairly expensive. Up in Vancouver, Canada, it runs about $1,600 a week for us to do a mall display, so that's a fairly big chunk of change. The other thing that we've gotten involved in over the past couple of years is linking ourselves to activities that have the right kind of client. An auction to benefit the arts or the heart or stroke foundation, or breast cancer organizations—any kind of an auction—is good for business. Not a silent auction. I'm not a real believer in that. I want a verbal auction. I choose auctions where people are spending serious amounts of

money—where bidding $1,000 is nothing. You want your photography to be perceived as a valuable product, so you have to get it out into these markets to see a real benefit.

What do you feel are the most important attributes of a Power Marketer?

One of the key things is discipline—having a yearly outline, and then a monthly outline, and then a weekly outline. The Power Marketer in our industry is somebody who is very disciplined and has a very structured plan that they are going to accomplish. And that usually requires somebody dedicated to do it.

Do you feel that Power Marketers are born, or can you learn to become a savvy marketer?

Yes, you can. I think you can learn to become a great marketer, but it's going to take some passion. The problem with many people in our business is that all they want to do is take pictures. They don't want to collect sales. It's something really simple that you can do.

How do you balance the passion for your photography and the necessity of having to be efficient with your business and your marketing?

I'm starting to learn how to delegate, to say, "'This is what I want you doing,' so I can really concentrate on getting the time to market." We have one of those dry-erase boards in the studio, and when we have a project, I mark it down on the wall. I give one project to each of my employees and say, "When the project is complete, erase it." It's interesting to see somebody who's got three projects up there, while the others have completed and erased theirs. The person who is lagging behind is going to try to catch up. It's a competitive atmosphere, but it makes us more efficient.

What are the most important things to you in life, not so much photography but in your life?

I'm a person who is driven by goals and challenges. I just have to have a challenge to do it. Obviously things like family are important to anybody. I also love my dogs!

At one point several years ago, I was losing my joy in my photography. I had forgotten the reason why I got into the business, which is that I love taking photographs.

One day I picked up a travel magazine and I saw these people on kayaks and with killer whales and I thought, man, that looks like fun! So in 1991, I organized a trip and I took eight people along! I rented kayaks, a boat, and all this kind of razzle-dazzle, and I just had fun taking photographs. That trip rekindled my passion!

What would you recommend to somebody who is looking to raise the bar on their marketing efforts?

One of the key things is going to be to identify the type of photography they want to do. The jack-of-all-trades is a thing of the past. You've got to have a game plan! Some of us get a little arrogant and think, "I'm a real photographer, I'm a Master Photographer, I am an artist." Well, I take photographs and I sell them. There's no "we are artists." There are a lot of guys who want to be the artist

You have to **make a decision** about where you want to take your business.

because they don't channel their efforts toward the people who can afford to buy profitable items, and then there are some people who want to make a good living. It's just the volume of work. That would be the first key thing. You have to make a decision about where you want to take your business. What type of branding do you want?

Once you've made that decision, then you start to build that game plan, and you do it with realistic goals. Most photographers fail with their projects because all they ever see is the whole project and they just don't get anywhere. If you beak down that big project into steps, it becomes more manageable—divide and conquer. You've got to think, "I'm only going to look at step one right now and then soon enough, step two." Then tear it up!

What is your hook? What is it that makes you unique and different in your marketing?

Our environmental work and our canvas wall portraits. There are so many calls that we get because we built an identity for our studio with these products. I built a powerful identity around wall portraits and environmental work.

What marketing campaign has been the most successful for you?

Mall displays. Actually, any kind of displays—malls, home shows, etc. However, while the home shows are good, you get a lot of people who go to them just looking for a good deal. But if you get into a mall—a higher profile mall that has some pretty good stores—it can work pretty well. I want a mall that has expensive clothing stores. I want that type of high-quality store that's frequented by people who are real nice to talk to.

To make it work, you've got to make your display a very good one. You've got to put good dollars into that display. So many people try to do displays on the cheap, and they pay a very dear price! There's no second chance to make a first impression. That is so vital.

Even the clothing you wear, how you physically present yourself is important. Yes, a lot of us wear jeans sometimes—but I don't wear jeans to the studio. I will wear khakis that look nice, and I dress well. It creates that image, that package, that perception.

Have you done something that was just a bomb?

Yes! Our newspaper ads. With my goals and prices, I'm expecting a four-figure purchase for every family session. That's not something you just pick up, like a pair of shoes. You've got to have a need for them. It's hard to create emotion with an ad in a newspaper. It was a waste of money for us. Also, our yellow pages ads—but there's a lot of controversy in that. I still think they're good in a lot of ways. People that do need to find us can find us. But for our kind of business, the newspapers have not worked. If I had a high-volume business, there's no question that I'd be in the yellow pages and in the papers a lot. If a photographer wants to reach clients who will invest a couple hundred dollars on their portraits, then newspaper ads could work.

What was the best experience in your life?

Probably when I've been out camping and hiking. I've got very fond memories of that. Actually, there's one memory in particular. My good friend Mike and I took off to a place called Flores Island—just the two of us and his dog. We built a campfire and decided to take a walk down the beach. When we arrived at the beach, we sud-denly realized that we were going to get a fantastic sunset. We looked back out to where our cameras were and thought, "We'll never make it there and back again." So the two of us walked over, hiked up on these rocks, watched the tide come in, and watched the sunset for at least an hour. No cameras, no words.

Who are your biggest inspirations?

It would have to be photography people, because that's been my whole life ever since I was young. I photographed my first wedding when I was still in grade twelve.

Are you serious? Did you go to school for it?

The first two years of my wedding photography career, my grandmother used to drive me to my weddings because I was not able to get my license.

Frank Cricchio is a strong influence in my career; Al Silver is, too. Paul Skipworth has had a tremendous affect on my life. The man is very smart and disciplined. He is also an incredibly fine photographer. He is one of those who are a step above in terms of the marketing, and he is so excited about his marketing. He wants to have great photographs that elevate him up above the rest.

I think for us and for a lot of other photographers, it makes sense to have a passion for building emotional sym-

I'm actually selling clients that **emotional symbolism** . . .

bolism in our photographs. It makes it a lot easier to sell them! It relates back to the theory that if you're priced higher, there will be a bigger demand for your services. Emotional symbolism actually is an incredibly powerful sales tool. You educate the client about the value of the image that you're making as it relates to their emotional return. "Mrs. Jones, you know, this portrait is going to give you such enjoyment. Every time you look at it you're going to remember, and you will get goose bumps." I'm actually selling clients that emotional symbolism, and it has worked extremely well.

3. Positioning for Profit

Do you ever find yourself saying, "It seems there are far too many ways for me to market and position my studio. How can I know what's best?" Photographers do have many opportunities to reach out to prospective clients. The list below should give you some idea of the variety.

What is Positioning?

What does the word positioning mean to you? To me it's a very simple concept: it means putting yourself in front of the exact customers you want, with precisely the message you want to communicate, at just the right time. The best part about being an entrepreneur is that you can decide all of these things on your own.

Revitalizing and reenergizing your marketing plan—or as I like to call it, your battle plan—is not an easy task. We began the brainstorming process with the Power Market-

ing self-test. We also talked about being able to identify what it is about your business that is unique and special, what it is that separates you from everyone else in your market. We call this a hook, and I trust you now know what yours is.

When you are in an area where several competitors are going after the very same dollars you are, you must have something that separates you from the rest of the pack and makes you stand out. Either you are unique and different, or you are out of business. It's that simple. Having a me-too approach will not get you very far down the road to being a successful Power Marketer. The old saying "The guy at the top of the mountain didn't fall there—there's a reason why he's there," holds true.

The ultimate compliment we can get as photographers is, "Boy, what a great experience we had having our portraits done! You made it fun, easy, and very relaxing. We all had a wonderful time. It may have cost a little more than going somewhere else, but it was worth it!" If your clients are made to feel special during the time they spend with you, they will undoubtedly become more emotionally attached to their portraits, which in turn means that they will spend more money on them. The bottom line is to make a profit so you are around to answer your phone when they call to schedule another session.

There is absolutely nothing wrong with making a profit; without it, you have no business. You shouldn't feel guilty about getting paid well for what you do; it allows you to support your family, take vacations, and accomplish the things in life that mean the most to you, and makes it possible for you to sustain your business so that you can provide the same service when your customer calls back to schedule another session. There is no reason to feel guilty about getting paid well for what you do.

The lesson in this whole thing is that if your clients have a positive experience with you, from the first time you an-

Ways to Reach Prospective Clients

price lists	web sites	pens
brochures	Internet banner	bumper stickers
flyers	ads	calendars
business cards	search engine	newspaper ads
direct mail	listings	magazine ads
signage	gift certificates	merchant co-ops
billboards	welcome wagons	slide shows
gift cards	hospital promos	video shows
auto lettering	mall displays	charity events
table tents	restaurant displays	church directories
bookmarks	library displays	frequent-user
bridal fairs	bank displays	photo clubs
senior fairs	beauty shop	promotional raffles
business fairs	displays	newsletters
county fairs	referral programs	telemarketing
yellow pages	vendor programs	campaigns
chamber	key chains	press releases
directories	coffee mugs	art shows
radio ads	notepads	window displays
TV commercials	refrigerator	sample albums
airplane banners	magnets	. . . and more
hot-air balloons	pencils	

swer the phone to when they pick up their portraits, they will become your best salespeople and will make many referrals to your studio.

Finding Your Niche

Before you can decide on the exact position you want to occupy in your market, you have to know what you want out of your life. In chapter 1, we talked about setting goals, both personal and professional, and how important it is to achieve a proper balance between your work and personal life. Now, if you are the type of person who needs to work seven days a week, from sunup to sundown, then your goals might be altogether different from those of someone who works hard when it's time to work, but wants to spend the rest of their time doing the things in life that are important to them. What is it you need in your life to make you feel fulfilled, complete, and satisfied?

Whether it's time with your family, time on the lake, or time at the office, you need to have a firm grip on what your priorities are. You must also have passion—passion for your work, for loved ones, and for living. Without passion, life becomes one big blur, and we go from day to day without any real direction or conviction.

I have a friend who is a wonderful photographer and a very hard worker. He loves to shoot weddings—so much, in fact, that he shoots two, three, sometimes four weddings in a single weekend. And that's not just during the prime season. Even in the so-called off-season, he always seems to have at least a couple of weddings booked every Saturday and Sunday. If you were to sit down and have a discussion with him, you would find out it is part of his overall battle plan to shoot that many weddings, and it definitely gives him a rush of adrenaline after he has finished a grand-slam weekend.

What's your studo's niche? Does everything about your business communicate this special appeal to prospective clients? Photographs and design by Jeff Hawkins Photography.

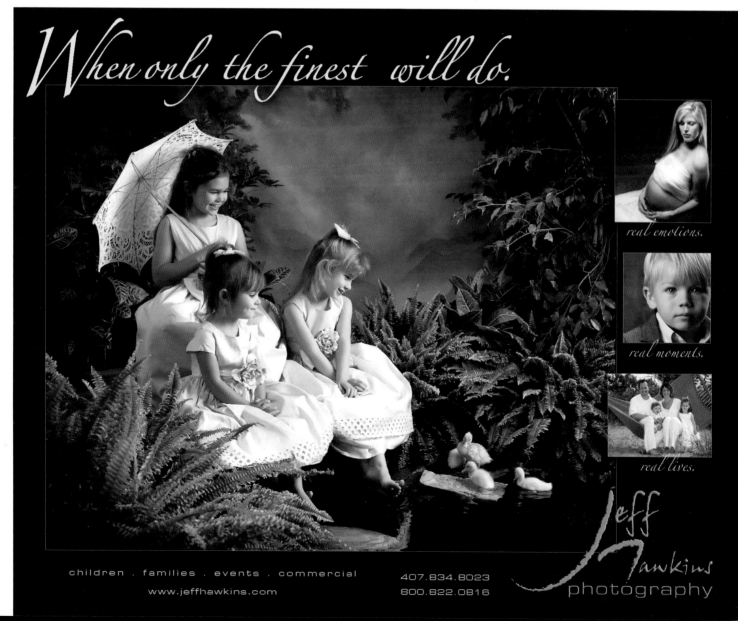

Now, if I were to shoot four weddings in two days, not only would I be practically useless to the last bride and groom, I would also be a lump of burned-out flesh come Monday morning. We all have a place and position to fill in the marketplace; he understands what his is and is very good at what he does.

If your goal for your studio is to photograph four to five hundred weddings a year, then you will need to position your business accordingly, carefully selecting everything from the vendors you build a referral network with, to the pricing of your packages. On the other hand, if you only want to cater to the elite and photograph ten to fifteen upper-end weddings a year, your approach will be altogether different. Either way is perfectly fine, you just need to know where you want to be and what your priorities are.

What makes a portrait by Chatsworth • Portrait Studio • *so special?*

Planning! Planning is very important to us. The clothing choices and location for the portrait are vital to the "style" of the portrait and it's overall impact.

As you plan your portrait session, consider the intended use of the portrait and where it will be displayed in your home or office. This is a key factor.

Superb artwork is another reason why a portrait created by Bradd and John is beautiful and complimentary. It is their artistic abilities and enhancements that separates them from others. The unique vision and perspective of a true artist is what makes their portraits sensitive and outstanding.

Bradd & John are masters of the tools and techniques which allow them the creative freedom to deliver what other studios only dream of.

Chatsworth • Portrait Studio •

On the windy hills of the Appalachian mountains, each morning the sun spills over the mountain tops shedding light and life onto our studio and our faces, where we capture the souls of human life.

The essence of our lifestyle is to capture the precious memories and timeless events throughout our lives.

When you display our fine-art, it will bring to your home and your family a rich image of beauty and a precious piece of art.

The seamless structures of our capabilities and artistic abilities are guaranteed to touch your life and the live's to come.

"To say that I am a photographer is wrong. I am an artist that through the view of my camera I see life as the most precious gift we have. As an artist my goal is to capture life and it's beauty, to present to you a very special moment in time that you can reflect on for eternity."
-Bradd Parker

"The thought of creating something that people will cherish their whole life is why I do what I do. I love being an artist. Everyday is new and exciting to me, whether I am shooting a senior or a newborn. I am able to stretch my imagination and create lasting memories in that persons life. I give the gift of memory, and the process of creation can be overwhelming"

-John Waldron

www.ChatsworthPortraitStudio.com

People have a lot of choices, so why should they spend their photography dollars with you? As seen in these pages from the pricelist of Chatsworth Portrait Studio, clients need to be clear on what is unique about your studio.

4. The Ten Categories of Power Marketing

If I collected 8x10 prints from everyone reading this book, spread them on the floor in a row, then asked a customer to come and choose the best, they would really have a hard time making a selection. The fact is, all would be very good—and many would look alike. Photographs are like most other products on the market: they are very similar; it's only the packaging and positioning that differs. We all claim to provide fantastic quality, but it's clients who judge the caliber of your work and customer service after they've experienced the way you do business. To lure and keep your clients, therefore, you must appeal to them by positioning your studio based on something beyond mere quality.

The overall goal is to somehow create value for yourself, your products, and your services so you can charge more, make more, and have more time off to do the things you enjoy in life. There are literally hundreds of things you can do to promote your business, but when you break it down, there are only ten categories of Power Marketing. A description of each follows.

1. Literature

This category contains your business cards, price lists, direct mail pieces, handouts, statements, letterhead, envelopes, box stuffers, flyers, brochures—and anything else that is printed with your name on it.

Quality. When a potential client first lays eyes on or touches your business card or portrait package flyer, he or she will immediately form an opinion regarding the quality. How does it look? How does it feel? What would you think if someone were to hand you your business card? Do you use paper stock you find in the clearance bin at the local paper supply store, or do you use a high-quality designer stock? Remember that everything the client sees, touches, smells, observes, or feels goes into determining what they will be willing to pay for your products and services. It's okay to use the half-priced discontinued stock if you're not aiming for an upscale reputation.

Believe it or not, I had a photographer come up to me after a seminar a couple of years ago who was ready to throw in the towel just because he wasn't getting much business, and the business he was getting wasn't willing to pay very much for his photography. Well, by looking at the hardware around his neck, it was obvious to me he wasn't lacking in photographic expertise or respect from his peers. In fact, he'd received lots of awards and lots of medals. When he handed me his price list and business card, it was immediately apparent what the problem was: his card was printed on thin paper stock with faded black ink, and his photocopied price list had black streaks running through the middle of the page. My first impression? I wouldn't want to invest any time or money with him if I were a customer, regardless of how great a photographer he was.

What would you think if someone were to hand you your business card?

Ask yourself whether the quality of your literature reflects the market position you want to occupy. If not, change it today. We will further examine the role that your literature plays in creating a positive image in a later chapter, but for now you need to be aware of how vital that first exposure to you actually is.

Content. I know of a photographer who ordered 10,000 full-color direct mail pieces to send to prospective customers who lived within his target market. He had recently moved to the area and wanted to introduce his studio to the neighborhood. He offered a free, all-you-

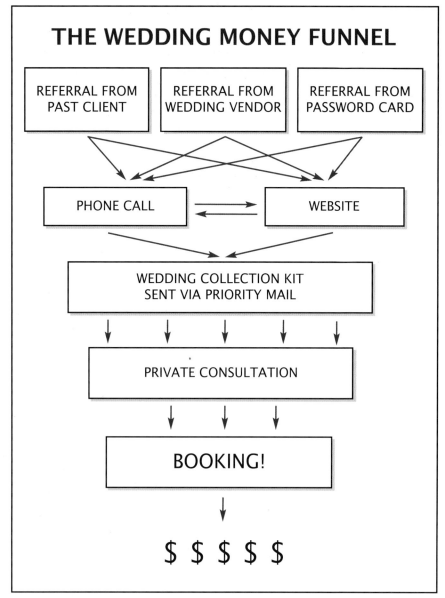

THE WEDDING MONEY FUNNEL

| REFERRAL FROM PAST CLIENT | REFERRAL FROM WEDDING VENDOR | REFERRAL FROM PASSWORD CARD |

PHONE CALL → ← WEBSITE

WEDDING COLLECTION KIT
SENT VIA PRIORITY MAIL

PRIVATE CONSULTATION

BOOKING!

$ $ $ $ $

By having a systematic and easy-to-understand lead-generation program, you will guarantee that you will have a steady flow of quality leads into your studio. The above chart details one way to accomplish this.

sure to be a gigantic influx of phone calls and walk-ins on the day the piece was to hit residents' mailboxes.

The day finally came—and went—without so much as a single phone call. He waited and waited and waited. Four days went by before the first call came in, and the person said, "Is this the studio that's having the free pizza party and the family portrait specials? If so, I would like to schedule a session to take advantage of your special offer. But I've got to tell you, it sure was difficult to get a hold of you! Your name, address, and phone number weren't listed in your mailing."

Despite the fact that he had put in all of that time and effort—not to mention money—he had forgotten to add his name, phone number, and address—a very expensive mistake! Simple rule #212 is: Always have someone else proofread any marketing materials a client will see. This can prevent a lot of simple-to-correct mistakes.

2. Curb Appeal

Everything about the appearance of your studio—from the signage outside to the general appearance of your studio sends a message to prospective clients. The interior of your studio sends a clear message, too: the lighting on your gallery prints, the way the phone is answered, the smell that hits you when you walk in the front door of your gallery, and even the cleanliness of your restrooms all impact your position in the market. Are you projecting the proper image for the position you want to own?

3. The World Wide Web

By now, most photographers have established some sort of presence on the Internet—either through a web site, a blog, or at the very least through an e-mail account. With digital photography and online proofing now important

can-eat pizza feast, complete with breadsticks and soft drinks at his open house. He had a great portrait special, an offer they couldn't refuse, and a deadline of the following week to call to schedule an appointment. He had all the right ingredients for success.

This photographer purchased an expensive list that gave him only the best-qualified leads for his business. The folks on the list made at least X dollars per year, had X number kids, shopped at X stores, and drove X cars—all the right stuff! He hired a local mail-room company to address and stamp each piece, then he prepared his staff for what was

elements of our industry, there is no reason why you should not be on the web.

Developing a web site is a very cost-effective way to introduce yourself to prospective clients, both near and far, to showcase your work, and to outline your session fees and package prices. If you don't have the know-how to build a web site, take a class and start with a simple, one-page site that features your contact information and other basic facts about your studio. If you prefer to outsource the work, there are many companies devoted to designing and maintaining web sites for photographers. Free blogging sites are also widely available.

Aside from marketing, the Internet is also a powerful sales tool. You can now create a personal web site for each of your wedding and portrait clients so that Grandma in Florida and Uncle Bob in California can view and purchase your work right from the comfort of their own homes. For instance, when we are finished photographing a wedding, we hand clients a small web site announcement card with a private password they can use to view all of the images from the day. When the bride and groom's web site goes online a few weeks later, we get a tremendous number of visitors. And guess who many of those guests are? They are next year's clients. They have seen us in person and have gotten to know a little about our style and creativity. They have also viewed our work online, so when they do call the studio, they are calling only to find out if we are available to photograph their wedding.

New referrals are also directed to our web site, which, again, immediately familiarizes them with our work. We give these prospective clients a password and allow them to browse through a wide variety of images. This allows them to get to know us at their convenience without having to schedule an initial sit-down visit. After viewing the images, a face-to-face meeting is scheduled—but only once mutual interest has been generated. Again, our Internet presence saves us a lot of time. If we aren't what

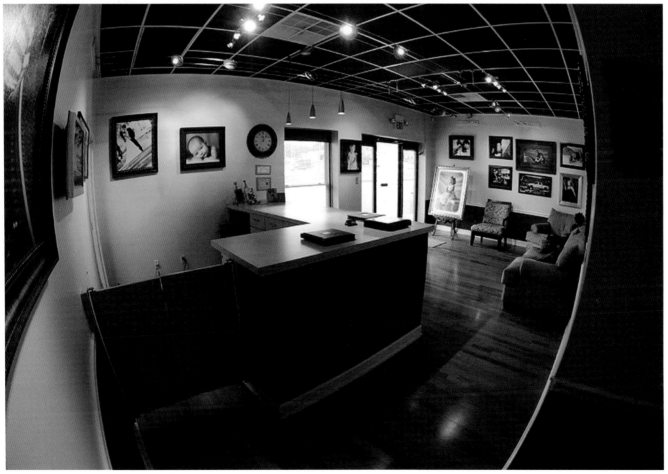

The design, lighting, and merchandising of your studio let clients know where you stand in the market. Photograph by Chatsworth Portrait Studio.

At Jeff Hawkins Photography, their web site makes it clear to clients that they are working with a unique, top-notch professional.

the client is looking for, they find out before they make the trek to our studio, and it saves us from investing time and energy in someone that may or may not be the right client right for us.

Without the Internet, our marketing plan would be very different than it is today. Because of our ability to — post wedding and portrait images on the web and keep in touch with current and potential clients via e-mail, we have been able to tremendously enhance our marketing impact.

4. Advertising

Advertising is the most expensive type of marketing. This category includes yellow pages ads, Val-Pak inserts, newspaper and magazine ads, mall display space, radio and TV commercials, and Little League banners. In essence, it's the type of outreach that you must pay someone to conduct on your behalf. Advertising is considered passive marketing, because it doesn't require you to become personally involved in the success or failure of the program.

You can easily get sucked into advertising in every form, but without careful monitoring you'll eat money faster than you can eat a pig at a pig roast. I prefer to have a Power Marketing approach, meaning I want to play an active role in the success or failures of my programs.

A word of caution: We all need to at least have a listing in the yellow pages so our clients can easily find us, but beware of the salesman who offers you the world on a platter! Regardless of the type of advertising you participate in, you must make sure it fits into your overall goals and objectives for your business and your life. Many businesses have disappeared due to overzealous advertising campaigns, so make sure you have your ducks in a row before jumping into expensive advertising.

5. Pricing

Once a potential customer believes something, it is virtually impossible to change their mind. Therefore, it is very important that you carefully consider where you want to position yourself in terms of the price of your work. Yes, my photography is high-priced. Let me tell you why.

If you are known to be the lowest-priced photographer in your market, you will never be associated with high quality or great service. If you walked into a car dealership and saw a BMW for sale for the price of a Yugo or a Ford Escort, you would be suspicious. You'd probably think there must be something wrong with it in order for it to be priced so low. Of course, the opposite is true also—if a Volkswagen was for sale for the price of a Mercedes Benz, there wouldn't be many takers.

A couple of years ago, I had a riding lawn mower I decided to sell, so I took an advertisement out in the local paper asking $50 for it. The mower had seen better days, but it still ran and would cut grass just fine. I just didn't want to be bothered with the hassle of trying to sell it. A week went by and I didn't get a single call. The second week went by, and still, nothing happened. By the third week, I began to realize what was taking place, and I raised the price up to $200. Bam! The calls came flooding in, and I got the asking price. At $50, people thought there must be something wrong with it, and so there were no takers.

When establishing your position in the market, you've got to decide what you are worth. More importantly, what

do you want to be worth? When you work for yourself (like many of us do), you have both the joy and the anguish of deciding what you are worth to someone else, and need to figure out ways to communicate that worth to your potential clients. If you want to be known as the low guy on the totem pole (which I hope nobody out there does), you will never be known for offering the best quality or the best service.

We always expect to pay more for good quality and great service. When you go out for a nice meal complete with soft candlelight and romantic music playing, with a gourmet wine selection and hand-carved chocolate bunnies for dessert, you will pay a premium fee. We call this selling the sizzle with the steak! When you want something quick and easy without all the glitz and glamour, you will pay substantially less.

How do people perceive your studio? Are you the intimate bistro where you would expect to spend $100 on a nice meal, or are you the drive through where $2.95 will get you the works? More importantly, where do you want to be in the future? If you are priced too low, people will associate you with low quality, poor workmanship, and bad service. There will always be plenty of business at the bottom of the pile, but it comes with a very high price.

Clients don't pay us for the cost of our time or the cost of their portraits; they pay us for the value of our time and the value we bring to their life. If we show up ten minutes late for a consultation wearing flip flops and a T-shirt, we show the client that we don't value ourselves very much, so why should we expect them to value us? If you want to be a Cadillac, then act like a Cadillac, dress like a Cadillac, and project an image like a Cadillac. (Or at least like the human equivalent!)

The compliments and referrals that stem from the work you produce for your clients validate your work. When there is a demand for your time, you can charge more for it. That said, you should note that you can build value for yourself by making it appear that you are busier than you really are. If your schedule is wide open, the customer will wonder why. If you make them wait, your value will rise, and so will your profits.

Your prices need to be based on what the market will bear, not on your expenses. When a customer complains about price, you just haven't shown them enough value

for the price you are asking. You should be proud of your prices! Remember, too-low prices scare people away. It's not that our clients won't pay our prices, but rather that we are afraid to charge what we are worth. I'm not saying you need to raise your prices through the roof tomorrow, but you do need to be acutely aware of your current position in the market, and you should have a well-defined course of action to achieve your goals for the future. If you want to position yourself differently down the road, start making changes today that will lead you down the road to success. Don't wait for another day to make the necessary changes to ensure a better tomorrow.

Pricing will be covered in greater detail in the second half of this book.

6. Press Releases

If you can inspire people to talk about you, there is little need to pay people to talk about you. All you need to do is tell the media something about you that might happen, will happen, or has already happened. Just let the media know that you've hired a new employee, that an existing employee received a promotion, that a part-timer is being promoted to full-time, that you'll be expanding your studio, presenting a new line of products, or will be hosting a holiday open house or a summer barbeque.

Editors are constantly looking for any **newsworthy item** for the business section . . .

You can also let them know when you are invited to speak at a trade association meeting or convention; win awards at your local, state, regional, national, or international competition; earn some sort of degree; or are publishing a book or an article in an industry magazine. These are all legitimate reasons to write a press release, and it costs you nothing.

With press releases, all you need to generate a little interest is a piece of paper, a pen, a fax number, or an e-mail address. If you think that the same businesses are being mentioned time and time again in your local newspaper, you are probably right. Editors are constantly looking for

any newsworthy item for the business section, and they love it when it comes to them in the morning fax.

If you want to be considered the expert, you have to look and sound like one. If nobody has appointed you the expert, appoint yourself! Blow your own horn! Your goal is to create an awareness of your business, which in turn will lead to an increased value for your products and services. If you can generate interest in your business by announcing all of the countless positive changes in your business, why not do it?

7. Time

We are all on equal footing when it comes to time. We each have 24 hours in our day and 365 days in our year, and we can't buy more for any price. The only choice we have is how we spend our time. What kind of value do you put on your time? Are Saturdays and Sundays more valuable to you than weekdays? Are your evenings more valuable than your afternoons?

I imagine most of you will say yes to these questions. If that's the case, why is it that we charge the same for our time on a Sunday morning or a Wednesday night as we do on Tuesday afternoon? It's perfectly okay to offer sessions on Sunday mornings or on a weeknight, but wouldn't it be nice if we could be compensated for giving up our most valuable personal time?

Wouldn't it be nice if we could be compensated for **giving up** our most valuable personal time?

I used to shoot about 75 percent of my senior sessions after 5:00PM during the week. I truly believed it just wasn't convenient for the kids to make it in during the day; after all, these students worked, they had practice, and they had other appointments to keep. (Not to mention the light in the evening was outstanding!) After a while, though, I noticed that some other studios were busy during the day and closed at 5:00 or 6:00PM. I also began to realize that other professionals—doctors, dentists, etc.—were open only during business hours, and people managed to find time to visit them.

I found that other studios offered sessions outside of regular business hours, but at a price. Based on this, I instituted "prime time" pricing for these sessions, but offered lower prices during regular business hours. It was amazing how many people magically found time for their sessions during my normal business hours. Yes, there were the people who still needed to have an evening session, but it was now their choice, and I was better compensated for my time.

I still shoot approximately 25 percent of my senior sessions after 5:00PM, but I can now justify spending that little bit of extra time away from my family because of our new pricing strategy. How much value do you put on your time? Would offering prime-time pricing help position your studio in a more favorable light? It's something to look into.

8. Referral Network

The referral network is your biggest ally. It's your most powerful marketing resource, and it can take your business to new levels. After all, referred clients spend more money, are generally happier, stay longer, and come to you already sold. Let's talk about the two types of referral networks that you can build in your business.

Other Professionals. The first network is comprised of other professionals like tuxedo shops, children's clothing stores, mens' and women's clothing stores, D.J. companies, caterers, civic groups (like the local chamber of commerce), florists, dental offices, doctors' offices, health clubs, entertainment centers, golf clubs, and so on. Not only can such businesses/professionals be an excellent source of referrals, but you can also partner with them in cross-promotions.

You may already have partnered with a strong group like this, or maybe you haven't invested much time or effort into developing this circle of peers. In either case, I challenge you to sit down with a pen and notepad and brainstorm until you come up with a list of other businesses you would like to develop a more substantial relationship with.

Once you've created your list, there are some simple things you can do to get the ball rolling. First, you can mail some of these business owners an invitation to a special open house at your studio to talk about how you can

all become part of a new referral network team. During this meeting, you can exchange information on each others' businesses so you become better educated about them, and they can gain knowledge about the many facets of your business, as well.

You can also pick up the phone and give them a call, or go visit them at their place of business. I guarantee they are just as interested in cracking the marketing code as you are. This kind of network is mutually beneficial, and it doesn't cost anything but some time to develop a constructive relationship with other companies that share your goals.

We have relationships with several other vendors in our market area, and they consistently send prospective clients in our direction. These referred clients are already prequalified, meaning the other business has already done a sort of screening for us and, since they know the type of client we are looking for, and what our price ranges are, they only refer people who meet those standards. This fact alone makes my job much easier. When I answer the phone and the person on the other end says "I was talking to Mary at ABC Florist, and she showed me some of your work and your package information. I want to check to see if you are available for my wedding," I can breathe a sigh of relief. With these clients, I don't have to deal with the standard questions most people ask when they find your name in the phone book. Prequalified clients are ready to do business with me.

Past and Present Clients. The second type of referral network, and by far the most neglected by photographers, is comprised of past and present clients. You probably have hundreds if not thousands of past clients in your database who know and trust you, have already purchased your work, and have had a pleasant experience with you. And what are you doing with those happy, satisfied customers? If you are like many photographers, not a whole lot! Their positive testimonies are largely untapped—but you could use them to draw new clients into the fold.

If you aren't already taking advantage of your clients' testimonies to earn referrals, you can begin today. Create a short questionnaire to give to your client once they have picked up their finished portraits. You can have them fill out the questionnaire while they are at your studio, or you can send it home with them to complete and mail back to you. Be sure that your questionnaire asks them to rate their total experience with your business—from their experience with your staff, to their satisfaction with the session, to their ordering process, and their impression of the final portraits. Try to stay away from questionnaires that let people check a box or write in a number from 1 to 10. You want to obtain as much information as possible from these clients, so ask them to write out their answers in descriptive terms. At the bottom of the questionnaire, you can ask them for the names, addresses, and phone numbers of friends or family members who might be interested in having their portraits created. If your clients are satisfied with their total experience, they will have no problem whatsoever with giving you these leads. And guess what you can do with those new names? You've got it! Send them a letter with an offer they can't refuse, or better yet, ask your client to write a letter to send to them.

Whatever you do, strike while the iron's hot! If you wait too long, the **afterglow will diminish.**

Whatever you do, strike while the iron's hot! If you wait too long, the afterglow will diminish. The entire sales and marketing game is built on creating a positive emotion, and you will lose your momentum if you wait too long. The best marketers and salespeople understand this dynamic and develop the emotional trappings to guarantee a fantastic experience—and large sales averages. If a customer says to you, "Boy, we sure had a great time with you and we just love or portraits," say, "Great! Can you put that in writing?" Then, do something to thank them for their time (you might, for instance, reward clients who fill out a survey with complimentary gift wallets, a free sandwich and soft drink at the local sandwich shop, or a complimentary session—it's up to you). Testimonials are king. Make getting them your number one priority, then blow your horn and sing your praises to the entire world!

On this note, keep in mind that there are only two kinds of service: great and bad. Mediocrity makes little or no impression on most people. Make it your goal to go above and beyond the call of duty when it comes to pro-

NAME	DATE	STUDIO	P-BOOK	PAPER	FRIEND	FLORIST	CATERER	CHURCH	WEB	ASSC	TV	RADIO	OTHER	SESSION	ORDER
TOTALS															

FACING PAGE—When a new client calls or walks into your studio, ask them how they heard about you and record their response. This will show you which forms of marketing are working and which aren't. If you are spending $200 per month on a yellow pages ad and receive only two calls from it, you can probably find a better use for your $200.

viding gold-medal, top-notch, number-one-rated customer service. This is the best way to create customers for life and to keep the referral highway filled with traffic.

It's easy to fall into the trap of writing checks every month for yellow pages ads, or newspaper ads, or costly mall display space. A few years ago, I spent $5,000 on a great looking TV commercial that was flashy, trendy, and upbeat. I expected great things to happen as a result of having commercial exposure of that magnitude. Guess what? It was a big bomb! I received a grand total of one phone call. I could have spent that $5,000 to better generate revenues for my studio. But instead I spent it on a very expensive lesson.

There is absolutely no better marketing program in existence than to build a client base with referrals from other professionals and past satisfied clients. If you can effectively use both types of referral programs to generate clients, you'll never need to spend money on expensive advertising again.

9. Database/Direct-Mail Marketing

While the short-term goal of a marketing campaign is to get customers to come to you for the first time, the overall goal is to keep them coming back over and over again—and to get them to tell their friends and family about you. You already have their names, phone numbers, and buying habits. They already know and trust you. That's what we call the perfect target market! If we can do a great job in nurturing and developing our past and present customers, there will be little need for expensive newspaper advertisements, bridal fairs, big yellow page ads, and the like. All your clients would come to you by way of other clients. Wouldn't that be nice?

10. Phone

The goal of every effective marketing campaign is ultimately to make the phone ring, right? If you can't book the session, all the marketing in the world is useless. But do you know how much it *costs* to make the phone ring?

Understand the Costs. If you already track each call that comes into your studio, this exercise will be easy for you. If you don't, you will need to track every call that comes in for a period of time—let's say one week or a month. (Of course, calls from your family, friends, and pizza delivery shop don't count!) When you've tallied your incoming calls, divide your total expenses by the number of calls you received. You might be surprised by the amount. I've heard of numbers as low as $3 and as high as $1,100. You can also add up your total sales for a given period and divide this sum by the number of calls received during that same timeframe. This will give you the approximate dollar amount that each call generated. While it's not an exact science, the exercise will give you an idea of where you are. Are you happy with the results?

Your Voice Mail. When your client reaches your voice mail or answering machine, what do they hear? The first thing you want to do is to listen to your message. This ought to be fun! If I surveyed a hundred studios around the country to determine what was on their answering machines, I'll bet that the average message would play out something like this:

> Hello, and thanks for calling. If you've
> reached this message during normal
> studio hours, we are either with a client,
> on the other line, or on location. Please
> leave us your name and number, and we
> will give you a call back when we re-
> turn. Thank you, and have a nice day.

Does your message sound similar? Don't worry; its not just photographers who do that, it's all of America! Don't you think people get tired of listening to the same old thing every time they call a business? So why not add a little pizzazz to the mix? Have some enthusiasm, exhibit some sincerity, and have some excitement in your voice!

There are several things you should pay attention to when listening to your message. Does it sound far away and tinny? Is there enthusiasm in the voice, and is it sincere? Are the words spoken clearly and concisely, or do the words run together and sound rushed?

There is nothing worse than calling another business only to encounter a voice message in which the speaker

sounds bored, irritated, and disgusted. It makes me not want to do business with them. Make sure that your own message is friendly, spirited, and welcoming. This is something you can do right now if you so choose. Grab a piece of scrap paper, write out your script, and put a new message on your machine.

Answering the Phone. The same rules apply when you answer the phone. You want to sound approachable, trustworthy, professional, and upbeat. A simple "Good morning. This is Eric Smith. How can I help you today?" is a good start. (Of course, a number of variations like "Happy holidays. This is Mary. How can I help you today?" work just as well.) If you use your first name, the caller is much more likely to give you their first name without you having to ask for it—and once you have their first name, use it! People feel important and special when they hear their name, and it makes a conversation more personable. Ask the needed questions and then shut up! The best way to show clients you value them is to listen. Hear them out; we were given two ears and one mouth for a reason.

Treat each call that comes into your studio like gold. These calls pay the bills and allow you to buy your new camera equipment. If you have a staff person who handles a majority of the incoming calls, make sure they fully understand that it's the studio's image on the line each and every time they pick up the receiver to say hello. The phone is our first opportunity to make a positive impression on potential clients, and there is no second chance to make a first impression.

Final Thoughts

We have so many choices when it comes to making a purchase. There are three grades of gasoline, six types of milk, ten different kinds of car batteries, three ticket prices for the ball game, and three different finishes on our portraits. Some people only buy the most expensive, and some people only buy the cheapest.

Regardless of what you are selling, I guarantee there is someone else out there selling it cheaper, better, and faster. So why should clients pay more for your products and services? The key is in your perceived value. They need to think they will get more from you than the guy down the street. If you don't already believe in yourself and your ability, why would anyone else? This point is well illustrated in an often-told story about Pablo Picasso. As the story goes, the artist was sitting outside one day. A woman passing by asked if he would do a quick sketch of her likeness. When he was done, the lady asked how much she owed, and he said, "That will be $2,000 please." The lady said, "For twenty minutes of your time?" And he said, "No, for a lifetime of experience."

Ultimately, the key to good marketing is that you must be heard. If you have something great but don't have the means to let people know about it, you will fail. You want people to talk about you and be able to easily find you. Your goal is to first create awareness for yourself, then to create value.

The phone is our first opportunity to make a **positive impression** on potential clients.

And keep in mind that this is not optional—you cannot *not* market, just like you cannot *not* communicate. When someone calls you and you answer the phone, you are marketing. If someone calls and you don't answer the phone, you are still marketing. If your business card is wrinkled and stained, you are communicating a message. Marketing is the way you shake hands, the way your voice sounds on the phone, how you look, and how you walk. Everything they see and hear determines how potential clients will view your business and the value of your work.

Once again, let's check in with our marketing experts. Beginning on the next page, we'll hear from Charles Lewis—a successful photographer who has been teaching marketing to other photographers for many years . . .

Mitche: **What do you see as being the biggest challenges facing our industry now and in the future?**

Charles: The number one challenge is digital. Digital is going to be the downfall of an enormous number of photographers because they're putting all of their time, money, and effort on this new technology. I agree that digital is the future of photography, there's no question. But they're putting money they don't have into it and spending time that should be spent on marketing and selling. People are thinking, "Well, I've got to keep up with the times. I've got to keep up with my competitors." But if you can't sell an image on film, you're not going to be able to sell it when it's captured digitally.

Digital is not a magic pill that's going to fix all their problems and help them meet their challenges. They should be spending their time on marketing and sales methods. How you present your photographs is the single most important decision of your entire career. It's more important than any other decision you will ever make. Who cares how you create the photographs? Who cares what f-stop and what equipment you use? What should really matter is putting the time and effort into marketing and selling instead of into the new technology.

I'm sure you've found yourself talking to the top marketers and photographers around the world. The top photographers are using digital as a tool, as just one more thing in their arsenal, not something that's necessarily replacing the way they've done it. It's just one more advantage they can offer their clients to up-sell, to make more dollars, and to make their clients happier and more satisfied.

Exactly! Everything goes back to self-image psychology. I think there are photographers who are so insecure about the fact that they're not making the living that they want to make that they say, "Oh, it must be because I'm using outdated technology. If I put, oh, let's just say $50,000 into new equipment, my sales will improve. I'll have to borrow the money, but I'll get into digital, and then I'll learn how to use it! I'll learn how to use the software, too, then I can do my own retouching and—oh, man—this is going to be so cool!" Of course, they're losing sight of the fact that if they can't do it with film, they're not going to be able to do it with digital. We are marketers and sell-

ers of photographic services. That's how we earn our living, and so if we don't invest a substantial amount of our time in the marketing and the selling aspects of our business, we're not going to be earning anywhere near the kind of living we should be earning.

If you could describe in a nutshell what your marketing philosophy is, what would you say?

The main thing is that you have to create a huge demand for your limited supply and then control the volume of work you do with the price.

What do you feel are the most important attributes of a good Power Marketer?

Well, there's no real secret. The main attribute is they devote the time, the effort, and the thought. They scratch off at least one full day a week, usually two full days a week, devoted strictly to marketing and selling. They won't take appointments, they won't answer the phone. They'll let either their voice mail take the calls or they'll have other employees and staff who will answer the phone. They know that the only way to create a huge demand for a limited supply and to earn a really good aver-

age sale is by devoting the time to get better at it and figuring out your marketing.

It's all a matter of having goals—knowing where you want to go, what you want to achieve, and how you're going to achieve that. There's no magic formula. It just takes time. So to me, the real difference is that the really good marketers are the people who devote time to it.

Why do you think so many great photographers, find marketing to be such a pain? Why don't they get more excited about it?
None of us went into photography for marketing and selling. Why are we in photography? We love it! We're passionate about it. We're creating something from nothing. We're right-brained, creative, artistic people. So we go ahead and we put all this time and effort into the equipment and the methods and the technology and the f-stops and the vignetting and the diffusion and the depth of field and then we expect—because no one told us differently—that if we have a really good product, it will sell itself. People will line up at our door. It just won't happen that way.

The great Donald Jack, the one man who totally altered my life forever . . . it's just incredible what he did for me when I spent two years understudying with him at his studio in Omaha. The first time I went in to offer my services as an apprentice, he, to my shock, accepted my offer. He said, "I have a wedding this Saturday, why don't you go with me?" Oh man, I was so excited!

The phone is our first opportunity to make a **positive impression** on potential clients.

So, I got in the car to go to this wedding one Saturday morning. We loaded up the car with all of his equipment, and got in the car. He backed out of his driveway at the studio and he headed down the street toward the wedding. The first thing he says to me is, "So, you're going to be a photographer, huh?" And I went, "Yeah, yeah, Mr. Jack. And I'm really excited. It's going to be really cool!" He said, "Really? How are people going to hear about you?" And I said, "Uh, Don, I'm going to be really good.

I'm going to be so good that everybody's going to talk about me. I'm going to be really, really good." And he said, "So they're going to just line right up at the door to be photographed by you, huh?" And I said, "Yes sir, yes sir. I'm going to work really hard. I'm really motivated. I'm going to be really good." And he said, "Well, Mr. Lewis, we've got a lot to talk about. . . ."

And how old were you at the time?
I was still wet behind the ears. I was in the Air Force. I must have been about twenty, twenty-one at the most. That's why so many photographers don't like marketing. Because they feel it's so undependable. You can't predict it, they think. You put in money and effort and work and you mail something out and it doesn't work, or you buy a yellow pages ad and it flops. They'd much rather have people just come in and sit down in front of their camera so they can create something nice and beautiful. That's what we do. That's what we love.

The *single* biggest decision of our career is how we present our photographs to our clients. If we mess that up, it doesn't matter how good our photographs are. It doesn't matter, because we're not going to earn the kind of living we deserve.

So the whole secret really is to have a system where every single contact we make counts. We have got to realize that we're selling in everything we do. It's all about selling—not pressure and not trickery and not manipulation. It's just a matter of finding out what people want and helping them to get it. That's what selling is.

What's most important to you in life? How does your marketing plan come into play with that?
There's no question that my family and my time with my family is the single most important thing. When I started my studio I worked 100 hours a week. I loved it, and that's a huge mistake. You can't love it. You've got to love your family, but you can't love photography. You've got to keep things in perspective.

If I had a client—a potential client that was perhaps going to end up being a good sale—I'd come in any day of the week, any time of the day or night. The end result was I was always choosing the studio over my family. My goal was to figure out how to earn a really phenomenal

living in photography in forty hours or less a week, no nights and no weekends. That's when I started discovering all the things that I've put into my system of marketing and selling. I was passionate that if it was a choice between the family or the studio that I was going to dump the studio.

How have you developed a balance?

If you know where you're headed and are passionate about getting there, you'll get there. All of my passion is in spending time with my family, in taking trips. So I've tried to figure out how to earn the kind of living I need to earn on the hours I need to do it so I can take four or five months a year off to do the traveling and the other things that I'm interested in.

We've also realized the 80/20 rule (80 percent of the money in our pocket comes from 20 percent of the work that we do). As the great Donald Jack taught me, to be successful, you must be willing to send some people away. You cannot be all things to all people. We determine who has the greatest potential for helping us reach our goals, and that's who we work with. We send the others away—we're friendly and diplomatic, but we send them away.

That's tough to do sometimes, to say no.

It's very tough. Especially when you're hungry. It's very scary, but it's absolutely a necessity. Otherwise, you're going to be spinning your wheels doing things that are not going to end up earning you the kind of money you need to earn and want to earn.

What could you recommend to a photographer who is looking to improve their marketing?

It is all based on what do they want. I do a lot of one-on-one consulting with photographers all over the world, and we spend an hour each month on the telephone. I'm constantly harassing them with questions—Where do you want to be? What do you want to do? How many sessions do you want to do? What's the average sale that you want? What did you do last year? How many sessions? What's the average sale? Now break it down by the client type and the product line. How many families did you do? What was the average sale? How many weddings did you do? What was the average sale? Because you have to have

the goals. And this is a very difficult thing for people to do because our parents didn't teach us this. Our teachers didn't teach us this. Most of our friends are not goal-oriented. Success is not normal. It's absolutely not normal. If we look around the country, most people are not what you would consider successful. They're not happy where they are, and they don't know what to do to change it. So it's very important that we have goals. I'd have to ask first: Where do you want to go? Where do you want to be a year from now? Where do you want to be five years from now? How many sessions? How many hours a week do you want to put into this?

What is your hook?

Your number one hook should be your guarantee that separates you from everyone else. You should talk about your guarantee all the time. When people are going to make a major buying decision, they're concerned about what happens if you don't deliver. What happens if things don't go the way you're promising me? People can promise anything. Words are cheap. So what will happen if it doesn't turn out the way I want? In my humble opinion,

The **single biggest decision** of our career is how we present out photographs to our clients.

my number one hook is our guarantee. We absolutely guarantee that you will be thrilled, not just satisfied, with your photographs. If you do not cry tears of joy when you see them for the first time, then we will give you all of your money back. No hard feelings. No hassles. If you're not thrilled, we don't deserve to have your money.

How do you go about communicating your hook to your customers?

The number one way is exhibits. The single best way to create a huge demand for your limited supply is through free exhibits throughout the community. And then on the exhibits you put not just a business card, but what is known as a lift card. The lift card communicates your top two or three hooks. It will have a headline, it's full of tes-

timonials, and then has a call to action, which compels the prospective client to do something. Obviously the number one choice is to go to the telephone and call the studio directly. That's what we'd like people to do, and many of them do.

What we need our marketing to do is to get **qualified people** to call us.

What we need our marketing to do is to get qualified people to call us. And we don't just mean rich and famous people that have lots of money. Yes, they do need some discretionary dollars, but that's not the key. The key is they need to be educated about how we do business, what is special about us—and they have to kind of agree with that. They have to say, "You know, I like the way this guy or this girl looks at photography. I love the emotion. I love the sensitivity. I like that. And I like the fact that, yeah, they're a little more expensive than the average photographer, but they're going to take really good care of me. They're going to spend a lot of time with me. They're going to meet with me ahead of time before the photography is done and advise me on clothing, makeup, hair, and locations."

This is the kind of thing I'm looking for. So when the telephone actually rings and there's a prospective client on the other end, they're more qualified. Therefore, the phone will ring less, but the booking percentage—the conversion rate, if you will—will be higher.

When you're not working—and you've already told me that you guys love to travel—what do you do for fun?
Travel is number one, because I crave stimulation. I love to learn history. I'm just passionate about history. So we love to travel all over the United States as well as to other countries and learn about their cultures and their history and the things that have happened in the world. That's just fascinating to us. Number two is I'm a radio-control fanatic! I fly radio-controlled airplanes and helicopters, and that's one of the hardest hobbies I've ever had. What

I've always liked about it, though, is that when you are doing that, you cannot be thinking about anything else. You can't be thinking about business, can't be thinking about that sale you had yesterday and what you did wrong and should have done better. You can't be thinking about your next marketing campaign. You have to have 100 percent of your brain cells concentrating on that airplane or that helicopter or it's going to be going into the ground. I've always really enjoyed that.

I had a friend in college who went out—and I don't remember what he spent on the kit—but he built his own airplane. I went with him one day out to this parking lot and he took it off, no problem. Got it up in the air, and then he couldn't figure out how to turn it around and it just kept going straight and eventually he just nosed it into the ground. And that was it. It was so far gone that he couldn't salvage anything. But it was a couple hundred bucks he spent, I think. And that really put a damper on his spirits, and he decided not to continue with that hobby.

And there's the key! There you have it. Bingo! You just hit on the whole key to everything right there! He gave up. He quit. He had one crash. One lousy crash. He had a crash and he gave up. I just love eBay. I'm on eBay all the time because I can buy used helicopters for practically peanuts.

From people that are giving up?
That's right. They give up. They buy it, they build it, they crash it, and most of them fix it again and then they're too afraid. They're too scared to go out and fly it again, and they give up. It's the same with many photographers who are learning to become good marketers. They try something once and then they stop. The key to success is persistence.

What's your favorite book or favorite author?
Napoleon Hill and his *Think and Grow Rich*. No question about that. No hesitation. If you haven't read every book that Napoleon Hill has ever written, you are missing the boat. A huge mistake that most photographers and all businesspeople make is that they study only with the people that are in their profession. There are a lot of brilliant people in this world who are not photographers who can

give us a great deal of advice. Napoleon Hill published *Think and Grow Rich* in 1937, and it's still a classic. That tells you how good this book is.

Do you have a favorite movie of all time?

Back to the Future. The first one. That's one of my all-time favorites. It's one of the best scripts I think I've ever seen put to a movie.

Who is your biggest inspiration in life?

Walt Disney, for sure. Walt Disney started with nothing and suffered enormous failures. His father told him he could never do it. He would never amount to anything. Why don't you face reality? You're just not going to amount to anything. Well, that was the kind of growing up he had. And he suffered a number of huge failures. He never quit. He never gave up. He would always keep going. He would always pick up the pieces. I wear a Mickey Mouse watch because it reminds me of Walt. I have a statue of him holding hands with Mickey Mouse on my desk. I have another plaque over here on my other wall from Walt Disney that has a fantastic quote from him on success. He has enormously influenced my life.

He's followed immediately by Donald Jack in photography—he altered my life forever, and I can never thank him enough. Finally, Harry Houdini. I really enjoy studying his life. He was a master marketer—one of the finest marketers there ever was. Harry Houdini's marketing techniques were phenomenal, and that's why people who are not in the field of magic still know who he was all these years after his death. Because he was a master marketer.

Any additional thoughts?

Be thankful that things are so difficult. If it were easy, everybody would do it. And because everybody would be doing it, it would be *really* hard. But because it's not easy, most people say this is way too much work. You mean I've got to scratch off one or two days a week to put into marketing and selling? You have got to be kidding me! I don't have time to do that kind of stuff. I've got to get to work on my Photoshop retouching. I love Photoshop! So be thankful that things are difficult, because life is a pyramid and you have to determine where on that pyramid you want to be. I'm not the world's greatest photographer, and I'm certainly not the world's most famous photographer—and that's okay with me. I'm fine with that. I know how much I want to earn. I know the lifestyle I want to have. I know how many hours per week I'm going to put into this. I have other interests that have nothing to do with photography.

You notice I did not say one of my hobbies is to take photographs when I'm on my trips. I don't want anything to do with that. I've got to get away from photography. And yes, I'll take a cheap little digital camera, and I'll do some snapshots, but that's it. Hobbies are so important to have. You must have interests other than photography that can get other parts of the brain stimulated. That way, when you get back into the studio, you will be earning a really great living on as few hours a week as possible. After all, we're in a creative profession and we can't be creative 100 hours a week. We can't do it. Our brains won't let us do it.

Be thankful that things are so difficult. **If it were easy, everybody would do it.**

So if you want to do the very finest work and have the finest successful business, you have to limit the number of hours you put into it. So if I can show you how to earn a really, really incredible living from your photography on thirty-five hours a week, then you're going to be so much happier because you're going to have other things to do that keep other parts of your brain stimulated. And when you are at the studio, you're going to be doing amazing work, because you're not burned out. You're not sick and tired of it. You're not worried about money problems, and you're going to become a better photographer for it, and a better person, a better father, a better husband, a better brother. That's what I'm all about.

5. Creating Value—Real or Perceived

So how do you create value for yourself? One of the key ways to create a higher perceived value is to under-promise and overdeliver every time. If you tell your customer their portraits will be done in four weeks, make sure they are ready in three. If you quote someone $500 for their portrait package, come in under that price. It's all part of giving your clients the positive experience that will reap rewards for years to come.

Defining Value

Value is not the same as cost. Cost is what we pay to purchase something. The value of our products and services should be significantly higher than the cost, or the client won't have an incentive to buy.

The value of our products and services should be **significantly** higher than the cost.

Let's say you have a product in your studio that sells for $100 (or should I say you *want* to sell it for $100). I think most of us can think of a something in our studio meets one of those criteria. Through all your marketing efforts, advertising, promotional pieces, positioning, and image creation, you want customers to flock to your studio to pay $100 for your Black Supersonic Whatsahoosit Widget. Now, whether you are successful at selling the Black Supersonic Whatsahoosit Widget is completely dependent on its value—or the "perceived value" it has to your client. So, will the widget be a hit? Basically, one of the following three marketing phenomena is going to take place.

Loss Leaders. First, let's imagine that your client's perception of your widget is $50, so you run a 50-percent-off sales promotion in order to have a successful campaign. In the real world, this is a popular technique that's typically used in retail establishments—especially before and after the holidays. Retailers motivate us with a very deep discount to lure us into the confines of the store and hope that we will purchase more than the item that is 50 percent off. Grocery stores are famous for using a low-priced item to lure customers into the store. They run an ad stating that a gallon of milk is on sale for $1.49, and on your way to the farthest corner of the store to pick up the milk, you pass large end cap displays towering with six-hundred rolls of paper towels or a thousand cans of pumpkin pie filling for $.99. Well, you can rest assured those items carry with them a nice profit margin.

Through their marketing research, the stores know that for every ten gallons of milk they sell at $1.49, they will sell a fair number of other products as well. Therefore, they will make up for their discount on milk with sales from other higher-profit items. This technique is called using a "loss leader" to get customers in the door, and it can easily be adapted to a smaller business. In our industry it's most prevalent in the high-school senior market; photographers offer these clients sessions at pennies on the dollar, or free, to get them into the studio, then the profit is made with sales of packages and wall portraits. If you have a strong sales program and effective salespeople to work with, this can be an effective strategy.

Luxury Appeal. In the second scenario, the client's perception of your widget is right at $100. Not more, not less. Right at $100. This is strategically worked to perfection by companies like Nordstrom, or The Bon Marché, or Lexus automobiles. They create a demand for their

FACING PAGE—The front of this marketing piece from Jeff Hawkins Photography establishes what makes the studio special. The reverse (see page 48) defines their qualifications, puts a friendly and personal face on the business, and makes a special offer.

Your story. Your forever.

Jeff Hawkins

Jeff Hawkins is proud to operate an International Award-Winning wedding and portrait photography studio in Orlando, Florida for the past 20 years. Together with his wife Kathleen, are excited to be authors of 9 published photography books! Industry sponsored, they are both very active in the Photography lecture circuit and take pride in their impact in the industry and in the community. In September of 98, the studio was nominated as "Small Business of the Year" from the Seminole Chamber of Commerce. They were recently honored as "Volunteer of the Year" by the State of Florida for their efforts in the "Heart Gallery" of Central Florida. In 2007 Jeff Hawkins Photography was voted as the best Photographer on WESH TV's A-List.

Jeff holds the prestigious Master of Photography, Certified Professional Photographer (CPP) and Photographic Craftsman degrees. He previously served on Professional Photography of America's Digital Advisory Committee representing the wedding industry. Jeff has many awards in print competition as well as having his work in the prominent "Loan Collection", He has been featured in many industry magazines and is listed as of the top 60 photographers in the world by Canon USA. He has photographed many named celebrities, a few include: Ed McMahon, Regis Philbin, Reba McIntyre, Billy Ray Cyrus, Mary Kay, Charlie Daniels, John Anderson, John Michael Montgomery, Marty Stuart and Shaquille O'Neal.

Jeremy Mager, has been an award winning photographer with Jeff Hawkins Photography for over 5 years. He specializes in Wedding and Commercial Photography as well as custom designed Videography with a unique virtual video album for special events. Photography has always been his passion. With his cutting edge computer skills, we really do have the perfect team and it shows in the award winning style of photography provided by Jeff Hawkins Photography.

Jeremy Mager

We can offer our clients all the latest technology, creating more than images, creating art! Let us capture your emotions, feelings, and relationships and document them for a lifetime! Remember, your memories are not expensive, they are priceless!

As a Seminole County Chamber of Commerce or WOAMTEC member, book a photography session or special event in and receive:

10% Off* your entire order

Mention this coupon when making your appointment.

*Offer available to active Chamber of Commerce and WOAMTEC members only. Offer not transferable, or redeemable for cash. Valid through December 31, 2008.

Jeff Hawkins photography
When only the finest will do.

407.834.8023
800.822.0816
www.jeffhawkins.com

FACING PAGE—The front of this marketing piece from Jeff Hawkins Photography establishes what makes the studio special (see page 47). The reverse (seen here) defines their qualifications, puts a friendly and personal face on the business, and makes a special offer.

products in such a way that we will gladly pay the asking price, just so we can be associated with that product. It's more about our image and making us feel special than it is what price we pay. They have made us believe that the price really isn't that important. We want to belong to the "club" so to speak. When you go to a Lexus dealer, the asking price is also the selling price—no dickering, no negotiating. If you want to drive a Lexus, this is the price. If you are a Nordy, someone who shops at Nordstrom, you know that they do not offer big sales, except for once a year. The rest of the year, we will pay pretty much their asking price. If you want what they sell, you pay.

Higher Valuation. In the third scenario, you manage to create for your product a perceived value of more than $100—maybe it's $120, maybe $150, maybe $200 or more. The greater the discrepancy between the selling price and the perceived value, the higher the level of motivation your customer will have for buying your product, and the greater the level of sales you will have. Accomplishing this is the subject of the following section.

Enhancing Perceived Value

So, how do you create a discrepancy between the selling price and the value of the product? Here's a rule of thumb that I want to encourage you to make part of the fabric of your business: don't discount—give stuff away. Let me say that again: don't discount—give stuff away! When you discount, you penalize good clients and attract the price shoppers. Give your clients something for free that adds value to their purchase or brings some joy to their lives.

In this business, value is often added by including a frame at no charge, a free portrait, a mini two-way portfolio, or a no-charge session when they purchase that specified product. The fun part for you, as a Power Marketer, is that you can do anything you want—just make sure your "added bonus" is something that potential clients can't get from any of your competitors. Remember one of the basic rules of marketing: either you are different and unique or you are out of business. Find out what everyone else is doing, then don't do it. Run as fast as you

can in the other direction. This is how you guarantee you will separate yourself from the rest of the pack and continue to gain ownership of your hook and category each and every day. Obviously whatever you do needs to make sense financially, and only you know what your restrictions and limits are. Fortunately, the sky really is the limit here, and the more creative you get, the better the client's response will be.

I love a group called Mannheim Steamroller and their leader, Chip Davis. Many of you may recognize the name (and if the name doesn't ring a bell, you'd know their music if you heard it on the radio). You can walk into any music store year-round and find a big display of their music—and it's never on sale. Instead, they motivate us to buy this music by including a free CD of holiday music, a free mail-order barbeque sauce kit, or a large tin of gourmet hot chocolate.

I am one of those people who will always look for the unique and different, and Mannheim Steamroller's approach to marketing is just that. With millions of album sales to their credit, I'm surprised more musicians haven't borrowed the technique. (From personal experience, I can tell you the barbeque sauce goes great with chicken and the hot chocolate is wonderful on those cold nights in front of the fire!)

The **more creative** you get, the better the client's response will be.

Another example of this technique is television infomercials. The product spokesperson will spend the first twenty-five minutes of the show creating a value in our minds of $19.95—and most of the time, we probably believe that's what the product is worth. Then all of a sudden, they sweeten the pot by announcing, "If you call in the next seven minutes, we will include a second one absolutely free!" You see it time and time again; it obviously works or they wouldn't continue doing it.

If the value in the mind of the customer is greater than the asking price—boom!—you have a good chance of making the sale. So the bottom line in all of this is simple:

always give customers value that is greater than the price they pay.

How can you immediately begin to create value (perceived or real) in your products that motivates people to want to do business with you? Remember that perceived value is strongly influenced by emotion, ego, and personal image—things that are intangible—and each of these should be considered in your marketing programs.

One thing you will find as you begin to brainstorm and come up with creative marketing programs is that you will have some good ideas and some not-so-good ideas, and you have to be willing to try them both. An idea I tried a few years ago for my wedding business sounded great at the beginning but turned out to be a lot of work in the end, and I'm sure you'll see why once you read this story.

You must be willing to risk failure in order to attain the **highest level** of success.

I was looking for an innovative idea that I could use to entice and motivate potential wedding clients to book with me instead of my competitors. Originally, I was going to use it for people who signed a contract at a bridal fair, but I ended up using it the entire year. My idea was this: for every one hour of coverage my client booked for their wedding session, I would provide one hour of limousine rental for free. So if the client had a five-hour wedding package, they would get a nice limousine for five hours, and it didn't have to be at the same time. That way, they could use it to pick up the wedding party from home, or shuttle guests from the church to the reception, or whatever they chose. Well, instead of working some sort of arrangement with a local company, I decided to just go out and purchase the entire company, lock, stock, and barrel!

The idea was a tremendous success. Our booking rate went through the roof, and we became the talk of the town. I hired a chauffeur, arranged all the necessary insurances, licenses, phone numbers, etc. Our clients absolutely loved what we did for them, but I had just purchased a business, complete with a toll-free number and yellow pages ad. The calls came in at 8:00AM Sunday morning and 11:00PM on Tuesday; people wanted to book wedding sessions, birthday parties, anniversaries, business get-togethers, and even sweet-sixteen parties. It was a real business, which meant I had to arrange coverage twenty-four hours, seven days a week for the phone and for a driver.

Many times I ended up being the chauffeur, the mechanic, and the person who washed the limo. The business did well, but it became very time-consuming and diminished my ability to provide my clients with something unique and different—something that would position my studio in their minds as a cut above the competition. After about a year, I decided to sell the company and move on to other ideas.

The moral of the story is this: Regardless of the outcome of your ideas, you must be willing to risk failure in order to attain the highest level of success. You will not be able to discover new lands unless you risk losing sight of the shore. Be bold, be adventurous, and have some fun!

As you can see, creating value for yourself and your company can be achieved in a wide variety of ways. It's all up to you and what your goals are in life. It's very easy for us to fall into that old management trap and get caught up in the day-to-day details of running our businesses. We end up running our studios instead of designing our lives. We all fall prey to the day to day stuff—answering phones, meeting with clients, managing our digital files, ordering supplies, and mowing the lawn. Before we know it, our free time is gone, and there is no time for the things in life that are truly important, like family and personal hobbies. You're working Friday nights, Sunday mornings, holidays. You don't have time to play with your children, or to take a drive with your family along the lake, or to read that good book you've been meaning to get to, or to practice your putting at the golf course. The things that are most important to us start slowly slipping away, and we become a slave to our business rather than its master. I encourage you to go back and read chapter 1 from time to time to keep yourself honed in on what's important in your life.

Whether you want to be the Cadillac in your market or the Volkswagen—and there is plenty of room for both—adding value to your customers' lives should be one of the

most important aspects of your marketing philosophy. There is always a way to add value, whether it be real or perceived. Not everyone can be the Cadillac (in fact, there's only one), and not everyone wants to buy a Cadillac. The truth is, there are a variety of widely respected models, and there's plenty of room for each of them in the market.

It's okay to borrow ideas from others within our industry and to incorporate strategies that we find outside of our field, just as long as they will benefit our business. You don't need to reinvent the wheel; just find an existing idea and customize it to meet your personality and style. Since you can't be all things to all people, find out what you are really good at and make it your trademark, your personal stamp. The day of the jack-of-all-trades is long gone, and the age of specialization is upon us. So decide what position or niche you want to occupy in your customers' minds, and be sure that everything you do will help you to achieve your goals and objectives.

Before we move on, I would like to share a few more thoughts with you. First, I hope you'll remember that we have the honor and the privilege to not only sell fine products and services to our clients, but to sell ourselves as well. Remember that believing in yourself and your abilities as a professional photographer and a Power Marketer can bring you rewards too great to number. You must also keep in mind that the challenge of creating effective marketing programs in order to achieve your desired position in the market can be difficult at times. In order to stand

It can take you to places you never dreamed of—if you are willing to **take the risk.**

out, you'll have to separate yourself from the crowd; however, the process will also be one of the most fulfilling and rewarding experiences you will ever have. Separating yourself from the rest of the pack is never easy, but it can take you to places you never dreamed of—if you are willing to take the risk. Life is not a spectator sport!

Power Corner

Focus on . . .
Rick and Deborah Ferro

From stunning imagery, to cutting-edge marketing techniques, Rick Ferro and Deborah Lynn Ferro have developed a surefire approach to business success. Rick Ferro is one of the leading wedding photographers in the nation. In addition to countless brides and grooms, his clients have included 7-UP, Sprint, the Miami Dolphins, MasterCard, and Mercedes Benz, just to name a few. In 1993, Rick became the Senior Wedding Photographer for Disney, and Walt Disney World became the world's most sought-after wedding destination! Deborah has been on the fast track in photography since 1996 when her passion for photography became more than a serious hobby and she opened her first studio. For more information on Rick and Deborah's educational materials for professional photographers, visit www.ferrophotographyschool.com.

Mitche: What do you feel will be the biggest challenge our industry faces in the future?

Deb: I believe our biggest challenge will be digital workflow. Photographers are just picking up their cameras and going with it, thinking they can correct any problems in Photoshop, and it's just eating up all their time. This creates big problems.

What is your core marketing philosophy?

Deb: From a marketing standpoint, the biggest questions we get are where do people even start to market themselves? How do they know where to spend their limited dollars? That will differ depending on your market. The way we do things will be different than somebody in a small town. Also, we're challenged to educate the public about the difference between a professional photographer and an amateur photographer.

What do you want to be your share of the market? There are all different kinds of clients out there at all different income levels. Where do you see your photography studio? We believe in going for the gold! Instead of working our way up to the client we eventually want, we believe in targeting that client first. From our image presentation through promotional pieces, to our advertising dollars, to our pricing, to the way our studio is set up, we are focused on that market. We believe that we are selling ourselves and that our images are an extension of ourselves. You only have five seconds to make a first impression! Everything from answering the phone, to your studio's appearance, to your marketing pieces—they all have a tremendous impact on whether you will procure the client. Do you know how many times people change doctors because they have lousy bedside manner? People connect with personalities and how they are treated.

Many photographers tell me that the reason they don't have the images we do is because they don't have beautiful clients or the kind of higher-income clients that we have. You sell what you show, so you should create a portfolio filled with images of the kind of clients you want to have! How? Set up a photo shoot in your area at either a beautiful location or the type of reception location where you would love to photograph at regularly. Get together with area vendors like a florist, bridal salon, vintage car or limousine service, and modeling agency, then offer to exchange images for their help with the photo shoot. Make sure your name is on each image you give the vendors so their customers will see it. You are now in control of the quality of image you want to present and market with.

What would you recommend to someone who is trying to take their marketing to the next level?

Deb: Remember that you make the phone ring. How? Have a plan—let's say, for example, a direct marketing piece or a bridal show—and a way to implement the plan. Then take action to implement it and follow up. Don't wait for the phone to ring. Go out and get people to call by getting involved in your community· through the Chamber of Commerce, charities, networking with vendors, and by visiting local businesses and leaving your business cards. Gloria Daly, a photographer who works with us, shared something she heard a long time ago that really stuck with her: "He who has a thing to sell and goes and whispers in a well is not as apt to get the dollars as the one who climbs a tree and hollers!" Just get out there and do it!

What is your biggest asset as a power marketer?

Deb: Our biggest asset is that we are in control of our client base, the direction of our photography, and our level of success. Success doesn't just happen, you make it happen!

What do you feel your hook is?

Deb: Clients come to us for the romantic location portraits we show on the Internet and through our advertising. Securing them as a client involves convincing them why they should choose us over all the other photographers out there. Our hook is that we tell our clients that they are not only hiring a photographer but also a graphic designer. With our ability to creatively enhance our images through Photoshop, whether we are retouching or designing our own digital albums, they are assured of a quality product unmatched by a mall studio.

Are power marketers are born, or can it be learned?

Deb: I believe that we are all born with a certain level of talent, but how we develop and use those talents makes a difference in our success. A great idea is worth a dollar, and a plan to implement the idea is worth a million, but without action you never see the money! Most people did not get into this business to make a million. They got into it because they had a passion for creating images. Being able to create great images doesn't pay the mortgage, though! Selling great images pays the mortgage. It takes both.

You met and fell in love, then merged your businesses and your lives. Tell me about the quality of life that you share.

Rick: Quality of life to me is very important, and I've been fortunate so far in my life. I've been around the world twice on a ship, and I've worked with the Dolphins. I've had three studios, and I set up Walt Disney World's photography department in 1993. So, I had some really great jobs, but it doesn't even compare to how things are right now. I never really had the chance to share my life with anyone like this before, and Deb is such a huge inspiration to me. My photography is getting better all the time, and I'm opening myself up to new ideas and areas that I never would have done before. I'm having the best time, and

it's because of her, actually! I get so excited that I can't sleep at night.

Deb: It's actually because of my cold feet!

Rick: If it all ended tomorrow, it would be totally fine because I would still have her. We are like two little kids!

How do you balance your personal and professional lives? Are there specific times during the week that you call "downtime"?

Rick: We try to go to a movie on Friday nights and also try to go to dinner during the week. Sundays we try not to do anything. In our house, I'm the chef; I enjoy cooking as much as photography. If I wasn't a photographer, I would probably try to enroll in culinary school to become a chef. Deb makes great reservations!

Deb: I do the desserts and the breads and stuff like that. We love to entertain, so we are constantly cooking. I love the fact that we can have a nice lunch and spend that time together talking and taking some time out. Our first year in business together, we used to take a lunch break and play a game of backgammon just to get our minds off the business and laugh. We also make it a point when we travel for business to take a couple of extra days just to spend time together.

Who are your biggest inspirations?

Rick: Don Blair and Monte Zucker for photographers. I had a teacher when I was in school named Mr. Williams, who gave me a lot of really good tips about life.

Deb: My mother. She's a very spiritual person, and if I could only be half the person she is, I would be very happy. She has more energy than I do; and because of her character, I admire her more than anybody I have met in my entire life.

Do you have a favorite quote or saying?

Rick: "I'll make you an offer you can't refuse!" (from *The Godfather*), "Leave the gun, take the cannoli!" (also from *The Godfather*), "Leave the camera, take the pixels!" (not from *The Godfather*).

Deb: "If you do what you love and are passionate about it, the money will follow." It's taken me a long time to believe that it's worth going after your dream to achieve what you really want out of life.

6. Image is Everything

An Easy Choice

I want to take you on a journey to a place where everything is perfect, where there is no stress or worry, and the streets are made of cheese! It's a place where you can buy anything, do anything, and be anything you want to be. This place is called your mind, and it's the most powerful tool we have.

Imagine it's a beautiful, warm Sunday afternoon in the fall, and you decide to go for a drive in the country. With all the hustle and bustle of everyday life, you don't get this opportunity as often as you'd like, but today is your day. As you drive along, you decide to head over to a nearby lake that is known for its vibrant fall colors and tranquil silence. Driving along the hillside, you notice that the leaves on the trees are beginning to fall softly to the ground. They create a bed of color on the pavement in front of you. With the window down, you can feel the wind tickle your face and smell the familiar scent of autumn.

Clients judge us **long before** we expose a single frame in our cameras.

The sun is directly in front of you, and as it hits your face, you feel the warmth of its rays. It's a feeling you crave and relish, and you want to soak up as much of this feeling as possible before the season passes and winter digs in. You come to the road that will take you to the lake, and you take notice of the fact there are no other cars coming or going. The road is yours. You begin to feel the excitement of being at the lake by yourself and taking in all it has to offer.

As you approach your destination, you find a place to park your car, and you begin the short walk down to the lake. You are about a hundred yards or so from the bank, and you notice two little stores next to the road—one on the left and one on the right. Your eyes are first attracted to the rustic brown building on the right. There is a bike laying in front of the store, and you can tell it has seen better days—the handlebars are covered with rust and several of the spokes are missing from the rear tire. You notice that the shop itself has a broken rain gutter that is filled with rotting leaves from last season, and the grass hasn't been cut for quite some time. The aged, painted dark-brown trim around the windows and door is beginning to chip, and there are a couple of spiders that have made their home in the upper right corner of the front window. The sign above the door reads Lakeside Quick Mart. The smaller sign in the window below the spider web reads Lemonade 50¢ and Cookies 10 for a $1.00.

Your eyes then meander to the little white building on the other side of the road. There are bright red geraniums neatly planted in oak barrels that are placed along a cobblestone walkway leading up to the front entrance. The pristine line of white picket fence that surrounds the entire building is punctuated with tulips, and a mailbox in the shape of a trout sits atop a cast-iron stake. On top of the building rests a sign, freshly painted in blues and yellows, and greens. It reads "Heaven on Earth Country Store." On a smaller sign below, the words "Where Friends Meet" appear. It almost makes you feel like you did as a little kid at your Grandma's house—it seems to be a safe, kind, and friendly place. You notice a small sign in the window that says "Hand-Squeezed, Country-Style Lemonade—Made Fresh this Morning—Only $2.00 a Glass." Your mouth begins to water as you imagine drinking that glass of hand-squeezed, country-style fresh lemonade. The side windows are open just a crack, and you can smell fresh chocolate chip cookies, which must have been pulled out of the oven only ten seconds ago.

You would pay just about anything to have a bite of one of those cookies right now.

You pause for a moment, glance at the brown building on the right side of the road, and then you turn your gaze again to the white building on the left side. You have to make a choice as to where to go. In a split second, your mind is made up! Was there really any doubt? It didn't matter that the lemonade was $1.50 more at the store on the left, did it? It came down to the image that each business created in your mind. And once that impression is made on our minds, it's virtually impossible to change how we feel. The Quick Mart may have had the best cookies in the world, but the business owners sure didn't do much to convince us to give them a try—no matter the price!

Prepare to be Judged

Clients judge us long before we expose a single frame in our cameras. As a matter of fact, humans make judgments about people, businesses, food, and other products within five seconds. That sure doesn't give us much time to form a favorable impression and to instill the value of our products.

As business owners, we must always be prepared to be judged. After all, every business decision we make—from marketing, to positioning, to image creation—expresses to clients who we are and what we do. When a prospective client enters your business, they evaluate what you wear, how you look, the way you walk and talk, and the general way in which you communicate with the rest of the world. It's as much about essence as it is substance.

Don't Overlook Simple Solutions

Most of us have been working for years to figure out the magic of marketing, yet we are met with a great deal of frustration. We are constantly trying to reinvent the wheel instead of looking outside the box for the answers. We earn our degrees from the school of hard knocks.

The eye-catching colors, unique design, and vibrant imagery in this marketing piece for Sarah Petty Photography all make a great first impression. Immediately, you know that visiting her studio is going to be a lot of fun.

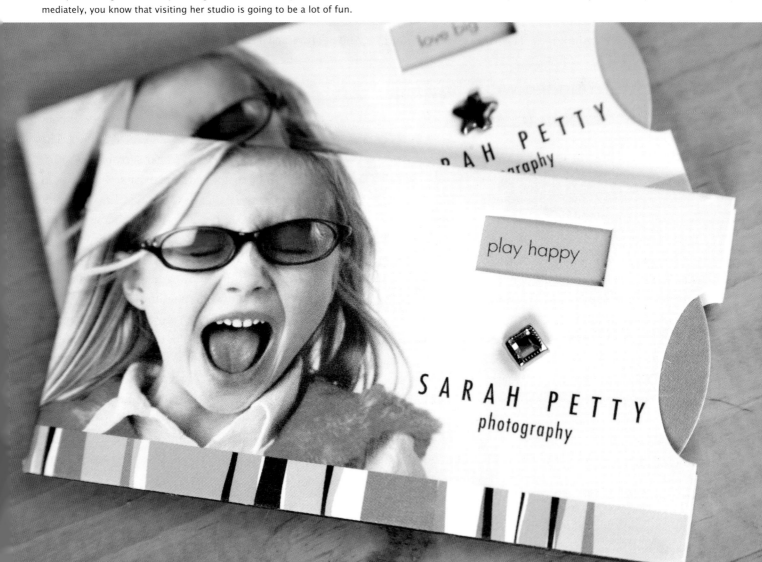

While there is usually a simple solution for overcoming most obstacles, we don't always see it. History is filled with such examples. For instance, though man's discovery of fire was huge, it took us over a million years to figure out how to utilize it. While ice cream was invented around 2000BC, the ice cream cone came about around a hundred years ago. In 1775, the flush toilet was invented. In 1857—eighty-two years later!—toilet paper followed.

We are surrounded with simple solutions to help us succeed, but we don't always see them. Some of the simplest solutions are right in front of our noses, yet we can't see the forest for the trees. Creating a positive image can often be accomplished by first addressing the little things; it doesn't always require a huge change.

Don't Become Paralyzed by a Fear Mistakes

P. T. Barnum used to say he knew that half of all the money he spent on advertising was wasted—he just had to figure out which half. As photographers and businesspeople, we make mistakes every day, but the most successful people in our industry are the ones who learn quickly from those mistakes and then make the necessary changes to ensure that they don't make them twice.

We are surrounded with simple solutions **to help us succeed,** but we don't always see them.

I want to share a story about the vice president of marketing of a Fortune 500 company who had an innovative idea for a new product. The rest of the board had their reservations, but he believed so firmly in his idea that he convinced the other members to grant him permission to proceed with the project. A few months later, when the project had completely and utterly failed to the tune of about $3,000,000, the VP began clearing out his office. When the president of the company walked in, he asked the VP, "Where are you going?" The VP responded, "I'm clearing out all my personal things and going home. I just made a huge mistake that cost your company $3,000,000. I assumed I was fired!" "Are you crazy?" the president said, "I just invested $3,000,000 in your education!"

Every idea you come up with isn't going to be a home run, and many will probably end up being strikeouts. But there is nothing worse in this world than never even swinging the bat! Risk is part of success, and those who are willing to stick their necks out each and every day—like you do—are the true heroes of our industry. You cannot experience the joy of discovering new lands if you never risk losing sight of the shore. After all, when you do things the same old way, you should expect the same old results.

You can, however, reduce costly mistakes by learning from other people's errors and by borrowing valuable lessons from other industries; there is nothing wrong with that. You should make it a point to study the leaders in our industry, and in others fields, and learn what it is that gives them their competitive edge. (You'll take a step-by-step approach to this process with the Five-Second Image Challenge a little bit later.)

The Five Biggest Mistakes Photographers Make

When it comes down to our marketing efforts, most of our mistakes lie within five distinct areas.

1. Failure to Have a Well-Thought-Out Marketing Plan. Anyone can captain the ship when the seas are calm; however, a good marketing plan does its best work when the seas are anything but calm. Eighty percent of all businesses do not have any form of marketing plan at all, and 80 percent of all businesses aren't around in five years. Do you think this is just a coincidence? We have two jobs: to photograph and to market; everything else is secondary.

2. Failure to Have a Clearly Defined Hook or Message. Without it, you are just a "me too," an also-ran, another run-of-the-mill business. You will not become successful simply because you are the best. Da Vinci was dead for over two hundred years before he became famous. I don't want to wait that long!

You need to know what it is that makes you special and unique in your marketplace. What is it that customers can't get from anyone but you? What is the compelling reason that customers should come to your studio instead of any of the others in your area? Again, the numbers speak for themselves: 80 percent of all photographers couldn't tell you what their hook is if asked. Are you one of the 80 percent, or are you among the 20 percent?

Professional-looking marketing pieces, like these from Christa Hoffarth, are well designed and have a cohesive feel that helps build brand recognition.

3. Failure to Have Professional-Looking Marketing Pieces. It's all about first impressions. Everything you do must match your image. If you want to be known for Cadillac quality, then everything you do should be consistent with that goal.

4. Failure to Project Your Sales and Goals into the Future. Let me ask you a question. If a bride calls you today to find out more about what you have to offer, when is she more than likely getting married? Maybe six, twelve, or eighteen months from now? Then why do we give her today's prices? Shouldn't we be charging prices that are based on and reflect where we want our studio to be at that later date?

All of our future goals for our business (and our lives) must be reflected in our price lists. If your goal for next year is to shoot half the number of weddings at double the price, then next year's prices should be in effect today! Or, on the other hand, if your goal is to shoot twice as many weddings at half the price, you should take all of

that into consideration when designing your current wedding collections. Wedding photography is one of the only industries where we are hired and retained for a job we will perform at some point in the distant future. And we should be charging those future prices today. Doesn't that make sense?

5. Failure to Price Your Packages to Allow for Costs, Overhead, and That Four-Letter Word: Profit. The average photographer makes less than $25,000 per year. Do you have a thorough understanding of your cost breakdown on your products? Do you know how much profit is generated from each sale? How many weddings do you need to book (or seniors or families) in order to achieve your financial and personal goals? What do you want to make this year, next year, and the year after that?

The biggest problem in our industry isn't that we are priced too cheaply, it's that we are afraid to charge what we are worth. Understanding what it costs to produce each of your products can give you the basic tools to make

sure you are making a profit each and every day. There are some wonderful resources available that will walk you through the process of figuring out what your costs are—and what your profit is. I encourage you to investigate this topic as part of your brainstorming and planning sessions. Ask yourself, Do you want to be average? Or do you want to be successful? It's up to you! (The subject of pricing will also be covered in detail later in this book.)

Target Your Efforts

In order to truly focus, you have to do less. You can practice hand-grenade marketing—just throw a bunch of stuff out there and hope it hits the target—or you can use laser beam marketing and hit only what you want. If you would like to eliminate a certain segment of the business you currently do (let's say, for example, the low-end children's market), then devise a game plan today that allows you to smoothly exit that market and replace it with sales from your more lucrative demographic.

If you want to be viewed as **a professional**, you must look and behave like one.

If you want to attract a $50 client, photograph a $50 client. If they like you, they will tell their $50-client friends about your work—which means you will be photographing $50 clients. If you want to photograph brides and grooms who want to invest $199 in their portraits, photograph one, and you are bound to get more. If you do a professional job and remember the value of the all-mighty referral, your clients will come to you informed about your quality, process, and pricing. Thanks to winning testimony from previous clients, a new batch of clients will arrive at your door already sold on your abilities.

As was mentioned earlier, though, once a client forms an impression, it's awfully difficult to change their mind. If you went after $199 clients and word got out about your good work and unbeatable products, how could you then convince those same clients that they should invest $5,000? The truth is, you'd have quite a battle on your hands to substantially increase the level of their invest-

ment. Now, there is profit in the $199 customer, but you need to photograph a lot more of them than you do the $500, $1,000, or $5,000 customer.

It all comes down to what your goals are in life. Sometimes you are better off going fishing than taking a job that doesn't help you achieve your ultimate objectives and professional goals. It's difficult to turn down business at first, but in the long run it will be healthier for you and your studio to do so. Let's face it: some customers are just not worth having. You have the ultimate say in how you spend your time.

So . . . what do clients experience when they pick up your literature, pull into your driveway, and enter your studio? You're about to find out.

The Five-Second Image Challenge

Do you remember what it was that triggered your dislike of snakes, or spiders, or flying, or seafood, or asparagus? You may not remember a specific incident, but I'll bet you are acutely aware of your likes and dislikes. Most of those precepts were embedded deep in our psyche from experiences that lasted five, ten, or maybe fifteen seconds.

When we are exposed to people and businesses, we quickly form an opinion of them in the same way. We make mental judgments about things in our world within five seconds of seeing, feeling, hearing, smelling, or tasting something. That judgment is filed away in our subconscience, and it colors our experiences and can affect future decisions. In business, those judgments can spell future success or ultimate failure.

In today's challenging world of professional photography, the old saying "first impressions make lasting impressions" is more important than ever. Our first perceptions are always the strongest and tend to stick with us the longest. Perception is reality. If you want to be viewed as a professional, you must look and behave like one. If you meet with clients for a wedding consultation or a portrait viewing, then hand them a 25¢ pen to fill out paperwork and expect them to spend $5,000, you've got another thing coming. Something as simple as a pen will influence your client's perceptions of your business. If you are the $199-type of wedding photographer, a 25¢ pen will be sufficient; if you have bigger fish to fry, you need to make sure that every last detail spells quality.

Are you making the best possible first impression on your potential customers, or is there room for improvement? It has been said that the sales process ends when the client writes you a check. Well, everything that happens up to that point determines how big that check will be. That's where the quality of your image creation and marketing comes in. The better job you can do with building a strong image in the mind of your customers, the higher the value your products and services will have—and the bigger the checks will become.

Ready? Let's get to work!

Step 1: The Image Inventory. Before you can take a look into your business with an open and objective frame of mind, you'll want to determine how other top-notch businesses handle this issue. Take a couple of hours on a Saturday or Sunday afternoon, and go to the local mall where the elite stores like Nordstrom, The Bon Marché, Pier 1 Imports, The Sharper Image, and Ralph Lauren are located. I want you to take a notepad along so you can write down anything that strikes your fancy. Notice their signage, the colors and fonts in their logo, the smells as you walk in the front door, the overhead music that's playing, the way they have their displays organized, etc. Colors and smells affect our emotions in a very big way, and all play a key role is the value we attached to the things we observe.

Once you have a good handle on your environment, take a look at the people who are shopping there. What type of clothes are they wearing? What style of shoes do they have on? How is their hair styled? What's the age range? Take note of the color of the women's purses and the brand of the men's jeans. What car models are parked in the lot, and what colors seem to be the most popular? Write down anything you can identify about these customers. If you see something in one of these businesses that will work for you, great—write it down! Stop by a nice art gallery or a fine furniture store, or maybe stop into one of the upscale photography studios in your area. Make the same mental notes about what you observe there. Plenty of great marketing ideas can be found if we take the time to look at the world around us.

After spending a couple of hours working your way through several of the top-notch stores, drive over to the local department store—whether it's Wal-Mart, Kmart, or the local five-and-dime. Observe the variables that you noticed in the first stage of this experience. Examine the signage and the cars in the lot. What impressions do you get from looking at the outside of their buildings?

When you walk in the front door, do you get the same sense of quality and value? What about the people shopping there—do they have the same styles of shoes, purses, and jeans? Walk around the store a bit, and get a good sense of who it is they want to attract into their building. It won't take you long to grasp what the marketing plan is of the big discount stores—high volume, low price. Load 'em up, move 'em in, move 'em out, yee haw!

It has been said that the sales process ends when the client writes you **a check.**

What does your perfect client look like? Is it someone who shops at Ralph Lauren and pays with a Discover card? Someone who shops at the warehouse stores? A combination of the two? Remember there is a difference between the type of client you may have today and the client you want for tomorrow. It's all part of knowing what you want out of your life and business and having a clear vision of your future.

Once step 1 is complete, go back to your studio and spend a few minutes reviewing these observations. That sharp pain you feel in your brain will only be temporary! It will go away as you begin to view the world through the eyes of your ideal client and gain a fresh understanding of the way perceptions are created.

Once you've completed this exercise, you will undoubtedly have an enhanced sense of your surroundings and will begin to see the world just a little bit differently than you did before. This is a good thing! The goal of this entire process is to learn to see the world and your studio the way a prospective client sees it.

Step 2: The Physical Inventory. Now it's time to make the same observations about your own business. The question I want you to keep in the front of your mind through this entire process is this: Who is my perfect client? Determine whether you want to cater to old-

The exterior of Chatsworth Portrait Studio is up-to-date, well maintained, and beautifully designed. Everything about it makes you want to see more!

school, new-school, high-end, or low-end clients, or if you prefer to attract clients somewhere in between. You need to know who your perfect client is in order to critique the dynamics of your studio's image.

Through this process, try to see your studio through the eyes of your ideal client. Remember that everything a potential customer observes about your business in the first five seconds will affect what they are willing to pay for your products and services. We're talking about perceived value. The higher the perceived value you have to your clients, the more you can charge, the more referrals you'll get, the more sessions you can shoot, and the more time off you will have to do the things in life that are most important to you.

To begin the physical inventory, first consider the outside of your entire studio, whether you operate out of your home or have a retail location. As you go through this process, it's important that you write down everything you notice. I suggest you create two columns. In the first column, note issues that can be taken care of rather easily, like raking leaves or washing a window. In the second col-

umn, list those things that may require a financial investment or a large amount of time, like painting the fence or getting new furniture for your gallery.

As you stand outside and observe your business, do you see weeds on the side of the driveway that need to be pulled out? What about your fence? Is it in good shape, or could it use a couple of nails and a fresh coat of paint? How does the paint look around the building? Does it look fresh and crisp? Are the shrubs and bushes properly trimmed and groomed?

Are your flower baskets overflowing with weeds and dead flowers? Do you deadhead your flowers on a regular basis? Is your lawn mown on a particular day each week, and is any necessary maintenance is performed? Are there weeds growing up in the cracks, and are there cigarette butts or bubble gum wrappers in visible sight? Are there dead leaves scattered all over the ground?

What about the windows? Are they consistently washed, or can you see fingerprints and dirt on them?

Note that having a top-quality image means that some things go unnoticed. If a window is clean, you don't no-

tice its lack of grime, do you? But you will definitely notice if the glass covered in finger prints and smudges. Or if the grass is neatly mowed, you don't notice that it doesn't need mowing. Keep an open mind as you go through this process.

Now, we are going to walk inside your studio for the first time. Is your entryway inviting? Have you hung high-quality signs that clearly list your business hours, or do you use a dry erase board?

As you walk in, how does the appearance of your studio make you feel? Does it give you that "wow" feeling? Does that feeling match the image you want to build? What smells do you notice? Are they fresh and clean or old and musty? What part of your studio do you see first? Does it look clean and organized? When people walk into your gallery, you should tell them everything you want them to know about you through the work displayed on the walls, the fragrance in the air, the style of the furniture, and the general overall feeling they get within that first five seconds. Not everybody has top-of-the-line designer leather furniture and turn-of-the century Victorian artwork in their studio, but we each need to make sure that what we do have supports the image we want to convey and appeals to the type of client we want to do business with.

Now, head toward your sales area or projection room. Do you display large prints on the walls or 8x10-inch prints? People can only buy what they see, and if all you show them are 8x10s, how can you expect them to invest in a 30x40-inch canvas portrait? It's not likely to happen! When I first opened my studio, I didn't have much of a budget for large prints, so I went hog wild and displayed lots of 11x14s and 16x20s. I had them everywhere! Guess what I sold a lot of? If you want to sell big, you must show big!

What about your sample albums? Are the pages routinely dusted and wiped down? Are all the prints inside still correctly mounted, or are a couple of them in need of repositioning? Are your shelves and countertops wiped down on a regular basis? Do you have candles located around your studio that add fragrance to the air? When a client walks into your studio for the first time, all of their senses are on high alert, and you want to make sure you give them an enjoyable olfactory experience.

Let's continue the process as we head into the camera room. This is a difficult one; we all get a bit lazy when it comes to maintaining our camera rooms. I have a tendency to put all of my equipment, filters, and film on one shelf, so after a while it begins to look very cluttered and disorganized. At the end of each shooting day, I force myself to put everything back where it belongs. It only takes me a couple of minutes. How is your camera room organized? Are the backgrounds neatly folded, or are they thrown into a corner because you don't have time to fold them during a session? How about your miscellaneous equipment shelf? If it's in the line of sight of your customers, how does it look to them? Could it benefit from a little time spent in organization and rearranging?

Take the same steps with your dressing rooms, public bathrooms, and the hallways that lead to them. If you have a portrait park, or even a small outdoor shooting area, take notice of the same things you noticed about the front of your building—the grass, the shrubs, the bushes, the trees, the flowers. When a client walks outside of your studio for the very first time, are they in awe with how beautiful everything is, or could your property use a little TLC? The image of your entire business is like one big apple pie, and the things we have talked about are the vital ingredients we need to make the best apple pie we can!

How does the appearance of your studio make you feel? Does it give you that "**wow**" feeling?

When clients arrive at your studio, do you offer them some sort of beverage, like a soft drink, a glass of wine, or a cold beer? Do you have snacks available in case they want something to munch on? I know several photographers who bake a fresh batch of chocolate chip cookies every single day, and you can smell them as soon as you get out of your car. That kind of attention to detail makes a person feel good—and anything you can do to make clients enjoy themselves even just a little bit more is worth doing. If they enjoy themselves during their time with you, they will be happier with their portraits and will spend more money and send more referrals.

Step 3: The Marketing Inventory. You'll need to sit down to complete this challenge. Grab a good cup of coffee, then gather every piece of literature you have. This includes things like business cards, price lists, brochures, wedding information, reorder forms, clothing tip sheets, coupons, contracts, direct mail pieces, newspaper ads, yellow pages ads, bridal fair ads—anything you hand out, mail out, or stuff into something!

Your marketing literature has a significant impact on your clients. It factors heavily into the client's perception of the position you occupy in the market. The quality of the paper it's printed on, the font selection, the quality of the ink, the color of the paper stock, the way you present it to your customers—everything sends a message. Do you just hand your clients a piece of paper with your wedding or portrait prices on it, or do you package your price list in an elegant envelope with gold-foil lettering, finished with a gold seal? Perception, perception, perception!

I challenge you to invest some time and money to create a **unique look** for your business.

If you are not exactly sure how to improve on what you already have, take a look at some of your competitors' literature and at some marketing materials from other industries. Your life insurance policy, the Franklin Mint plate sales flyers, the welcome kit from your local chamber of commerce, sales flyers you get in the mail, and wedding invitations from your supply house may prove to be a good source of inspiration.

These are all things that can give you fresh ideas on how to improve your marketing literature and your image. You can do anything you want if you just open your mind up to new and innovative ideas from outside of the box. I challenge you to invest some time and money to create a unique look for your business that is unequalled in your market—one that separates you from the rest of the pack.

There are a few other simple ways to enhance your image and create greater value for your products and services. First, say thank you. Any opportunity you have to say those magic words should be treasured and taken advantage of. We should never pass on a chance to make our clients feel special and appreciated. This alone can make all the difference in the world in your business this year. Say thank you, and mean it—say it a lot! Send thank-you notes within twenty-four hours of a client's visit, or call them within twenty-four hours after they pick up the final order to make sure everything is okay. Take advantage of other occasions to touch their lives during the year, too. Send a card on their birthday or anniversary, to congratulate them on a job promotion or an award they received, or to wish them a happy holiday. For that matter, there's no reason why you can't send a card for no particular reason whatsoever. You will be amazed how much goodwill you can create from simple gestures like this.

That's it for the image challenge! How did you do? You probably have a few pages of projects to do in and around the studio over the next several weeks and months. Don't feel overwhelmed by the amount of stuff you wrote down. It just shows you have lots of potential for future growth and improvement! To make your to-do list a bit more manageable, you can break it up into a weekly task list. Get your staff and your family involved, have a neighborhood work party, and throw everyone a barbeque, complete with beverages, as a thank-you for lending a hand. Have some fun with it, and get other people excited about getting involved. Life is meant to be enjoyed, whether we are playing or working!

___The most difficult part of the wonderful world of marketing lies in learning to understand the way the world around us works. We need to look into the way perceptions are created about you and by you, how value and perceived value are ultimately controlled by you, and how the entire process begins with the creative juices only you can provide. Your brainstorming can lead to incredible breakthroughs for your studio—and your life.

Mitche: **What is the biggest challenge that you think the photography industry will be facing in the coming years?**

Kathleen: I think one of the biggest will be workflow management, and learning how to control where you spend your time. There is also an influx of really new photographers popping up all over the place, so it's important that you understand who your market is so you can effectively compete with them.

Jeff: Also, the overwhelming influx of products, software, and equipment onto the market. It gets to be too much for photographers to absorb. You can easily get caught up in the trap of using all this stuff. You need to identify the products that are going to work for you and your business, and stick with that. There are always going to be new toys, but you need to focus.

Another challenge is that all of the consumers have access to the same types of technology that professionals do, and we have to have something that separates us from the amateurs. They have access to equipment that will do a phenomenal job. What we have to do as professionals is separate ourselves from those amateurs, and position ourselves as photographic artists.

Who is your perfect client?

Kathleen: Anybody who has a sign that reads "Make me feel special!"

What are the most important attributes of a Power Marketer?

Kathleen: The ability to apply critical thinking skills. If you understand that people want to be made to feel special, then learn to have interpersonal skills to work with them, you have just accomplished the first step in becoming a Power Marketer.

Jeff: I think you also need an ability to identify personality types, what type of person are you talking to, what are they interested in, and really listening to what they have to say. You can then provide them the product that will help them get what they are looking for. There are tons of different products that we can offer them, and it's our job as good marketers to educate them so they can make the right decision.

Power Corner

Focus on . . .
Jeff and Kathleen Hawkins

What happens when you combine the talents of one of the best photographers in the country and one of the best marketing minds in the industry—then throw in a little love for good measure? You get the dynamic duo of Jeff and Kathleen Hawkins! Jeff has been a professional photographer for over twenty years. He has photographed many celebrities, including Ed McMahon, Regis Philbin, Reba McIntyre, Billy Ray Cyrus, Mary Kay, Charlie Daniels, John Anderson, John Michael Montgomery, Marty Stuart, and Shaquille O'Neal. Kathleen holds a Masters in Business Administration and spent nearly a decade teaching marketing and business courses at a local university. Together, they are a very dynamic team who have become the epitome of success. They are also the team behind several successful books under their belts, including Professional Marketing and Selling Techniques for Wedding Photographers, 2nd ed. *(from Amherst Media®). For more information on their educational materials and workshops, visit www.jeffhawkins.com or www.kathleenhawkins.com.*

What is most important to you from a "life" standpoint, and how does that come into play in your business?

Kathleen: Keeping your priorities in perspective. Our faith first, then our family, then our career third. Making sure that we are working our business instead of letting our business work us.

Jeff: I think also, that when you own a photography company, it's not a job, it's a business. If you have a job, you work for somebody else. It may mean working a lot of extra hours, but I don't think it's really considered work when you are the owner. I think that's important for people to understand.

How do you balance your personal and your professional lives, with everything you have going on?

Kathleen: We believe in working less and getting paid for our talents, so that we can give our family the things they need and have the time needed to maintain our faith. We understand the importance of giving back to others and to the industry and take time for that, but also know how important it is to take time out for each other, our family,

I also think that the service we offer and the products we have are **unique in our market.**

and our education. These goals and proper prioritizing have helped us stay ahead of the changes in the industry and continues to provide us with the personal and professional growth we desire.

What is your hook?

Jeff: I think what separates us is our style. We are able to use our digital technology to create more artwork for our clients. I also think that the service we offer and the products we have are unique in our market.

Kathleen: Jeff created a phrase, and he calls himself a "photo-relationist." It's basically a PR concept, meaning that when we get a new customer, we look at them as customers for life. We want to photograph their wedding, their children, their family, all of it.

Jeff: In essence, we are documenting and capturing relationships, and that's the way we approach our marketing.

Have you had a marketing campaign that has been an absolute home run?

Jeff: I would have to say the Lifetime Portrait Credit. It was started because we wanted to establish and develop relationships with our wedding clients, and to continue them for the rest of their lives. They basically get free portrait sessions for the rest of their life. They don't have to pay a session fee, they only pay for what they purchase.

Kathleen: When a client hires us to photograph their wedding, they automatically become a member of the program. It has not only separated us from the industry, it's done much more!

What about your least successful?

Kathleen: We did Halloween portraits one year. There was this park where businesses would set up a booth, and we thought it would be a great way to let people know that we did children's and family portraits by offering them affordable Halloween photos. The little trick-or-treaters would come around to each booth, and I think we each had to have 50,000 pieces of candy. So, I went out and spent $1000 on candy alone! Unfortunately, people just didn't want to have photos of their kids in Halloween costumes. We did get one good client out of it, and if he comes back for a second session, maybe we will get back our initial investment!

Jeff: We went out and bought hay and all kinds of nice set items, but the interest just wasn't there. Needless to say, we won't be doing that again!

Favorite book?

Kathleen: Any type of motivational book. I'm a success book junkie! I love them!

Jeff: I'm not one to sit down and read much. I don't have enough time for that.

Who are your biggest inspirations?

Kathleen: I would have to say Jackie Applebaum, the owner of EventPix. She has so much going on at any given moment that it used to make me second-guess whether or not I was focused enough, because I wasn't as organized as she is. Every time we have any contact with her, we come back and we do something to improve our business.

Jeff: I would have to agree with Kathleen. She has really inspired us both!

Do you have a favorite saying?

Kathleen: Just because you can, doesn't mean you should! Just because you can be a lab, doesn't mean you should be a lab. Just because you can build a web site, doesn't mean you should build a web site.

Would you like to reinvent the way your studio operates? Although you are searching for ways to take your business to the next level of success and profitability, are you met with frustration? If you truly devote yourself to accomplishing the following twelve steps over the next seven days, I guarantee you will re-energize and invigorate your creativity and give yourself a whole new perspective. It won't be easy, but if you are diligent with your follow-through, your life will change forever!

If being an entrepreneur were easy, everyone would be doing it. It takes a very special person to keep their nose to the grindstone each and every day, through good and bad times. Seven days is long enough to only begin to create new habits, so upon reviewing this chapter, your goal should be to make these steps part of your everyday routine. It's very easy for us to get caught up in the day-to-day details of running our businesses instead of designing our lives. I challenge you to take this project seriously; you will reap the rewards for doing so!

1. Make a List of Goals

Make a list of your personal and professional goals for the next twelve months. This is perhaps the easiest task on the entire list. Grab yourself a good cup of coffee and a notepad, and spend some quality time writing down what your goals are for the next twelve months. First, list your personal goals, then write down your professional goals. Once you figure out what you want out of your life, the rest will come easy.

Do you want to take a vacation—or two or three—this year? Do you have your eye on a special boat or a set of golf clubs? How about your garden? Would you like to spend more time cultivating it or working in the yard? What about other hobbies you may have, but haven't made time for recently? If it's important to you, then you should make time in your schedule to read, or write, or paint, or play with the dog. Having a strong marketing plan will allow you to be more productive in your working hours, which will allow you to take more time off to do the things in life that are important to you. It all goes hand in hand.

2. Set Aside Brainstorming Time

Set aside fifteen minutes a day for the next seven days to study in the field of marketing and brainstorm about your

Attractive promotions, like this one created by Chatsworth Portrait Studio, can help take your business to the next level.

Tiny Treasures

Babies... You wish they would stay little forever, but time has other plans. Chatsworth Portrait Studio stops time, if just for a moment, capturing the miracle of your baby so that for years to come, you can enjoy images of a time that seems like only yesterday. Your child's portraits will be beautiful works of art that add special warmth and charm to your home.

With this plan we will photograph your child at the stages of 1, 3, 6, 9 & 12 months of age.

225.00
(savings $100.00)

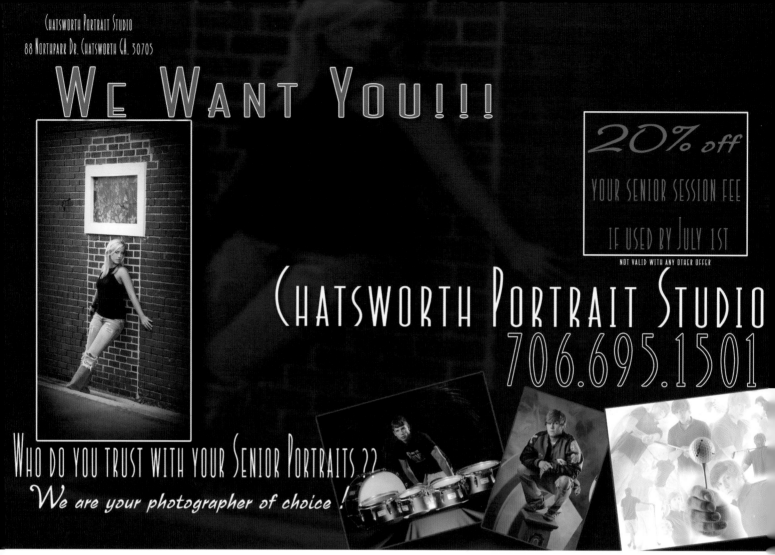

Adding a promotional piece to every item that leaves your studio is a good way to encourage additional purchases. This piece, from Chatsworth Portrait Studio, is a good example.

business. This is very simple. Grab a stack of 3x5-inch cards and spend some quality time with yourself getting the creative juices flowing. It's easy to get carried away with spending all of our time playing with our new toys or reading up on the latest digital camera, or fiddling with Photoshop. We call that the substance of the business. For this exercise, we are talking about the essence of your studio. Where do you want to be in six months? Twelve months? Two years? Five years?

We have so many resources available to us, whether it be videotapes, magazines, books, CDs, or newsletters, and the tips they contain are ours for the taking. Give yourself some time to work through the materials and to accomplish any other business-related tasks you've been putting off. Make sure that you are working in a place where you won't be interrupted or distracted. Power Marketers are not born, they are developed. By spending just fifteen

minutes a day immersed in learning and brainstorming, you will begin to create positive habits that will stick with you for the rest of your life. Once you come up with an idea, write it down. After you put it on paper, it will be much easier to expand the idea and develop it into creative breakthroughs.

3. Take the Five-Second Image Challenge

Take the Five-Second Image Challenge to learn how prospective clients see your business. (See pages 58–62.) Working on any problems you identify will only serve to strengthen your business.

4. Distribute Promotional Pieces

Add a sales flyer, coupon, and/or reorder form to every item that leaves your studio. Anything that leaves your studio—portrait orders, statements, bulk mail, dance

packages, sports team packages, wedding albums—should have some sort of promotional piece included. If we don't give our current customers the opportunity to make additional purchases, we are leaving a tremendous amount of money on the table.

The most neglected and underutilized market we have is comprised of our current clients. They already know about us, have done business with us, have written us a check, and more than likely have told their friends and families about us. Why not maximize this potential and make sure our studio is in the forefront of their minds? When you do, you will be surprised at the response you will get.

5. Track Your Results

Track each and every call, walk-in, and inquiry for the next seven days. This project can be done simply with a piece of notebook paper and a pen. First, create columns across the top of the page that list the prospective client's referral source, and then create a column along the left side of the page for the prospective customer's name and date of inquiry (see the chart on page 38). When somebody calls or walks into your studio for the first time, ask them how they heard about you. Was it via a referral from a satisfied customer, another photographer in town, or from the local florist, church, or yellow pages add—or maybe an event facility, family member, or neighbor? This will do two things. First, you will find out what forms of marketing are working for you. Second, you will find out what is *not* working. Tracking your inquiries will show you which efforts are returning the best results and which need to be reworked—or dropped altogether.

6. Emphasize Add-On Sales

Make it a goal to add on at least one item onto each order for the next seven days. This doesn't have to be a big item, maybe even only one more 4x5-inch print, a two-way portfolio, or an additional unit of gift wallets. If you consistently work on adding just one more item to each of your orders, it will add up to a substantial amount of money over time.

This can be done in a couple of ways. You can either add some extra value into your packages that gives your customers the incentive to move up to the next package on their own, or you can create a unique product that can be added on at the end of the sales process for a nominal amount. If you let the way your packages are built do most of the work for you, there will be little need for you to have to force-feed another item down your clients' throats. Since we are artists, it's sometimes difficult to sell our own work, so it makes sense to let your packages work for you.

7. Do Some Networking

Spend at least thirty minutes this week talking with at least two other photographers in your area. Most of us are friends with several other photographers in the industry, but how do you feel about sharing your knowledge and expertise with other photographers in your market? We need to realize that we all are charged with the responsibility of educating the general public about the benefits of having professional portraits done. To that extent, we are all on the same team.

Make it a goal to develop a **stronger relationship** with other photographers in your market.

You don't have to give away any trade secrets, and neither do they, but sharing ideas is one of the most powerful ways to educate ourselves. Whether you get together for a cup of coffee to talk about programs you are both working on, or make a plan to refer clients back and forth to each other, or play a round of golf at the local country club, make it a goal to invest some time in the next week to develop a stronger relationship with other photographers in your market.

8. Contact Your Existing Clients

Develop a direct mail piece. This should feature your hook, plus an offer. You will want to make sure that you (1) give them a compelling reason to do business with you again; (2) give them an offer they can't refuse; and (3) give them a short deadline in which to respond to the offer (no more than two weeks from the date of the promotional mailing).

Once you have created your piece, send it to your client database. These people already know the quality of your work and the level of your service, and will be more likely to respond to a promotion like this than someone who knows nothing about you. (*Note:* If you have been around for a number of years, you may want to scale your list down to include clients you've worked with in the last twelve to twenty-four months.)

Make sure that your **web site** is listed on every piece of literature that leaves your studio.

Whatever the response is on the first mailing, you will achieve approximately the same response with a second mailing, and a very similar result from a third mailing. Once is nice, twice is better, and three times is a charm! This will all depend on the time you want to commit to the promotion, the amount of dollars you want to invest, and the size of your customer base.

9. Meet Local Vendors
Spend thirty minutes this week talking with other vendors in your market. Whether you photograph weddings, seniors, families, children, or llamas, you have undoubtedly developed a network of relationships with other vendors in your industry. It could be the clothing store where your high-school seniors purchase their clothes, a tuxedo shop where the groomsmen from your weddings rent their tuxedos, a local hospital where babies are delivered, a florist, an event facility, a jeweler, or a llama farmer. In any case, it is vital that you have a good working relationship with each of them.

This is perhaps the single most powerful form of marketing you can develop and invest time in. If you make it a goal to have at least one sit-down meeting with one vendor per week, you will steadily grow your referral network.

10. Laugh
Take at least thirty minutes per day to take a walk on the lighter side of life. Did you know stress is the number one killer in the United States? When things get difficult in life, we get overwhelmed with that feeling of uneasiness. Most stress is caused by change, and our world is overflowing with change every day.

Having a sense of humor is vital to our ability to overcome those feelings and to making sure we maintain a proper perspective of our life. It's easy to forget about the little things that make us happy—holding a baby, going for a walk, watching a good sitcom or movie, getting a letter from a good friend, hitting a great drive off the tee, or even something as simple as watching the sunset on a warm evening. If we can figure out a way to keep it light in the face of stress and change, it will keep us healthier, make us happier, and above all give a more fulfilling feeling about ourselves.

Did you know that when you laugh so hard your cheeks hurt and your stomach aches, your brain releases a natural painkiller called endorphin that gives you a general sense of well-being? Can you remember the last time you laughed so hard you had tears in your eyes? If not, it's time to search out some good laughter.

11. Promote Your Web Site
Make sure that your web site address is listed on each and every piece of literature that leaves your studio. Today, most of us are highly dependent on the Internet for getting information on the world around us, communicating with customers, and reaching potential customers. If you don't already have a web site, getting one should be a top priority. Your competitors are there, and you need to be there as well.

An Internet presence allows people to learn about you, see a gallery of your work, and communicate with you at their convenience—twenty-four hours a day, seven days a week, 365 days per year. You can add staff bios on your web site, educate people on the importance on different aspects of photography, and even list your awards and accomplishments.

Perhaps the biggest reason for being on the Internet is it allows clients to view and purchase your work from the privacy of their homes. This creates additional sales from each wedding and session and exposes the entire world to our work. Families and friends are becoming increasingly spread out, and what better way to bring them together than with a personal web site of images?

Is your web site and e-mail address listed on every piece of literature that leaves your studio? Is it listed in small print at the bottom, or is it presented boldly and distinctively?

12. Send Out a Press Release

Keep your local papers up to date on the latest happenings in your business by sending out a press release to every newspaper within a hundred-mile radius of your studio. If you have recently won an award for your photography, hired a new employee (or promoted an existing one), expanded your camera room, attended a photography convention, or had an article published in a trade journal, you have a legitimate reason to write a press release. Editors are constantly searching for local news to publish, and there is no reason why your studio shouldn't get its fair share of column space.

One of the keys to a successful marketing plan is to keep your name in front of your market as often as possible. A well-written press release can accomplish this. Keep the fax numbers next to the fax machine and get into the habit of writing at least one release every four weeks. It doesn't have to be very long—only a couple paragraphs—but it should be structured to answer the basic questions of journalism: who, what, when, where, why, and how. If you apply this simple rule, you should see your name in print before the week is out!

Well, there you have it—Mitche's twelve-step program! Are you ready to make a commitment of this magnitude? Are you willing to make the changes necessary to ensure that you are successful with this program? I didn't say it would be easy, did I? I wish you luck!

A uniquely designed promotional card, like this one from Sarah Petty, is sure to attract a lot of attention.

Power Corner

Focus on . . .
Skip Cohen

Skip's career in the photo industry started at Polaroid in 1970 where, over the course of seventeen years, he held positions in research, personnel, and customer service, and was the U.S. marketing manager for Polaroid's photo-specialty dealers. In 1987, he left to take over Hasselblad USA as President/CEO and to pioneer Hasselblad University. In 1999 he helped launch an Internet photographic retail site as president of PhotoAlley.com.

Skip is now President/Chief Operating Officer of Rangefinder Publishing Inc. and has responsibility for Rangefinder *magazine, the Wedding and Portrait Photographers International Association and Trade Show, as well as* Focus on Imaging *magazine. Two key industry fundraisers created by Skip include the sale of Ansel Adams's Cadillac to the Coastal Hotel Group in 1991 and the sale of Ansel's Hasselblad gear to shock jock Don Imus in 1997, raising $100,000 for charity.*

With Bambi Cantrell (see page 81), Skip has also written several instructional books for photographers. To contact Skip Cohen, please call (310) 451-0090.

Mitche: **What do you feel is the biggest challenge facing our industry in the future?**

Skip: Keeping up with technology and reaching our target audience. We are all competing, not just against ourselves, but other businesses. If it took three times for a consumer to remember your name years ago, today it's six to eight. Professional photographers are competing against companies like BMW or that "Zoom, Zoom, Zoom" commercial for Mazda, for example. Everyone is competing to get through the "noise" and build brand recognition in their target demographic.

Describe your marketing philosophy.

Education. It's all about being accessible to your customers and providing quality education.

What are the most important attributes of a Power Marketer?

Knowing your target market, without a doubt. There's a great line from a marketing consultant by the name of Ed Foreman. He said, "If I can see the world through Mitche's eyes, then I can sell Mitche what Mitche buys." In order to achieve success in any industry, you need to know your client.

What things are important to you in life, and how does your marketing come into play with those priorities?

If you love what you are doing, you tend to do it well. You tend to have more enthusiasm. People accuse me of being wound a little too tight sometimes, and I laugh about it. If you look around the industry, I have always believed that if you're not having fun with what you are doing, get out and change gears. I've been very fortunate in my life, and I love what I do! I love photography, I love what great photographers are able to do, I love the magic. I've always believed that with the exception of modern medicine, there is no industry that has given the world more than photography.

If you think about it, everything from capturing a wedding to documenting the violation of human rights is captured by a photographer. If it wasn't for photography, what would 9/11 look like? It would have been a bunch of pencil sketches. Or for someone's wedding we would have drawings of a wedding cake. Photographers tell the story, good or bad. If you don't love what you are doing, make a change. I happen to love what I do so much that people accuse me of having an overindulged zest for life! Basically, it's a "work hard, play hard" approach.

In order to **achieve success** in any industry, you need to know your client.

How do you balance your personal and professional life?

Sometimes very well, sometimes lousy! There's a very thin line between your personal and professional life if you love

what you are doing, because your professional life becomes your hobby.

When you are not working, what do you do for fun?

Scuba diving is probably my ultimate passion. I think it has a lot to do with sitting on the bottom of the ocean where no phones can ring, with no faxes to deal with. It's a total departure for me. In the first five years I was diving, I logged around three hundred dives. Both of my kids are certified, and we've had some pretty incredible adventures.

Tell me about your family.

I have two kids and I've always had an absolute ball with them. I'm very close to both of them. Debbie and I have been married for over thirty years. When I was a kid, if somebody asked me what I wanted to be when I grew up the answer was always "a Dad." Now I'm a third-generation "Papa"—and it just keeps getting better.

What do you feel has been most successful marketing program you have ever done?

The most current would be the growth of *Rangefinder* magazine and WPPI, but it's been a team effort. Our readers and photographers said they wanted more from an educational and programming standpoint. We've done our best to listen, and the growth of both has been tremendous. The most successful "solo" programs both involved Ansel Adams and were fund-raisers. The first was when Hasselblad sold his 1977 Cadillac to raise money for Photographers + Friends United Against AIDS, the second was selling his camera gear with the proceeds going to the Elizabeth Glazer Pediatric AIDS Foundation.

What about your least successful attempt?

Actually, the least successful became one of the most successful. I'm talking about Hasselblad University. I had an idea in the early 1990s for a four-day weekend with about ten different programs, and the student could pick six of those classes to attend. We had the best of the best when it came to the instructor team. The problem is, we didn't realize at the time that very few people could afford Santa Barbara, CA during the last weekend of the summer! You couldn't get a room for under $300 a night right before Labor Day. The program was a total and dismal failure. We had to cancel it. We built it and nobody came, but the logo won an award!

We've done our best **to listen,** and the growth of both has been tremendous.

After that, I hired Tony Corbell to come to work at Hasselblad, and we decided to figure out a better way to launch Hasselblad University. The next year we went out with a full ten-city tour that was an absolute blowout. We had just done it the wrong way to begin with.

Who are your biggest inspirations?

My Dad, who was also best man at my wedding and is still my best buddy. I feel pretty lucky to be in my fifties and still be able to drag Dad off to a convention. On the public side of life, JFK and Bobby Kennedy are big inspirations. On the photographic side of life, I'm the luckiest guy in the industry—my friends keep me focused.

8. The Next Step: Selling

Marketing is a big challenge, but it's really only the first step in building a successful business. Once you you've gotten prospective customers interested in your business you need to translate that interest into purchases. That's where selling comes in. With solid sales skills, you'll be able to convert more phone calls and inquiries into customers and take your sales averages to levels you never dreamed of. (And, most importantly, you'll be that much closer to creating the quality of life you want for yourself and your family.) Without good sales skills, the best marketing—and the best photography—in the world will be a total and complete waste!

Marketing? Selling? What's the Difference?

This is an important foundational understanding for your business—and I want to make sure we have our foundation poured before we build our house. In my view, marketing is everything you do up until your phone rings. Sales is everything that happens after that. Now, any sharp business person will tell you that the marketing and sales processes are both taking place every second you are in business, which is true. For the sake of simplicity, though, let's agree (at least for now) that marketing gets your phone to ring, and sales is everything after that.

Selling Makes the World Go 'Round

The whole world's economy revolves around the buying and selling of products and services. From Wall Street to Main Street, our lives are built on the buying and selling principle.

Think about it. You meander into the grocery store on Sunday afternoon to do your weekly shopping and you buy lots of stuff. Let's say that one of those items is a carton of one dozen eggs. When you purchase your carton, that effectively ends the sales process for that particular dozen eggs, but let's work backwards and see what the

process entailed. To begin with, some broker had to sell the store those eggs. Then, there was a farm out there that sold the eggs to the broker's company. For the farmer to be able to collect those eggs, he had to have all the right equipment to handle the eggs with care and to guarantee the health of those eggs. Each of those pieces of equipment was bought and sold by someone—as were all the parts and materials required to build the equipment . . . and so on, and so on.

Those eggs came from chickens. For the chickens to lay eggs, the farmer had to have a rooster, who needs to eat something (as do the chickens). So the farmer had to buy grain and pellets and sterilized water, which means somebody had to sell those products to him. And then there is the actual carton that the eggs go into. All of the raw materials that go into making that carton have to come from somewhere, which means somebody had to buy and sell

Without good **sales skills**, the best marketing in the world will be a total and complete waste!

each of them. If we are talking about cardboard, each of the ingredients was probably bought and sold five or six times going back all the way back to when a single tree was standing tall amongst its brothers and sisters in an ancient forest.

All of this buying and selling happens just so that you can go to the store, spend a buck fifty, and buy a dozen eggs to make egg salad sandwiches, or a cake, or breakfast, or a souffles . . . and then you'll also need to buy flour, and sugar, and—oh, you get the point!

If something as simple as a dozen eggs requires that much buying and selling, just think about things such as

a jumbo jet, or x-ray machines, or computers. The world is all about buying and selling. And whether you like selling or not, as a business owner, you are in the business of selling.

Buying is Based on Benefits

People are going to buy things . . . but they also have a lot of choices. So why do people buy the things they do? They do it because it benefits them in some way—it may feed their family, make them feel better about themselves, improve their perceived social standing, etc. The greater the benefits, the more they are motivated to buy, and the more they *will* buy. If you can increase your customers' perception of the benefits of buying from you (their motivation for buying), it will equate to dollars in your bank account.

I can remember a seventeen-year-old who came to our studio several years ago for his senior portraits. His parents were in the process of getting a divorce and neither one was in a position to be able to afford an investment in photography. He had a job-full time job at the local hardware store after school to pay for his car (his pride and joy), lunches, and dinner for his girlfriend now and then.

When he came to me, he asked if I would take his senior portraits. He wanted to be able to give each of his parents a beautiful 20x24-inch canvas wall portrait. He also wanted some 8x10's for grandparents, and of course lots of wallets for his friends and relatives. Being the kind of guy that gives people the benefit of the doubt, and is willing to work with people and their financing, I told him that if he would come in every two weeks and make a payment to me, by graduation he would have the entire amount paid off and he could present his mom and dad with this wonderful gift. This was a good kid with a sharp head on his shoulders and a good set of ethics and values. He was just going through a difficult time at home.

We did the session a few weeks before Christmas and had a great time in the process. At the ordering session, he also decided to give each parent their very own twelve-way folio that they could keep on the shelf, in addition to the rest of his order.

The first two weeks went buy and sure enough, Friday afternoon at 4PM—just like he told me—he showed up to make his first payment. He pulled out a thick envelope and began to count out $100 dollar bills until he has a stack of over $2000—the total order amount.

I said, "Hey, buddy. You are only supposed to pay me a small amount every two weeks until the order is paid in full. What did you do? Go out and sell your car?"

It turned out that was exactly what he had done. "My mom and dad are going through a real hard time right now," he said, "and I wanted to do something nice for both of them for Christmas and give them their portrait of me. So I went out and sold my car."

The greater the benefits, the more they are **motivated to buy**, and the more they *will* buy.

He wanted those portraits so much, they offered such a significant benefit to him, that he was willing to part with the most cherished thing in his life. Money wasn't the issue, but the value of his portraits was. (Of course, if he'd come in and told me that, I probably would have let him take his order home for Christmas, then pay for it over time—but he beat me to the punch.)

An Emotional Process

Another important lesson you can learn from the previous story is this: In photography, the benefits are mainly emotional. The sale is emotionally driven, then justified logically. Believe it or not, though, the emotional benefits are what motivates most purchases (outside of necessities, like food).

Think back to the most recent big-ticket item you purchased for your family—whether it was a car, a new plasma TV, a boat, or something else that required some serious thought before making the decision to purchase it.

- Why did you make the purchase?
- What were you thinking before you made the purchase?
- What were you thinking about during the purchase?
- What was the deciding factor?
- How did it differ from your original concept?
- How did you feel after the purchase?

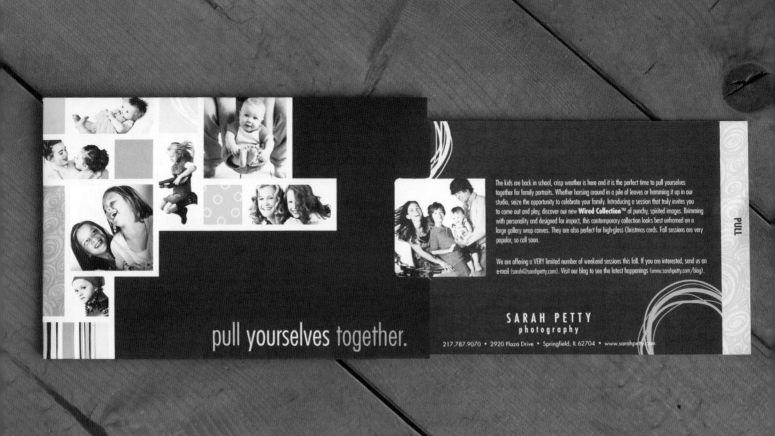

This promotional piece from Sarah Petty Photography play to the reader's emotions, selling portrait photography as a way of increasing and celebrating family unity.

- What type of follow-up did you receive?
- What was your budget for this purchase beforehand?
- How much did you actually spend on the purchase?
- Did you end up buying additional features that you didn't figure on before making the initial decision?
- How did you feel once it was completed? Did you have feelings of guilt, or did you justify in your head all the reasons why it was okay to spend what you did?

If you are like most people, quality and price won't be listed among your top motivators. People don't buy for quality or price, they buy for benefits. They may make a purchase to gain the *benefits* of high quality (a luxury car may be more reliable and impress your friends), but once there are enough benefits established, price becomes secondary. People who are motivated enough (*i.e.*, people who see sufficient benefits) will buy just about anything in this world. If you can keep that in the front of your mind as you spend some time immersed in the sales thought process, you will be miles ahead of the game.

Here's the trick, though: benefits are extremely personal and vary from customer to customer. That's where the job of a salesperson comes into play.

Start with the Right Atmosphere

There is a subtle difference the successful and the unsuccessful salesperson. The unsuccessful salesperson attempts to sell whatever it is they have. The successful salesperson creates an atmosphere that makes the customer want to buy whatever it is they have.

Have you ever gone to a restaurant with high expectations, only to have them crushed as soon as you walked in the door? If so, you probably didn't spend as much as you might have—you skipped dessert or didn't order the wine. Conversely, have you wandered into a restaurant without any particular expectations and walked away with a tremendous experience? Some of my most expensive dinners have been at places where I was pleasantly surprised by the tantalizing appetizers, delicious meals and desserts, an extensive wine list, relaxing ambience, and service that was second to none. At that point, it doesn't

really matter what the price is, does it? The experience and the emotion become much more powerful than the price of a bottle of wine.

Remember this: People don't like to be sold to, but they love to buy! I don't know about you, but when I get in the car and head down to the local store to make some sort of purchase, I have an exciting feeling of exuberance and anticipation. Whether it's a new car, a pair of pants, or maybe just the makings for one of your world-famous barbecues, you probably have a little fun shopping for it, right? Often, we also spend more than we anticipated before we left home don't we? Why? Because something in the way the products were packaged, or displayed, or designed made us want to buy them—made us feel the benefit of owning them.

Why Should Customers Choose You?

Before we go any further, let's take a inventory of your sales tools and see where you currently are with your understanding of the sales process. To start, I want to ask you a very important question—and it's probably the most important question you can ever ask yourself about your business:

Why you?

The answer is *not* allowed to be, "Well, because I create beautiful images for my customers that they can enjoy for generations to come. I know how to pose them, I know how to light them, and I know how to take blemishes off their faces." That's not what we are looking for. Instead, we want to think about specific reasons a prospective customer would choose you to be their photographer instead of any other photographer in your market. Why do your customers buy from *you?* Why are you better than your competitors? What strengths and weaknesses do you have? What strengths and weaknesses do your competitors have? How is your business viewed in the eyes of your competitors?

Keep in mind, it's not enough to list why you are *as good* as your competitors, you must know why you are *better.* If you have to stumble around to come up with that answer, your customers or prospective client will interpret that as insecurity and doubt. In today's' fiercely competitive marketplace there has to be something besides the quality of your work that gives people a compelling reason to spend their dough with you.

I want you to be specific with this exercise. Take just a couple of minutes right now and scratch out some thoughts on paper—and, remember, the reasons should *not* be tied to your creative skills or your technical expertise as a professional photographer. Dig deeper and come up with at least three reasons why people should spend a portion of their expendable income with *you.*

Here are the beginnings of a few sentences that may give you some direction for this exercise:

I am the only one who . . .

I am unique because . . .

My prints are more expensive because . . .

We can offer better prices than our competitor because . . .

Okay kids, how did you do? You may have been able to write down ten reasons why someone should choose you, which is great. Or you may have sat there for most of the time thinking intently and coming up with next to nothing. Either way, that's okay. We will get you there—eventually!

This question—why you?—*must* be answered before you will be ready to become a powerhouse sales dynamo in your business. Over the next couple of days, give it some more thought.

The Power Selling Self Test

While you are sitting their with a pen and paper, this would be a great time to dive into our next exercise, which is the Power Selling Self Test. For each of these questions,

Keep It Light

If everything you have to say is always stuffy and professional, you are likely to lose to someone whose talk is professional *and* friendly—with a touch of funny. Friendly and funny are a million times more engaging than professional. Laughter is universal across all social economic boundaries, across nations, and in all types of industries. If you don't consider yourself someone with a sense of humor, study it, read about it, and most importantly, lighten up! Life is good, and so is having a sense of humor!

Keeping an up-to-date blog can help all your clients feel like insiders. They'll enjoy checking in to see your latest sessions—and be more likely to book one of their own. Promoting your blog with a great-looking card, like this one from Sarah Petty Photography, can get the traffic moving on your site.

I want you to grade yourself on a scale of one to ten, with one being the lowest and ten being the highest. There is no pass of fail for this test, and you will not be graded. It is simply information, and the more useful information you can have about yourself and your business, the more prepared you will be to tackle the challenges and obstacles that appear along the road to sales success. Here we go!

1. Do you have a comprehensive sales strategy for your studio—beginning with the first phone call and ending when the portraits are delivered? If so, what is it?
2. Do you feel you are maximizing each and every order that you write as far as the dollar amount?
3. What are your averages for weddings, families, children, seniors, etc.?
4. How do you feel about your sales skills on the telephone? Can you answer their questions effectively, overcome their objections, build a bond be-

tween you and the prospective customer, then get them to commit to an appointment time to come in and meet with you?
5. Do you have incentives built in to your price list that encourage your customers to invest more on their portraits? Have you reviewed them lately?
6. Do you have confidence in your price list, and do you communicate that confidence to your prospective and current customers? How?
7. Are you able to overcome objections easily and effectively? What words do you use?
8. Do you have a system for follow-up after your customers have received their portrait order? What is it?
9. Do you have a referral program in place that motivates your customers to send you new business during the year? What is your program?
10. Do you offer incentive-driven packages in your price list that act as a silent salesperson? What are your incentives?

Let's switch gears just a little bit and think about the following statements. These can all be answered with a simple yes or no.

- I feel good about myself and feel confident about my sales skills.
- I usually say the right thing at the right time.
- People seek out my company.
- I don't seem to get too discouraged, even if I fail repeatedly.
- I am an excellent listener.
- I can read people's body language with ease.
- I can see many ways to define a problem and understand its causes.
- I am skilled at drawing out other people's concerns and problems.
- I manage my time so well that I am able to accomplish everything that is important in a typical work day.
- I focus on the big picture goals for my business rather than always reacting to whatever the "crisis of the day" is.
- I keep looking for ways to be more efficient and productive.
- I don't care how long it takes to succeed at a task, because I know I'll succeed in the end.

And we are done. How did you do? This was only an exercise, but I do encourage you to take some time and expand on the answers that you came up with . . . especially when you note areas where you can make improvements. Even if you aren't a born salesperson—even if you sometimes feel like you were born to fail—if you can learn the basic principles of successful selling techniques, you can become a superstar salesperson.

The Secret is You
There is no quick fix or magic wand I can wave, no potion I can give you to create the success you are dreaming of in your life and in your business.

There is, however, a secret formula, which I am about to give you. Grab a pen and get ready for me to rock your world. Are you ready? Come a little closer . . . closer . . . Okay. Here it is: there isn't any secret. There's just *you*—

and that's exactly what successful salespeople are really selling.

Here is what the best salespeople sell—in order of importance:

1. Themselves
2. Their company
3. Their products and services
4. Their price

Average salespeople do things the opposite way:

1. Their price
2. Their products and services
3. Their company
4. Themselves

When it comes down to it, customers buy *you* first—way before they can buy your company or your product. If they like brand "you"—if they respect you, trust you, and enjoy interacting with you—then they will probably buy whatever you want to sell them.

Shared Traits
All successful salespeople have several traits in common. If these descriptions sound like you, great. If not, there may be areas where you can focus on strengthening your skills and boosting your confidence. The best salespeople:

1. **Associate with other positive, encouraging, and successful people.** They stay away from people who bring them down or constantly complain—people

> There's **just you**—and that's exactly what successful salespeople are really selling.

who never seem to go nowhere. You know the type of person I'm talking about here. Invest your time building relationships with other successful people—people who have the same aspirations as you do and want to make a difference in the world.

2. **Keep abreast of the newest and hottest ideas.** How much time do you spend each day reading a new magazine, trying new ideas out, or even just watching a new show on television? New information and ideas are essential to success. You can bet that your competition is keeping their eyes open—and so are your clients. Open your mind and look around you. See what other people are doing. You must have a steady diet of change and innovation in order to succeed

Establish Great New Habits

Education is important. We all have been to seminars and workshops where we got so fired up we couldn't wait to get home so we could implement the ideas. We've all read a book that touched us in a very powerful way, or watched a video that opened up our minds to some new and creative technique. Right?

If you are like most other people, though, those fantastic life-altering ideas either fade out or get pushed to the side before they actually get implemented. Our brains get filled up with the chaos of life (kids, cars, grocery shopping, the weather, practice, games, mowing the lawn, sessions, employees, receivables and payables, vacations, and everything else) and those great ideas get filed away in notebooks or simply forgotten.

Making the most of education (whether it's from books, seminars, articles, or other sources) is like hearing a song on the radio. If you hear a song and you like it, you want to hear it again. If you hear it five times, you can sing along. If you hear it ten times, you can sing it on your own without the music. The same is true with marketing and selling ideas: if you want to become a master at these techniques, ten times is the key.

Good habits take time to create, and bad habits take time to break. So, commit yourself to reading every book you can get your hand on, watching every DVD you can find, listening to every CD you come across, and going to seminars and workshops that focus on the business side of your business, instead of only attending ones that teach you the technical side of photography. This is how you'll achieve the critical mass of information it takes to have marketing and selling ideas really sink in.

When you see an idea that you think will work for you, make a plan to implement it not just once, but at least ten times. Whether it's sending a thank-you note to every client after their session or writing a monthly newsletter, once you've done it ten times it will become a productive new habit. Regularly adding these habits to your sales life will quickly make you an expert in salesmanship—and quickly increase the size of your bank account!

3. **Set and work toward goals.** Decide what you want, then get started attaining those goals. Don't just talk about it, do it. Along with education, setting goals is the surest method I know to set yourself on a course for success. If you don't develop the hunger and courage to pursue your goals, you will lose your nerve and give up. Do you spend some quality time each day setting and reviewing your goals? In the evening, my mind is mush, so I make a point of waking up early every day—when I get my best work done—to do my planning and goal setting, and my best thinking. During this time, there are no phone calls, no people, no crying babies—nothing but my brain and me.

4. **Make the most of every opportunity.** They take advantage of opportunities that come their way. We've all heard people say, "Boy, she sure is lucky!" or "He seems to get all the lucky breaks!" But luck isn't random—it's the result of hard work, perseverance, and dedication. When an opportunity arises, you must also be able to recognize it (often it shows up in the form of adversity), then act on it. Opportunity is very elusive. It's all over the place, but very few can see it because it usually involves change, which is a very scary thought.

5. **Take risks and make mistakes.** Taking chances is a very common thread among the ultra-successful business people in the world. If you want to succeed, you better be willing to risk whatever it takes to, as they say, "get 'er done." Thomas Edison failed over 6,000 times before he finally invented the light bulb. Donald Trump has had more than a handful of disasters, and Barry Bonds has struck out more times than almost everybody in the history of professional baseball. I don't think for a minute we would call these people failures, would we? The best teacher I ever had was failure—and, believe me, I've had my fair share of that. If you learn to look at mistakes that you make and failures you have had as learning experiences, though, it puts a whole new perspective on things.

I want you to become more successful with your business, and have a more fruitful life—and to truly believe that you

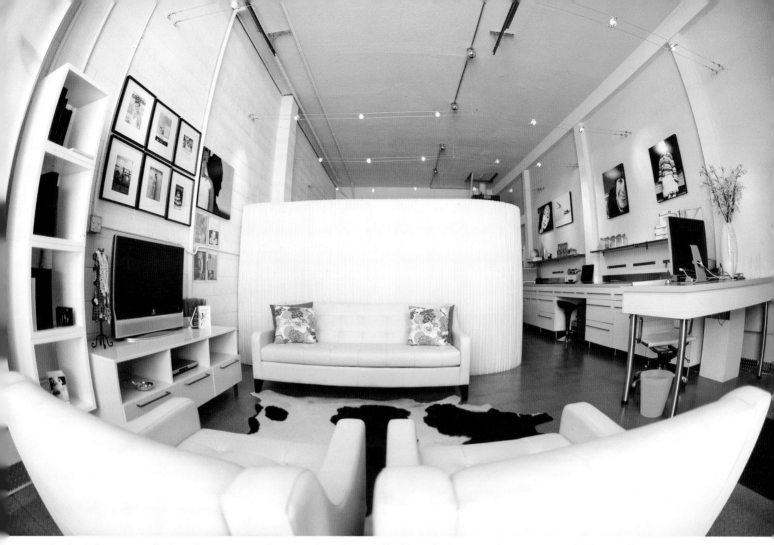

What kind of experience do clients have at your studio? Notice how Christa Hoffarth's studio decor, seen here, gets every client's visit off to a good start.

can achieve whatever you set your mind to. You must believe in your products, your services, your pricing, your staff, your message, your hook—and, most importantly, you must believe in yourself. Having a high self-esteem will lead to higher success.

Free-Association Exercises

Before we move on to defining each step of the selling process, we are going to do some free-association exercises. I want you use your spoken voice for this—speak the words out loud. (*Note:* People within earshot may think you are going crazy when you begin to talk to yourself, so you may want to send your family on an errand or outside to play with the dog.) Don't worry about making mistakes, I simply want you to do the best that you can.

1. Describe your favorite movie . . .
2. Describe the moon . . .
3. Describe a set of keys . . .
4. Describe love . . .
5. Describe anger . . .
6. Describe a portrait session at your studio . . .
7. Describe one of your 8x10 prints . . .
8. Describe the experience a customer will have at your studio . . .

We communicate facts, feelings, conviction, and emotion to our clients through the words we use. Being good with words—being good at painting irresistible mental pictures—is of the best skills you can have as a salesperson. Doing this means adding vivid details into your sales presentation. Choosing the right words helps to convey your passion, your enthusiasm, and the zest and zeal you have for the craft of photography.

I recommend writing out a list of all products and services you offer. Then, come up with a paragraph or two

that describes each one in a vivid, colorful, and effective way. In fact, why don't you do that before you begin the next chapter? Here are a couple of examples, describing a wedding album, to get you started:

Not so good . . .
At John Doe Studios, your wedding album will include about fifty images, some in color, some in black & white. These will be selected from throughout the wedding day. You can pick the color of the album cover and add whatever text you want.

Much better . . .
Each John Doe Studios wedding album is elegantly designed to tell the story of your special day, with all its beauty and romance. We will combine breathtaking color and black & white images with meaningful words to produce an album that will make you laugh and bring tears to your eyes—an album that is as unique are you are.

Another Big Secret Revealed . . .
I have been to countless seminars and workshops, read dozens of books, listened to umpteen tapes, watched numerous DVDs, and spent time with some of the best and richest salespeople in the entire world.

After exposing myself to all that education, here's what I can tell you. There are thousands of ways to do just about everything—thousands of different closing techniques, conversational "ice breakers," different ways to overcome objections, to say hello on the phone, etc. It's very easy to become intimidated and overwhelmed with the overload of information. As a result, most people simply do nothing.

Fancy techniques won't amount to a **hill of beans** if your clients don't like you.

With that in mind, I have boiled every speck of knowledge that I have ever learned about successful selling into one little golden nugget—and I am about to give you that secret so you can have unsurpassed sales success and wealth beyond your wildest dreams. Are you ready? Here it is . . . *be nice.* That's it. People buy from people they like. All the fancy techniques in the world won't amount to a hill of beans if your clients don't like you. So, be nice.

A well appointed studio sets the stage for building a good relationship with your client. Photos by Michael Warshall.

Mitche: **In your opinion, what is the biggest challenge that faces our industry now and in the future?**

Bambi: I think there are a number of challenges. Sure, the economy is not very good and obviously that is a major challenge for all studios. But, I think, equally as challenging is the struggle that photographers are having with technology. There are as many headaches with digital as there were with film—if not more. An enormous amount of work goes into it, and photographers don't appreciate the value of their time. We are generally just folks who would do this for nothing because we love what we do. We're very passionate about our craft, and we don't tend to appreciate the value of our time.

If you can, describe in a nutshell what your marketing philosophy is.

I do not allow myself to become the purse police. In other words, I don't allow myself to prejudge a person's ability to pay a healthy sum for my services, and I don't look at them and assume, well, nobody in my town would be able to afford this or that because no one has ever charged that before. It's like saying that only a rich person buys a Mercedes or a BMW, when in reality there are a lot of people from blue-collar neighborhoods who buy things like that. Though they are really beyond their means, they do it because it makes them feel good and they want to buy it. We wouldn't have a national debt in the United States if people shopped within their means. So, first, it's not judging people and basing my pricing upon what I assume that they can afford to pay.

Is there a step one-two-three that you actually go through with your marketing to achieve this?

Yes there is. I can tell you exactly what I do. I study fashion magazines like a guru. I study them very thoroughly to see how people who are successful at marketing handle marketing. And then I absolutely copy their concepts— not what they're doing, but I copy their concepts and philosophies. These people spend millions of dollars trying to attract my client, so rather than look at other photographers, I study how other businesses do it. To me, we make the biggest mistake by being little lemmings who just copy one another's pricing.

So, I prefer to tailor my marketing after successful companies like Calvin Klein, Armani, and Gucci—those that are successful at making their products become a designer label. People who are successful like that have very good advertising agencies that work for them, and so I use their concepts.

I try to create a product that is very unique looking, and then I am very careful not to underprice it. That's the worst thing you can do. There's a firm and absolute truth in our world: you're only as good as what you charge. And it's about perception and about the perceived value of a product, not its actual value. We all pay the same amount of money for the basic paper that our work is printed on, but not everyone creates a Bambi Cantrell or a Joe Buissink. It's what's on that paper that counts.

Here's a follow-up question to what you said about perceived value: do you have certain things that you can recommend to someone who is either (a) getting into the industry for the first time, or (b) they've been in it for so long, they've gotten complacent with their promotions and their marketing and forget that perceived value and real value are not necessarily the same?

Yes! They need to go shopping. That sounds very simplistic but they need to go shopping and they need to study. They are not going for the entertainment value; they're going to study how successful companies are continuing to market their products. It's not only about marketing, but it's also never getting complacent and doing the same thing over and over again. I hear photographers all the time say things like, "Well, if it isn't broke, I'm not fixing it." Photography is a profession that changes. I got married in 1975, and when I got married, the double ex-

Everything I've **ever learned** about photography, I've learned from fashion magazines.

posure was the rage. Well, if you do that technique today, would you be real popular in the photo industry? Of course not. I must say, however, that a lot of that double imagery, a lot of the digital stuff that we're seeing right now, is very similar to the double exposures of the 1970s.

What are the most important attributes of a Power Marketer? Is it a photographer's ability to separate themselves from the rest of the pack and do things so uniquely different that nobody could compare or compete with them?

I think that's basically it. It's the photographers who do not allow themselves to become complacent and continue to do things the same way, but who, every single week and every single day are always striving. These photographers ask, "What can I do that's different? Where can I go next?" And they're giving themselves lots of visual imagery to help them to grow. I go back to fashion magazines. Everything I've ever learned about photography,

I've learned from fashion magazines. There, things aren't always technically correct, but when it comes to being successful, you can't focus just on what is technically correct. Besides, brides do not know what a technically perfect photograph looks like—the only thing they understand is impact. Impact is absolutely everything. And so my Power Marketing stems from the standpoint that I never allow myself to become complacent and always, every single day, I'm pushing myself. I ask myself, "What can I do differently? How can I grow? Where are the trends at not only now, but where are they leading me?" This way, my photography can be on the cutting edge every single day, and I can continue to do new things and reinvent myself. You have to reinvent yourself. That is especially important when the economy is in a bad slump. Everybody and their brother has a camera now, so you must continue to reinvent yourself if you want to keep your uniqueness and be able to continue to be one of those people who are sought after—even in difficult times.

Do you think Power Marketers are born, or can they be self-taught?

I think there are some people who are born marketers, but I don't think that it's something you can't learn. I think you can learn it. You have to develop a plan and you have to continue to strive for that. You can't just try something one time and go, "Okay, it didn't work," and then go lay down and do the same thing you've always done. You have to have a particular plan. You have to lock yourself up in your office for two days and say, "This is really important." I know a lot of mediocre photographers who are outrageously good at marketing; they do a fantastic job of that and are very successful. And I know, on the other side of the coin, some of the world's top photographers who are starving to death because they do not know how to sell their products and they give themselves away.

What's most important to you in life, and how does your marketing come into play with those things?

Everything centers around my family. Photography is not my religion, it's only my profession. I want to be successful in my profession so that I can pursue the more important things in my life, which are religion, my family—things that have more lasting value. Photography is a real

nice thing, and I am very grateful that that's what I love to do, but it is not like it's the absolute Holy Grail. It's not what life's all about. That's probably one of the most difficult things—that balancing of one's spirituality with their career and then keeping balance with your family and your goals as a family.

It is a constant battle, but one of the rules of my household is always that we always have at least one meal together every day, and we have dinner together literally every day except for on the weekends. It's tough when you have a kid who's eighteen and wants to have their own life. But we try to make it a special point of having meals together every single day, and we don't allow business things to get in the way of the more important things in life. Another thing that I've done too is that I give myself permission to take time off. I think that's one of the problems with small business owners—we tend to work all the time.

I'm in my office every day at 6:00AM, but I make a point of taking a weekend off every month, even in the busy season. Even if I've got tons of weddings in the summertime, once I have three weekends booked, I take the fourth weekend off. That way I have a weekend off that I can spend with my family and have a normal life. So many times we tend to just work, work, work, work, work for six months, and then we crash and burn and our family doesn't see us for six months. Well, about two years ago the little light bulb finally went on in my head, and I said to myself, "You know what? You're not going to starve to death if you just do three weekends a month. Raise your rates a little bit and then do three weekends." It's worked out really well. So, now I have a weekend off next month. I'm going on vacation with my family at a normal time of the year, and so that's what we do.

What two things could you recommend to somebody either getting into the business or someone who's been doing it for a long time and wants to take their marketing to the next level?
Here's what I would do. Step one: I would buy all the top fashion magazines.

Step two: I would go through those magazines and I would pick out the ads that stand out. They can be really outrageously shocking, and that's a good thing too.

There's a wedding gown designer by the name of Reem Acra who for years had this wonderful ad of this bride wearing red—bright red—eye shadow. It was very shocking! Like any of our real brides in the entire world would probably wear red eye shadow. But the point was is that it

My hook is the fact that I have all of the elements that a **designer label** has.

was so outrageous that it was like, "Wow!" You had to stop and look at the ad. That's the whole point in advertising—to get people to stop and look at your stuff. Find out what the common denominator is between all the ads, and adapt that to what you're doing. Take notes and say, okay, what did they do to get me to notice this ad? What does it look like?

Step three: Create some photographs that have the same feel and are outrageously different from what you usually do.

And it doesn't matter what kind of photography you do, right?
Right. It can be portraits, weddings, any style. This is not about weddings. This is about portraiture in general. Today's high school seniors are so fashionable it's not even funny. Calvin Klein to me is top dog, number one—absolutely!—because they have found a way to make men's underwear so completely interesting that men will spend $18.00 for a stupid pair of underwear! $18.00 for a pair of underwear! Look at its box, look what comes in it.

What is your hook? What separates you from the rest of the pack?
I've become a designer label. That's what my hook is. I am a designer label in Northern California.

So, over the years you have branded yourself as a designer label?
Absolutely! I have branded myself. My hook is the fact that I have all of the elements that a designer label has.

What are those elements?

I start with a unique product, an interesting product. Not a perfect product by PPA standards, but a product that is very interesting. And that product changes every season. It changes weekly, monthly. It continues to adapt. The second thing that I've done is I charge a very healthy premium price for my product. If you look at Calvin Klein and Armani and Gucci—and people buy those stupid little purses with the ducks on them!—what separates those from the cheap products is the fact that they've found a way to make their products look unique and people feel secure buying that product because they are paying more for it. When a Tiffany's opened in our town, I thought, "A Tiffany's store? Why in the world would they have one here in our little town when there's all kinds of jewelry stores that sell for much less?" Well, it's because some people prefer to spend more money at certain occasions—like for a wedding. It's one time in their life that they're going to splurge and not go cheap.

If I'm going to be a designer label, I have to do my advertising like a **designer label** does.

When it comes to the wedding arena and pricing, logic does not reign as king. They're not buying a carton of eggs from us. They're buying a piece of artwork. They're buying something that's a very unique product that they can't get anywhere else. And when it comes to a wedding, I have found that the more expensive I've become, the more sought after I've become because it's like, "Well, I want the very best for my wedding. I should hire Bambi because she's very expensive, but she's also very good." You get what you pay for—which constantly comes to the floor on the wedding day.

With the designer label you've created, how do you go about communicating that to your customers?

If I'm going to be a designer label, I have to do my advertising like a designer label does. In other words, my ad in a magazine is going to be very striking. It's going to be captivating. I'm going to do images that are very unique

and very exciting. Not the typical picture of a bride standing at the altar. They're never going to see a typical advertisement featuring the normal picture that everybody has in their studios. You would never see that from me. I don't want them to believe that what I do is like everyone else's work, because that gives them a reason to go price shop.

Which marketing campaign or promotion has been the most successful and most productive for you?

I have a very specific type of approach to my wedding business and my portrait business where I do advertise, but it's very soft sell. I'm not one who's going to go out and do tons and tons of advertising. I'm not after large numbers, I'm after quality—the very elegant, high-end type of client. So what I basically do then is make sure that the promotional literature that is going to go out to a bride is very unique, that it's beautiful and that it's not like anything that they've ever seen.

Has anything failed miserably?

I can tell you exactly what failed miserably. It's when I tried to be the cheapest guy in town! I'm not kidding you. When I started as a photographer on my own about fifteen years ago, I decided that I would be the cheapest photographer in town, and I'd generate so much business that people couldn't stand it and they had to come in to see me, and they'd hire me. I'd be so busy that I'd beat everybody else to death, right? Well, I was the cheapest photographer in town, and I just about starved to death that first year because people kept thinking, well, if you're that cheap, then you really must be horrible.

When you're not working, what do you do for fun?

I really like taking pictures for myself.

Do you take your camera with you on vacation?

Yeah, I take my camera when I go on vacation. My favorite vacation though is spending time with my son, and I go scuba diving. But other than that, when I'm on vacation I like to lay and become a little beach potato and read. I want to read everything on the bestseller list. I want to do absolutely nothing. It's going to be a chore for me to get up and go walk on the beach!

9. The Sales Process

Mmm . . . Cheese!

If you like cheese as much as I do, then you've probably had the opportunity at some point to visit a factory where they make cheese. One of my favorite places is the Tillamook Cheese Factory in Tillamook, Oregon. You walk in and are immediately overcome by the immensity and grandness of the building. If you want, you can take a guided tour behind the scenes and hear about the entire process from beginning to end.

If you know anything about making cheese, you know it all starts with milk from a cow (and if you have ever been to Tillamook, there are cows everywhere). From there, exact ingredients, temperatures, and aging are combined to give each type of cheese its distinctive flavor and texture. There are conveyer belts, and cheese cutters, wrappers, boxers, stackers, and loaders, and quality-control personnel making sure that every single block of cheese meets rigorous standards.

At the end, big boxes are loaded onto a big truck and then carried away to the retail stores, where you and I can go in, buy the block of cheese, and take it home to enjoy! They definitely have their system down; every step along the way is controlled by a process—and at the end of that process, a marvelous block of cheese is produced that tastes exactly like the block of cheese you bought last week at the store. However, if any part of the system fails, the cheese doesn't make it to our bellies.

The Five-Step Process

Just like making a good block of cheese requires a specific process, you should have a well-planned system in place for selling your product. The sales process for photographers is broken down into five steps, meaning you have five different chances to build your relationship, and to build value in your products and services. Let's talk about them now.

Step 1: The Pre-Sell

The pre-sell is everything that you do before a prospective client makes contact with you. Your marketing, networking, the professionalism of your marketing arsenal, your advertising, word of mouth, the irresistibility of your offers, your relationships with people throughout your community—all of these things go into creating value for your work and your business. Together, they comprise the first step in creating an effective sales atmosphere.

We all make decisions about **what kind of value** something has for our life.

Earlier, I mentioned that people make judgments about you within the first five seconds after they are exposed to your voice, your signage, your business card, your physical appearance, your answering machine, etc. That five seconds will either help you build value or it will take it away. If you haven't already done so, I strongly suggest you spend some quiet time with the Five-Second Image Challenge on pages 58–62.

Perception is reality; we all make decisions in our subconscious minds about what kind of value something has for our life and how much we are willing to spend for that value. If you want to be viewed as someone worth spending a lot of money on, every aspect of your studio's brand must be top-notch.

Step 2: The Initial Contact

On the Phone. Our initial contact with a prospective client usually occurs on the phone—and I would venture to say that, for most of, taking phone calls is not our favorite thing to do. You didn't get into photography be-

A well-appointed and well-organized area for taking calls, like this work station in Christa Hoffarth's studio, will make any employee who works in the reception area feel like a real professional.

cause you liked talking on the phone, did you? However, this is the first real opportunity for you to sell yourself, educate the prospect about what they can expect from their experience with you, and begin to build a long-term relationship with them (the key to any successful business). Understanding that the telephone is one of the most important—if not *the* most important—selling tools you have will help you begin to look at it a little differently. After all, when a call comes into your studio, it means your marketing has done its job—and now it's time to begin the sales process.

The first rule to follow is that you always want to be smiling and happy when you answer that phone, even if you are having a bad day. People can sense positive energy and negative vibes through the telephone, so take a deep breath before answering the phone and show your best side. We all have bad days now and then, but you should never let that come across on the phone. As soon as the

phone is answered, it's game time! The goal is to get them excited about you, your photography, and the experience they will have with you

Questions About Pricing. It doesn't matter what country you live in, whether you are located at the far reaches of the earth or in located in downtown Metropolisville, we all get the same question during this first phone call: How much? Since you know that 99 percent of all prospects are going to ask that question, wouldn't it make sense to have some sort of script figured out ahead of time instead of trying to spontaneously come up with an answer?

In many cases, your answers may actually be questions—questions that help you better understand the prospect's needs. After all, people ask about price because they don't know what else to ask. What they really want to know, though, is whether you are the right photographer for them. Are you going to be able to meet their

needs? Allow them to enjoy themselves? That's what they really want to know . . . but the only question they can think of is, "How much?"

Imagine you walked into a friend's jewelry store and they said, "Hey, would you do me a favor and watch the store for a few minutes while I go to the bank to make a deposit? The phone hasn't rung all day, but if it does go ahead and answer it and do the best that you can." You agree, and he leaves you all alone with a million dollars worth of jewelry . . . and the phone.

All of a sudden the phone rings, so you answer it and a nice young man on the other end of the phone asks, "How much are your diamond rings?" What do you say? At this point you have no useful information for him, because you know nothing about diamonds—but can you think of some questions to ask him? How about:

1. What size diamond are you looking for?
2. Is it for a woman or a man?
3. What type of cut do you want?
4. What type of setting do you want? Gold? Platinum?
5. Do you need the ring by a certain date?
6. Would you like the ring delivered or would you prefer to pick it up?
7. Do you have a budget in mind for the ring?

That wasn't so hard, was it? In fact, there are probably many more questions you can think of off the top of your head. So why is it, then, that when someone asks us how much we charge for one of our products or services, we break out into a cold sweat and our stomach starts to churn? Why do we feel that we need to give them some sort of solid answer before we have any information? The biggest mistake many photographers make is that they try to sell every single product they have. As a result, they never really find out what the customer wants. God gave you *two* ears and *one* mouth for a very important reason: you should listen twice as much as you talk.

Price is usually part of the conversation, but rarely is it the deciding factor as to whether or not the client will come to you for their portraits. So, if price isn't going to be part of the deciding factor for them, then don't *you* make it the stumbling block. Your ability to discuss pricing confidently is directly related to your strength and be-

lief in yourself and your products. If you don't have faith that your product is worth every penny, you won't be able to sell it. (*Note:* A little later on we will dive into some meat-and-potatoes techniques for handling objections over the phone and in the sales room.)

If you don't have faith that your product is **worth every penny**, you won't be able to sell it.

Additional Tips. Here are some quick-hitting concepts that you should remember about the initial consultation—whether it is on the phone or in person.

1. Always speak with a clear and professional voice voice—show confidence in yourself, your prices, and your system. If you sound and act confident, that will rub off on your prospect and they in turn will have confidence in you as well.
2. When asked prices, don't give specifics, give ranges. Once you have qualified your prospect and know what it is exactly they are looking for, you want to say something like this:

 Mrs. Jones, someone in your situation can typically expect to invest between $300 and $1200 on their portraits. We have no minimum and you can spend whatever you would like. How does that sound?

 This lets them know that you really can work with just about any budget—but you have also planted the seeds for an order north of $1000. (You may need to adjust your range to fit your particular studio's numbers, but I think you get the point.) After you have said that, one of two things will happen. Either she will say, "Did you say *$300?*" and fall over dead, or she will say, "Oh, that's fine," and move on.
3. Planting the "seeds of money" with everything you say is also a big part of the emotionally driven sales process. Use key words and phrases like "wall por-

traits," "packages," "collections, "folios," "multi-pose packages," and "albums" to paint a beautiful picture in their mind about what fantastic work you can do for them.

4. Use qualifying questions to establish the needs, budget, and desires of the client. (Remember the diamond story on page 87?)

5. Accept the fact that not everybody is meant to be your customer. Once you have a solid idea about what a prospect is looking for, if you don't feel they fit into your game plan it's okay to send them down the road to another photographer. Not everyone can afford you, and not everyone has to be your customer. It's okay to just say no.

The Ping-Pong Exercise. Let's take some time right now to do what I call the Ping-Pong Exercise, which will give you a firm grasp on how to handle initial contacts with clients on the phone. Phone conversations are usually just like a tennis match or a ping-pong game, with several volleys back and forth. This exercise is intended to begin for you the process of creating powerful scripts that can be used anytime, anywhere.

Phone conversations are usually just like a **tennis match** or a ping-pong game . . .

I'm going to give you some examples of statements that prospects all over the world seem to ask photographers on the phone, and I want you to write down how you would respond to each one. This will be the beginning of your phone script. I highly recommend you come back to this exercise later today and give it some more thought—but for right now, go ahead and jot down some short answers. Ready?

1. How much are your 8x10s?
2. How much will family portraits cost me?
3. Can you mail me some information?
4. I will think about it and call you back
5. The guy down the street is a lot less than you are!

6. Wow! Your prices are the most expensive I have found yet!

You may have encountered some questions—or stalls—other than the ones I have mentioned here, so take a minute right now to write those down. Then note how you would respond.

Now we are going to switch gears. I want you to make a list of questions that *you* will ask. Here are some ideas to get you started:

1. How did happen to hear about us?
2. When was the last time you had your family professionally photographed?
3. Do you have a budget for your portraits?
4. Do you have a deadline when you will need these portraits completed?
5. How many people are in your family? What are their names?
6. Do you have any pets you would like to have included in your portraits? What are their names?
7. Do you have a special location where you would like to have your portraits created?
8. Besides the wall portrait for you, have you considered gift portraits for the rest of your family and close friends?
9. How large of a wall portrait are you thinking of for this occasion?
10. What style of photography do you enjoy the most? Traditional? Black & white? Casual?

I hope this exercise got your creative mojo working and started you thinking about how you deal with prospects on the phone. Thinking along these lines will help you access information about what the customer is looking for and will get them talking about themselves and their family—which keeps things on an emotional level. The more you can get them to talk about their family, or their wedding, or their child, the more emotionally attracted they will become to your studio and to you as their photographer. Again, we are in the business of selling emotion. If you can do that, the sales will follow.

Step 3: The Session

Once a prospect has committed to coming into your studio for a session, they no longer are a prospect— they have now earned the stripes of a customer. Hooray! Therefore, the next steps in the sales process are the walk-around and the actual session. Now the customer is actually in your studio, the sales game really gets to be fun and exciting!

First Impressions. When a customer first steps into your showroom or your gallery, their senses are firing on all cylinders. Their eyes are observing every little detail around the room—your wall portraits, frames, furniture, lighting, carpet, paint colors, curtains, and on and on. Their ears hear every sound that is being made—the music, the sound of traffic on the road, people talking in the background, a small water feature you may have in the corner. Their nose can smell every fragrance—and not all fragrances are considered good. The taste buds in their mouth can even taste the air. All of these senses lead into their heart, and how they *feel* about you and your business.

Be the Best Version of Yourself. It goes without saying that you *must* make sure that everything your customers comes in contact with is the best it can be. However, you also need to be true to yourself and stick to who you are. If you are not the highfalutin, baby-grand-piano, vaulted-ceiling, four-car-garage, hang-out-at-the-country-club type of photographer, then don't pretend you are. Me, I'm more of a barbecue-on-the-back-deck, guitar-in-the-corner, hang-out-at-the-beach, playing-with-my-kids type of guy. That's not to say that I don't enjoy the finer things in life, I definitely do, but we all need to stick to our core values and beliefs—and who we are is expressed in the way we make people feel when they walk through our doors. Just be true to yourself and you will find that like-minded people will flock to you.

Greeting Your Client. The first thing that should happen when clients arrive is a warm welcome to make them feel at home. Take their coats, then offer them something to drink. This is an easy place to go the extra mile and provide an experience they can't get anywhere else. Consider offering soft drinks that come in old-fashioned looking bottles or bottled water with your logo on it. Many people will gladly indulge in cup of gourmet coffee—and even if you are not a coffee drinker, there is no better smell than fresh coffee brewing coffee. (*Note:* To get the most bang for your buck scent- and taste-wise, invest in a little grinder; don't buy the coffee that comes straight from the can.) You might even offer a selection of locally made wines—consider listing them on high-quality paper in a nice leather folio, like the wine list you would get at a fine restaurant. These ideas will definitely create a great impression—but don't limit yourself. Think out of the box and bring some new and different ideas to the table. What other kinds of things can you do to provide a six-star experience to your customers?

Be true to yourself and you will find that **like-minded** people will flock to you.

The Walk-Around. Once your customer is comfortable, they will automatically do what I call the walk-around, meaning that they will gravitate towards the imagery you have around the room. They will look intently at wall portraits, browse through albums, sit in your chairs, and basically absorb everything that you have to offer.

Let them know that if they have any questions at all, you will be more than happy to assist them. You want them to feel like they are in their own home. This will relax their bodies and their minds, which will help you throughout the remainder of the selling process.

The Planning Session. Next, it's time for the sit-down—or what I like to call the "Planting The Seeds of Money" chat. Basically, this is a planning session. If your customer has specific ideas about poses, clothing, style, mood, etc., this is their opportunity to tell about their vision. It's also a chance for you to get to know them a little better. Many times, the conversation may end up being about where they went on their family vacation, or how their team did over the weekend, or what the kids did last summer. Wherever it leads, just be willing to go with the flow—it's part of the relationship building that will make a huge difference in the long run.

The planning session is also an opportunity for you to continue to "plant money seeds" by talking about the

People are more inclined to buy things they can see and touch. So if you want to sell albums, make sure you have a selection of them displayed attractively. Photograph by Christa Hoffarth.

things they can see around the room. Anything that you want to sell should be on display in your showroom—and nothing smaller than a 16x20-inch print should be visible. If they want to see what one of those big ol' 8x10s looks like, you can direct them to an album. People are more inclined to purchase items that they can see and touch than products that they are only told about. So make sure you display the products and sizes that you want to sell. Wall collections, digital composites, wall folios, family lifestyle albums—whatever products generate good profits for you and give them a memory they can cherish.

This is a great time to begin fishing for what types of products your customer might be thinking about— allowing you to add some water to the money-seeds that have been planted. To take this metaphor a little farther, it's almost as if you are a gardener—fertilizing the ground, planting seeds, watering those seeds, making sure there aren't any weeds growing anywhere. Ultimately, it means that *you* are maintaining control of the entire process, even though your customer really doesn't notice anything.

Obviously, nothing has to be decided at this point in the process, but you want to at least get them thinking about all the different options that are available to them. If they want to talk about budget, that's okay—just make sure that you maintain that high level of excitement during this step. Talk about what you plan to do during the session, what combinations you would like try, and what look you feel would be great in black & white, and how great their clothing choices are—get them ecstatic about what is going to happen—and of course, let them know that the session won't really hurt too much; the bruises should heal in a couple of weeks!

The Session. During the session, there are even more opportunities to plant some seeds. Whether you are photographing a family, a senior, a child, or an engagement session you can easily keep the buying engine revved up by making a couple of simple statements during the session:

> Mrs. Jones, this is absolutely stunning, I can't wait to see this image big on the wall!

> Mrs. Jones, this image is so wonderful that I may even consider using it as one of the large prints in my gallery.

These simple statements yield powerful results. Of course, they aren't going to come out and immediately say, "Yes, I agree, let's just go ahead and order up one of your 30x40 canvas prints," but it *will* get them thinking big.

You can even take it as far as this, "Mrs. Jones, come here. I want you to see this! Then have her look through the viewfinder on your camera. This may sound a little unnerving to you, but when Mrs. Jones looks through that viewfinder, she is seeing the results of all your experience, your understanding of lighting control, and posing, and composition, and background, and mood, and color harmony. This is not some simple snapshot that Uncle Bob

took in the backyard, this is a very special image that you have created just for them. I absolutely guarantee you *will* get tears. You will get a few, "Oh my word, my little baby is growing up." And you also will get a couple, "That is the most beautiful thing I have ever seen." Emotion, emotion, emotion.

The Wrap-Up. The session is now done and everybody gathers all their stuff. Then it's time for the wrap-up. At this point, it's advisable that you sit back down at the table so you can have a short chat about how the session went and how they are feeling. If you are doing your job correctly, they should be so excited that they are nearly jumping out of their skins.

Make sure that **every image** you do show is pleasing to the eye and sellable.

Now, set a time for them to come back to view the images and place their order—plus give them whatever paperwork you want to send home with them. Be sure to include a price list, along with a worksheet they can fill out that lists all of the possible gift recipients on one side (Mom, Dad, brother, sister, Grandma, Grandpa, aunts and uncles, boyfriends, girlfriends, teachers, special family friends, etc.) and print sizes on the other. This will give them the opportunity to do a little bit of homework before they come back for their ordering session.

Scheduling the Viewing Session. Here's a good rule of thumb: if their session was 3:00PM on a Tuesday, then more than likely 3:00PM next Tuesday will work as well. Never set an appointment for later the same day or even the next day. Let the emotions they are feeling play around for a little bit. Anything good is worth waiting for! On the other hand, if you wait too long, the emotion will start to dissipate. I don't let it drag out much beyond one week.

During the next several days you will have time to edit, do some black & white conversions, tweak out a couple of images if that's what you want to do, and prepare the images for viewing. I suggest you at least do what is called "pretouching" on each image—removing any ob-

vious eyesore or embarrassing blemish. You don't have to completely retouch each image, but at least make sure that every image you do show is pleasing to the eye and sellable.

Step 4: The Sales and Ordering Session
Designing the Sales Area. There are some basic "must have" elements that go into a productive sales area. Again, it doesn't have to be big and expensive. There are solutions to every problem, and if you want it bad enough, you will find a way to make it work.

1. **The feeling of home.** The sales area must be tranquil, relaxing, and comfortable.
2. **All the trappings.** Provide beverages, candles, soft lighting, and homemade cookies or other snacks.
3. **Visual enticements.** Showcase properly lit prints, storyboards, wall folios, wall portraits, etc. Everything you want to sell (or, more importantly, everything you want your customers to buy) must be in clear sight. I call it the 45 degree "Cone of Money." Your customers should be able to sit in the comfortable chair and see everything you have within 45 degrees of where they sit.

When the Customer Arrives. Whether you call it a sales session, an ordering session, the premiere, the unveiling, or the preview, when your customer arrives, they should be welcomed with the same vigor and enthusiasm that you met them with the first time. Let them spend a couple of minutes relaxing and taking their minds off of their job, or their kids, or the traffic, or anything else that causes them stress in their lives. Your studio should be a safe place for

Prepare to Sell a Wall Portrait

One of the last things you can do is grab a tape measure, either your own or even an inexpensive giveaway, and go up to a blank spot on the wall—preferably right next to a very large wall portrait. Then, say, "Mrs. Jones, do me a favor. When you get home, I want you to measure the spots on the walls where a potential portrait might hang."

As you say those words, pull the tape out as if you were actually measuring the space on your wall. Even if you are a small person, you will be able to pull out at least 20 inches of tape for them to see. It's just another tiny little seed, but it will return very lucrative results. You will never have a person come back and say, "I measured the spot on my wall and I need one of those big 8x10s."

If you want to sell wall portraits, you have to show wall portraits. Photograph by Sarah Petty.

them to relax their mind and body for just a little while. Offer to take their coats, get them a refreshment, and invite them to take a seat in your sales room—which should have soft music playing and the lights dimmed. Usually, the excitement is so thick you can taste it in the air. ("Mrs. Jones I can't wait for you to see your images—they turned out fantastic!")

The Importance of Digital Projection. Even if you are a film shooter, you should still be using digital projection for your sales. For those of you that are still stuck back in the 20th century and are using proofs, I am going to convince you in the next few paragraphs to stop using proofs immediately and convert to a digital projection sys-

tem. Here are the top reasons why you want to sell via projection.

1. **You get quicker cash flow.** When your customer places their order, you get usually half (if not all) of the order amount paid up front. With proofs, you may have to wait several weeks, or months before you get your final order *and* any money. I talk to people all the time who have customers who *never* come back and order from their proofs.

2. **You will get larger orders—guaranteed.** You will at least double, if not triple. your order averages by projecting your images. You will sell more wall portraits, sell more multi-pose packages, and allow your customers to have more fun during the process as well.

3. **Other people's opinions are kept out of the sale.** When your proofs go home with a customer, you are leaving yourself open to every Tom, Dick, and Harry who looks at them to throw in their two cents. Then your customer begins to think about things—and you don't want them *thinking*, you want them *feeling*. The only opinions that matter are yours and your customer's.

4. **You'll reduce copyright infringement.** You won't have to worry about your customers making illegal copies with their $99 scanner. If you send proofs home with customers, you may as well start including a scanner as well—you know that's what they're doing, don't you? By projecting, your customer will only get what they order.

5. **You can address any problems immediately.** Any problem your customer may find with an image can be overcome immediately during their sales and ordering session. If, on the other hand, they take a set of proofs home with them, those objections will fester and grow to the point where they don't like the image . . . which means they won't like a certain series of poses . . . then that will lead to them not liking *any* of the images. Sale over. At a projection session, if Mrs. Jones says to you, "I don't like the blemish on my son's forehead, and I don't care for my wrinkles. They make me look old." You can say, "Well, Mrs. Jones, that's the great thing about com-

ing to a professional photographer. Before we make any prints at all, we make sure that each image is absolutely to your liking. We will make sure the colors are vibrant, we will remove any blemishes, we can even soften some of those character lines that we all seem to get as we get a little older. Basically, before we print anything, each image will be perfect." With those few words, the objection is handled effectively.

6. **Only your best work is in the marketplace.** The only prints that are made are ones that they enjoy and want to order, which means all of the ones they didn't want (I call those the rejects) will never see the light of day. Let's say you send a set of thirty proofs home with a customer. Realistically, how many of those will they order? Five? Six? Seven? Which means that twenty-three will be rejects. Do you really want to have your customers' rejects out in the marketplace representing your work? I sure hope not!

7. **You won't have to chase proofs anymore.** No more calling after twenty-one days and saying, "Mrs. Jones, it's been three weeks and you need to come in to place your order, or I'm going to have to charge you for the proofs." Do you think they care? They have already made copies of the ones they like! Having to make a call like certainly doesn't help the emotional sales process, either—in fact, it puts a big kibosh on it.

8. **Customers absolutely love it.** It's their family, and you make them feel like gold. You give them a wonderful experience. How could they not love it?

9. **Your images have more impact.** This is the biggest reason that you should project your images: a piece of paper can not evoke the kind of emotion that all of your hard work deserves and demands.

Now, some folks are still out there thinking, "Well that all sounds good, but . . ." I hear all kinds of excuses around the world why photographer feel they can't use digital projection. Here are some of the leaders (and some notes on why they really aren't good excuses at all).

1. **I don't like to sell.** Well then, then find someone who can or learn how to do it yourself. There are tons of resources out there for you. In fact, you are reading one right now! It's okay if you don't like to sell in the traditional sense, but don't let that keep you from the lifestyle and income you deserve.

2. **I use my proofs as advertising.** You sure do! And we already know that twenty-three out of thirty proofs are rejects. Why would you want your rejects to do your advertising?

3. **I sell my proofs.** Yeah right. And how much do you get if you sell them? Is it enough? Do you think you would have larger order averages if you got rid of your paper proofing?

4. **I don't have the space.** Okay, that's a legitimate concern, but you don't need to have a giant ballroom in order to make an effective sales room. Something as small as a 10x12-foot room will work out just fine. Don't let space stop you from making the switch.

5. **I don't have the time.** Let me ask you: if you could invest only one more hour with each customer and potentially double, triple, or quadruple your averages, would you be able to *find* the time? I think so.

6. **I'm a wimp.** The biggest reason I hear: I'm just a big baby and I don't really have any excuse! When even you yourself realize there's no excuse, it's definitely time to get moving and make the change.

Now, let's get back to the sales and ordering session. Your customer is relaxed, comfortable, and ready to view the images from their sessions.

Do you want your customers' rejects **out in the marketplace** representing your work?

The Slide Show. First step is the multi-media slide show that you have produced. There are many great software options out there that do a bang-up job of making your slide show look hip, happening, and cutting edge. (Personally, I recommend ProSelect—check it out at www.timexposure.com.) Most of these programs also

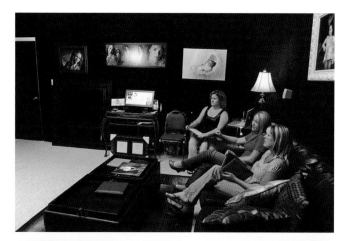

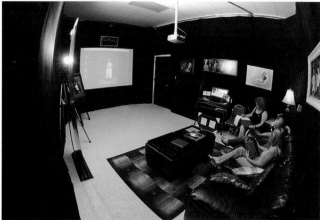

Presenting your images in a digital slide show, rather than sending clients home with paper proofs, has some big advantages for photographers. Here, we see customers relaxing in the projection room at Chatsworth Portrait Studio.

allow you to attach an audio file and then sync your images to the music so they will end at the same time. Royalty free music is available all over these days, so check out what is out there and select some music that captures your style—and their emotion! Make sure that the style of your show reflects the taste and personality of the customer you are with at the time, as well as the type of session. You don't want to use an upbeat rock song with twangy guitars and heavy drums if you are showing heartwarming images of a newborn baby.

The Selection Process. As the slide show is progressing, make note of the comments that are being made about certain images. You can bring these up later on. Right now, though, let them bask in their glory of seeing their family or themselves up on the big screen. For many people, this will be a once-in-a-lifetime experience—and you need to keep that in mind as you go.

Once the show is over, you will get comments like, "How am I supposed to choose?" or "I want them all!" That's exactly the way you want them to feel.

Explain to the client that the next step is going through all of the images one at time. For each, have them tell you one of three things: I like it, I don't like it, or I'm not sure yet. Don't worry about doing the side by side comparisons yet—you can get to that later. Just have them judge each image by itself. Then, one at a time, go through each image and let your customer tell you what they think. If they are not sure, it becomes a maybe—that simple.

We all have different philosophies on how many images we shoot and how many we should present to our customers, but I will tell you this: there is a point—a certain number of presented images—beyond which all you are doing is spending more time in the selection process. When you pass this point and the selection process becomes cumbersome, the emotional balloon begins to lose some of its air.

Let's say, for this example, that you started with forty images, which is about right for a family, senior, engagement session, child or baby session. Then let's say that after the first time through, you narrowed it down to twenty-three, meaning they eliminated seventeen. That's a good start.

Now, go through the same process again. This time, the client will be more familiar with the images and have a pretty good idea of what the entire session was like. If they are still not sure about a shot, don't worry about it—they don't have to decide right now.

Introduce Additional Products. At the completion of the second round, let's say you are down to seventeen. At this point, Mrs. Jones is going to be thinking, or saying, "Oh my goodness, how am I ever going to choose?" This is the perfect opportunity to bring in some additional products that they may not have been thinking about initially. That's why they invented albums, folios, and wall collections. We all have products that will accommodate multiple images, and this is when you bring them out. You Might say something like:

> Mrs. Jones, we have some options here.
> First, if you can find one image that you
> can live without, we can get you into a

sixteen-way folio. If you can find seven that you can do without, you can get a ten-print album. Or if you can eliminate nine—over half—we can get you down to an eight-way folio. Okay?

At this point, you may need to let them discuss amongst themselves what they want to do, which is fine. Remember, they are now emotionally attached to these images and it will be very difficult to let them go— even if it means stretching their budget a bit. Let them talk, let them feel

Break away from your traditional thinking and **create something unique for your studio . . .**

On at least 75 percent of your sessions, you will be able to sell some type of product that allows your customer to keep a multitude of images in a single product. You will have to look at your product line and decide what those items are. If you don't have any, you will need to create some.

A great place to start is with what we call the Lifestyles Album. We developed this product several years ago as a way for people to be able to keep a large number of their images without having to get individual prints of each one. It's basically just either a 4x5, or a 5x7 album with either ten, twenty, or thirty prints inside. Regardless of what type of session you photographed, you can create a beautiful, one-of-a-kind album that captures the personality of your customer.

Something else that has become quite popular is a Wall Collection, which can accommodate eight to twelve images. There are also digital composites that can be created in Photoshop with a couple of easy strokes. The sky is the limit here, so break away from your traditional thinking and create something unique for your studio that no one else has.

Final Selections. Once they have decided that part of the sale, it's time to move on and select the images for their package. You can use the same process, but now there are fewer images, so you can switch it up just a little bit. For example:

> Now Mrs. Jones, I know you like all of the remaining images, but what we need to do is decide which ones will only be included in your [name product] and which ones we will be doing something else with—images for gift portraits, wall portraits, gift wallets, small folios, etc. Okay?

Suggestive Selling. It may take a couple of times to get down to their final selections, and you may even need to do some suggestive selling here. For example:

> Mrs. Jones, if I can recommend something to you, I would suggest using the portrait of the family down by the river as your large wall portrait for the living room. Then, use the black & white of the family in front of the trellis as a smaller wall portrait in the dining room or hallway. How does that sound?

You are the professional and you have earned the right to suggest things to your customers. When you go to the doctor and he makes a suggestion about how to recover from your sprained ankle or tells you what to do to lower your cholesterol, do you listen? You bet you do. Your customers will listen to you as well, just give yourself the chance!

Finally, Select the Wall Portrait. Once the customer has selected the images for their package, their wallets, and other specialty products, the last thing they select is their wall portrait. That way, the process begins with little de-

Should I Do À La Carte Pricing, or Should I Do Packages?

In my mind, the best strategy is to have your à la carte prices listed in order to establish a baseline value for your products. The meat of your sales, though, should come from the sale of packages, bundles, or collections—whatever you want to call them. You can use the techniques we talk about in chapter 14 to help build some packages that not only give your clients a compelling reason to invest at a higher level, but also will give *you* substantial profits. That way, both you and the client go home happy!

cisions and then ends with biggest and most important decision.

This is completely the opposite of how most photographers have done their sales in the past. However, having the customer select the wall portrait *first* effectively kills any chance of them ordering large packages, or albums—or anything else for that matter. They are asked to sprint to the finish line and make the biggest decision first, which leaves lots of emotion (and dollars) scattered along the way. You will be fighting an uphill battle for the rest of the session. Additionally, the wall portrait should be your customer's favorite image from the session, and that takes some time for them to decide.

People won't remember what you did or said, they **will remember** how you made them feel.

At this stage, the order is complete. Your customer has selected the images and products they wanted, they have known the prices throughout the entire process, and they are completely and totally immersed in your sales system without even knowing it—or feeling it! They have also made all their own decisions along the way . . . with a little help from you, of course!

Step 5: The Follow-Up

The last step in the sales process is the follow up, which I believe is one of the most important parts. Keep in mind that this is one stage of the process where little things really mean a lot. Writing a thank-you note within twenty-four hours after each client's session is always nice, as is making a quick phone call two to three days after their finished order is picked up. You could even consider sending out complimentary gift certificates for them to give out to their friends and family—or even a thank-you gift like a gift certificate to the local coffee house for some free cappuccinos.

Are your competitors doing this? Do you want to swim in a red ocean with every other photographer in your market, all fighting over the same customers with the same techniques, the same products, the same service . . . or do you want to create a blue ocean where you are the only swimmer in the sea?

In the end, people won't remember what you did or what you said, they will remember how you made them *feel*. Passion is the fulcrum point of all sales. If you show passion during your relationship with your customers, that emotion will transfer to them, and will create a desire in their hearts to *buy*. Passion is an emotional feeling that is like the mumps—it's very contagious!

A piece from Chatsworth Portrait Studio strikes the right emotional note in promoting their fall family portraits.

Mitche: What is the biggest challenge facing the industry and your business in the coming years?

Tim: I think it is the same challenges that faced us for years, its separating yourself from the crowd, defining yourself—especially right now. We have all this diversity with technology, with equipment, and we've got people entering this profession in numbers unseen before. So I think the real challenge is defining yourself as unique, so that in the midst of all the voices, all the faces, all the photographs in the crowd, you can stand out. That's easy to say, but in the execution it is very challenging. And while defining yourself you are maintaining excellence amidst all the novelty. Technology has provided so many avenues that a range of people are getting into this. If we are not careful, we also forget to maintain the excellence.

Bev: With so many young people jumping into the industry without a lot of background, I think excellence will be the key. Excellence and actually understanding lighting, and quality photography, and all the different things that we have studied for decades, is going to be the difference between making it or not.

In a nutshell, what is your marketing philosophy?

Tim: To sell the results of your art, not your art itself. I think that there is a lesson to be learned from that sentence. Too many photographers sell 8x10s, they sell texture sprays, they sell mounting. Really successful people, in my opinion, sell the way the art makes you feel. They sell the results of the art. They build the relationship. People want to buy the experience, they want to buy feeling, they want to buy a celebration. That, to me, in a nutshell, is what we are selling. Brand yourself tighter than you ever have before.

Bev: When you think of that brand or who you are, it isn't something to be taken lightly. You are going to be doing it for a long time. Most importantly for us, it is selling the relationship. When you are branding it isn't an overnight thing, it is something that takes time and years of your message going out.

What is the most important attribute for becoming a Power Marketer for photographers?

Tim: The first thing that comes to my mind is having a clearly defined vision. I think photographers are their own

I met Tim and Bev several years ago at a PPA convention and can remember how impressed I was with their attitude toward life: family first, then business. They have figured out over the years how to blend their individual talents and skills into one successful partnership, and their forward-thinking approach to business has carved out a niche that is an example to the entire industry. Their work is truly inspirational and, as you will be able to tell from this interview, they love living. For information on Tim and Bev, log onto www.waldensphotography.com.

worst enemies. We are so taken by all the things that are around us—but there are some wonderful things that other people do that I don't do. When I look at it, I admire it, but I don't always go home and do it. That sounds like an odd statement, but you clearly need to define your own vision so that everything lines up with your own style of photography—your thoughts, your logo, your paper color—and then you have to stick with it. Unless you clearly define yourself you are going to find yourself with whatever the wind blows tomorrow, and people out there are going to say, "Cool paper, but I have never heard of this person before." The most powerful tools are not cool, clever little things. They are principles that we have known for years but rarely do. Not giving up and being patient are also important.

How does your marketing come into play with all the priorities that you have set for your life?

Deb: The most important thing to us is our family above everything. It is so easy to push that aside when you are building a business, but you have to make yourself realize

that you have your children for only a certain amount of time. The importance of our family also ties into our love for photography—we are helping others to celebrate those relationships that we have enjoyed with our children. I don't really think we became great photographers until we had our children.

How many children do you have? Are they part of the business at all?

Bev: We have two daughters. They are pretty grown, but they still need Mommy and Daddy. We are training our oldest in the business right now. I have been teaching her Photoshop. She wants to work behind the scenes.

If you could recommend two things to someone who is just beginning, what would they be?

Tim: These are simple to say, but difficult to execute. First, define yourself in the marketplace. Find your niche. Brand yourself. And do one thing extremely well. While maintaining your excellence, that will define your marketing. If

We create emotion in our portraits, so **we started** promoting it in our marketing.

you create the desire, then your marketing can fulfill that desire in the people giving you the opportunity. Second, develop your hook. Anytime that you can add emotion to your imagery, then you sell the results of your art, not the art itself. When images speaks for the relationship between a father and son, a mother and daughter, or a husband and wife, it can be taken into your marketing to start selling that relationship, not that piece of paper.

What has been your most successful marketing philosophy or campaign?

Bev: It was when we learned the value of emotion and started treating that in our marketing. We create emotion in our portraits, so we started promoting it in our marketing pieces, running ads with faces and the slogan "Behind Every Face is a Story." Everything changed with that slogan, and we matched everything to it—business cards,

banners, letterhead, website, etc. We are also running a campaign right now called "Few Things in Life are Black and White."

When you are away from the studio, what do you guys do for fun?

Tim: Together or individually? We enjoy watching movies. We love going to Starbucks and hang out and talk. We met our daughter the other day and just talked for a couple of hours about nothing. And we enjoy spending time with friends—friends are very special gifts. We hang out with our friends as much as we can.

Bev: I like when the house is quiet and I work on projects on the computer. I love designing on the computer. I also do Girls Night out with my girlfriends and spend quality time with them. And I love spending time with my daughter. It isn't just a mother-daughter relationship; she's in her late twenties and it is a best friend relationship now.

Who is your biggest inspiration in business or life in general?

Bev: Early on, it was David Peters. I was in love with his work and we followed his work for a long while. Now, there is a mixture. Tim is actually my main inspiration, because he keeps me laughing. We were put together for a reason.

Tim: Photographically, my father, who I lost a few years ago. Arnold Newman, who recently passed away, has always inspired me. Of today's image makers, I respect Mike Taylor—I like his work. David Peters, too, mostly because of the emotional base. Beverly, as well—she keeps me emotionally based. We are a great fit.

Biggest experience?

Tim: In our personal lives, our children. Photographically, I remember the first time watching my father make a print in the dark room. It was like watching David Copperfield. It was like magic. I remember it like it was yesterday—I remember the smells and the chemicals.

Bev: The miracle of life—our children. Photographically, our trip to Italy. We were finally taking photographs for ourselves and not someone else. We played with photography and got re-inspired—out of our rut. It was a magical trip to me.

10. Other Factors in Making the Sale

Features and Benefits

Remember back when you were a kid riding around all summer on your bike without a care in the world? Nothing bothered you and life was good. You probably even had a family-run pizza joint down at the corner like I did. I can remember on Friday nights how my entire family would all meet down there at dinner time to enjoy a big slab of pizza and some sodas.

My favorite part was when my mom gave me quarters so I could play the pinball machines in between slices. If I ran out, she always seemed to have more. Moms are always good for change, you know. There was an endless supply of quarters coming from the bottom of my mom's purse—at least it seemed that way.

Looking back, and looking back as a marketer, I can see that it wasn't necessarily the pizza that got my attention—it was the pinball. That was something that benefited me directly, and I thoroughly enjoyed my time on the flippers. The feature, so to speak, was the pizza; the benefit was the pinball.

Now that I'm a big kid, I don't get to ride around on my bike all summer—and I sure don't get to play pinball very often—but I understand the value of features and benefits and how they play an integral role in the sales process. All products have features and benefits, but it's the *benefits* that motivate people to take action, or to buy.

Think about it. Why did you purchase your last car? It probably had all sorts of cool features and modern ameni-

Beautifully designed greeting cards are a great way for you to keep in touch with your clients. These are from Sarah Petty.

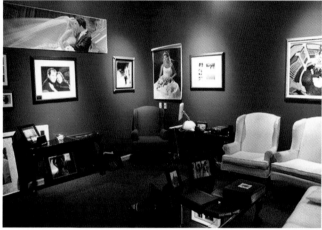

Scenes from Michael Redford's studio show how a welcoming area can be designed to showcase a variety of portrait products.

ties, but when it came down to it, the *benefits* of those features is what got you nailed down. It had antilock breaks, which would keep you and the kids safe on those rainy nights. It had a DVD player in the back, which made it convenient to travel with young children on long trips. It had an extra large cargo space, which meant that everybody in the family could put their suitcase in. It had a surround-sound speaker system, which meant everyone could enjoy the music. It had a moon roof, so you could stare into the sky on those warm summer nights. It had a six-cylinder engine, which was strong enough to tow a boat but small enough to give you respectable gas mileage. You didn't buy the DVD player, or the moon roof, or the six-cylinder engine or the speaker system, you bought the benefits and the value that those particular things brought to your life.

Let's take this a bit further. What about the features and benefits of a ball point pen?

Feature: It has a clicker on the end that retracts the tip.
Benefit: You won't accidentally get ink all over your shirt.

Feature: It has black ink.
Benefit: You can sign all of your legal documents with it.

Feature: It has a metal clip on the side so you can put it in your shirt
Benefit: It won't fall out when you bend over.

How about a coffee cup?

Feature: It has a handle on the side.
Benefit: If you are drinking something hot, you won't burn your hands.

Feature: It holds 8 oz. of fluid.
Benefit: The contents won't get cold before you can drink it all.

Feature: It's white.
Benefit: It will go with just about any color you may have on your table.

How about an 8x10 print? Now you have to work a little bit . . .

Feature: It's an 8x10.
Benefit: *(1)* You can purchase frames for it just about anywhere. *(2)* It will fit nicely on a desk or bookshelf. *(3)* It's suitable for viewing at close distances.

Feature: It's printed on archival paper.
Benefit: The print will last for generations to come.

Feature: It comes laminated.
Benefit: It will hold up to fingerprints, dust, and other potential damage.

Feature: It is UV protected.

Benefit: The print won't fade over time when exposed to a limited amount of sun.

As you may have guessed from all this, we're in the business of selling benefits and need to structure our sales techniques toward that goal. Look at the following examples. The bad ones emphasize the feature (the product itself), the good ones focus on the benefit (the advantage of buying the product).

Bad: What type of life insurance do you have?

Good: If your husband were to die today, how would the house payments be made?

Bad: Do you have a cell phone?

Good: If your most important customer called right now, how would you get the message?

Bad: Who do you currently use for long distance?

Good: If your long distance charges were 50 percent higher than they should be, how would you know?

All of these questions make the buyer respond in terms of his own interests and how the benefits of those products can enhance the value of their experience with the product.

Get the picture? Next time you go into your studio, make a list of each item you have, then list the features and benefits of each. After you have them on paper, practice reciting them in conversation so that the words come out naturally. This is the language of a successful salesperson—and all you need is a little practice, practice, practice!

Eliminating Risk

Eliminating risk is another important factor in determining your customers' desire to purchase. If you can eliminate the risk in their eyes, they are much more likely to buy big. How much simpler can selling get, you ask? In order to harness the power of this strategy, ask yourself these questions:

1. In the eyes of my customer, what risks are they taking when they make a purchasing decision? *(The risk of overpaying? The financial risk of going over their intended budget? The feeling they don't really need the product? The fear they will regret it down the road?)*
2. How can I remove that risk during the sales presentation?

A risk is usually just a mental barrier that causes people to hesitate. As a professional salesperson, your number-one job is to identify the risks, then eliminate them as you go along—so you need to be an expert at risk removal! Nobody likes taking risks, but everybody wants the reward that risks brings with it. If the risk is the price, then the reward is the value. One at a time, brick by brick, remove the risks that the buyer perceives as stopping them from doing business with you. Then drive home the rewards, both logically and emotionally.

Overcoming Objections and Closing

If you hear things like, "Let me think about it and I'll get back to you later," "Let me talk it over with my husband and I'll call you tomorrow," or "I can get the same thing cheaper at the studio down the street," you are losing many potential customer each month—but needlessly so.

There are time-tested responses that can easily turn objections into **more bookings**.

If fact, a good salesperson welcomes those types of objections, because they see them as opportunities to build value in their product. And, as luck would have it, there are time-tested responses that can easily turn objections into more bookings and bigger orders.

An Ounce of Prevention. When dealing with objections, prevention is *always* the best medicine. Most ob-

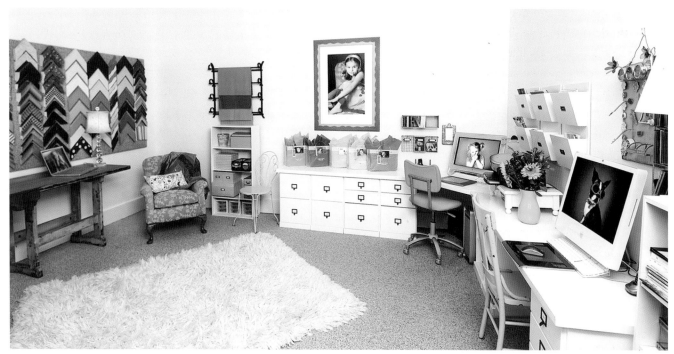

Everything about Sarah Petty's production room reflects the fact that she believes in her product—a critical factor in being able to sell it effectively.

jections can be overcome simply by addressing them as you go instead of waiting until the prospect brings it up. To do that, you have to get real about your place in the market: your studio—*every* studio—has perceived weaknesses. You're too big, too small, too new, too far away, too expensive, etc. The tendency for us is to hide our weaknesses so that nobody can see them, but a better strategy is to minimize any weakness by turning it into a benefit—to turn your perceived weaknesses into the exact reason whey they *should* do business with you.

For example, if your studio is on the other end of town, people might perceive this as a disadvantage—unless you directly address and eliminate this potential concern in your presentation:

> Mrs. Jones, although we may be farther away than other studios you may be considering, you will find our service very attentive—just like we were right next door!

Or, if your prospects always are saying they can get their portraits for less somewhere else, don't wait to hear it from them—beat them to the punch by justifying your higher prices during your presentation. Tell them why you

are more expensive on your wedding coverage, or why your wall portraits cost more.

> Mrs. Jones, if you shop around long enough, you can always find someone who can meet your needs for a few dollars less. We don't claim to be the least expensive or the most expensive. But our customers have found that when choosing us as their photographer, they get a greater value for their investment. They are getting a team of industry professionals and that saves money in the long run. Isn't that what you are really looking for?

Likewise, if your prospects are always saying, "Let me think it over and I'll get back to you." They are telling you that your presentation did not give them a compelling reason to book the session today. Adjust your presentation to create a sense of urgency and this objection will not be heard again.

Track Objections and Plan Responses. Every day we hear the same objections over and over again, yet we still show up to work each day with the same old stale tech-

niques—just hoping and praying that today will be different. But it doesn't change. This will absolutely wear you down over time. Nobody likes to hear objections, because they make us feel like we aren't doing a good job. But when you have no objections, you have no sale because the customer isn't interested. And when you have too many objections you also have no sales because the customer isn't convinced. Objections are, by their very nature, a mixed bag.

Here's a great exercise. Start writing down all the objections that you get on a regular basis—for the next couple of weeks, listen to your prospects very carefully. Every time you hear an objection and don't get the booking, write it down. By the end of the two weeks you will be able to see a clear pattern emerge. It will tell you what part of your presentation is weak.

Based on this information, you can preplan your responses. This will make your life a whole lot easier. In fact, studies show that salespeople who use carefully thought out and planned responses make an average of four times more income than those who just make up their responses on the fly. That's an amazing amount! Realizing that your income and your lifestyle are directly related to you ability to overcome objections should be a good reason to overcome any discomfort you have with handling objections. Best of all, very powerful and motivating responses to all objections are already available to you. You don't have to reinvent the wheel to tackle this problem—you can just profit from other people's experiences.

Have faith, ye people! Objections are a sign of interest. They show that your prospect or customer is engaged in the sales process. Depending on what type of objection you get, each statement also helps you to understand exactly where you are in the sales process.

Here are the four steps to overcoming any objection:

1. **Neutralize or cushion the objection.** What this basically means is that you agree with your customer. Use phrases like, "I understand how you feel, Mrs. Jones," or "That makes perfect sense," or "I totally agree with you," or "I would feel the same way if I were in your shoes." When a prospect or customer says something that could potentially be confrontational, their defensive guard is all the way up, because they are expecting you to react in a negative way, or not react at all.

2. **Repeat or restate the objection.** For example if the objection is, "I want to check around before I make a decision," you can say, "Mrs. Jones, I totally understand your need to make sure you are selecting the right photographer for your needs." In that one sentence you have neutralized the objection by agreeing with them, then you have restated the objection back in a way that makes sense to them.

3. **Give them a reason to decide today.** You could do this, in this scenario, by continuing with a statement like, "Mrs. Jones, I totally understand your need to make sure you are selecting the right photographer for your needs. I heard that from many of our current customers before they selected us. But after checking around, they found that we were best able to meet their individual needs and provide them with a wonderful experience."

4. **Ask a closing question.** Ask a question that gets them to agree with what you've just said. For example, "Now, isn't that what you are really looking for Mrs. Jones?"

Of course you will need to add some of your own words, your own personal style, and practice the delivery so you are comfortable with the presentation, but by following these four simple steps, you will be able to book more sessions, generate more sales, and make your life much more rewarding.

Every time you hear **an objection** and don't get the booking, write it down.

More on Phone Skills. Earlier in this book, I covered the main objections we hear on the phone—this happens on what seems like a daily basis. In fact, eight out of ten calls that come into a studio end with, "Let me think

High-school seniors are all about individuality, and Chatsworth Portrait Studios appeals to this fact on the cover of their senior portrait price list.

about it and I'll get back to you," or "Let me check with my husband and I'll call you back." Eight out of ten times!

Experience shows that they never call you back and you never get a second chance to win their business. So, if you accept that excuse and let them go easily, you are losing eight out of ten possible orders. That means you need to do a better job of helping them overcome their indecision—and get them excited about you and create a sense of urgency.

Overcoming Some Common Objections. Let's go through a few objections and see how we can use the four-step process to overcome them.

I don't have time during the week. Can we come in on Saturday?

I would love to be able to come in on Saturday, but unfortunately we are closed on weekends. I would be more than happy to come in early one day during the week, or perhaps one evening after work would work better for you. Would you prefer to come in before work or would an evening be better for you?

Can I have some proofs to take home and show everybody?

Mrs. Jones, I would love to give you something to take home with you, but we now have a better system that will allow you to get only the images you want. We are going to prepare a special slide show presentation of your entire session, and you will select your images during that presentation. You can order only the ones you enjoy the most, which means you will be able to show off your best stuff to your friends and family. How does that sound?

I will order more later, but I only want the small package right now. Mrs. Jones, I totally understand the fact that your portraits are ending up being more than you had initially anticipated. But what we have found from our past clients is that once the initial order is placed, they don't come back to place the rest of their order. What I suggest is this. Instead of going with the 24x30 wall portrait of the family, let's just go with the 16x20. And instead of the twelve-way wall collection, we can make that an eight way. Also, if it would help, we can even split your payments up to make it a little easier on you. Fair enough?

If you work these simple techniques into your scripts and into your presentation, I guarantee you will book more customers and substantially increase your averages—just by changing a few words!

Additional Closing Techniques

With literally thousands of closing techniques, it can be overwhelming if you try to eat the entire elephant all at one time. There are some basic strategies, however, that you can implement right away to put extra dollars in your bank account.

The Feel, Felt, Found Close. One approach is the "feel, felt, found" technique, which can be used on just about any objection:

> Mrs. Jones, I understand how you **feel**. Many of our customer **felt** the same way before making the decision to come to us. But after they had a chance to experience our wonderful service and excellent products, they **found** us to offer the best value for their investment.

What mother who received this marketing piece from Sarah Petty could resist booking a session?

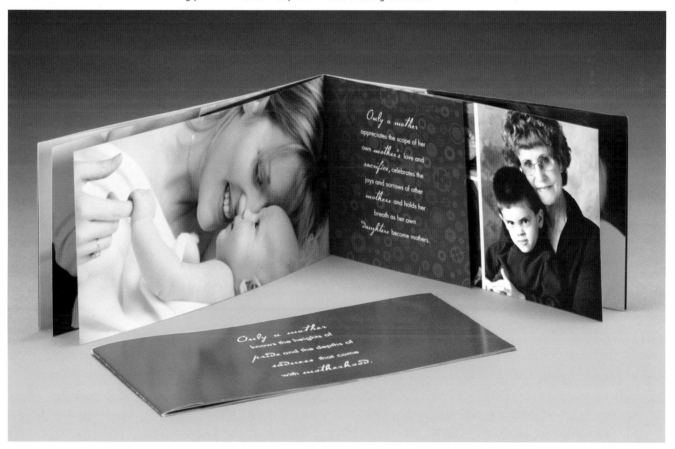

Isn't that what you are really looking for?

The Boomerang Close. Turn an objection into an advantage. For example, if the customer says that you are more expensive than everyone else in town, here's what you might say:

> Mrs. Jones, that's the very reason why you should come to us. Although we may be a few dollars more, I am confident you will see why once you have had a chance to experience our service. All of our custom prints are hand-finished and retouched. They are textured for lifelong protection and mounted on durable art board so they will never peel or curl. Additionally, all of our prints come with a 100 percent unconditional guarantee so you never have to worry about any damage that may occur to them. Also, once you become a customer, we look at you like family, so we extend to you a lifetime portrait pass that entitles you to as many complimentary sessions as you would like. So actually, we are less expensive in the long run than any of our competitors. I believe what you are really looking for is to get a great value for your investment, isn't that right?

The Minor Point/Alternate Choice Close. This close, which offers only two options, is usually used when a customer is having a hard time making a decision. It can get them off of the fence and can add dollars to the order if done correctly. Basically, whatever you *want* your customer to do should be the second of the two options. They will usually go with what they heard last, believe it or not. Some examples:

1. Would you like to pick up your order, or would you like us to deliver it to your home?

2. Would you like to only put 50 percent down today, or do you prefer to pay the entire amount and get the 5 percent prepay discount

3. Will the 16x20 be large enough, or do you want to go with the 24x30 just to make sure?

4. Would you like to pay by check or credit card?

5. Would you like your wall portrait unframed, or would you like us to handle the framing for you?

You can use the same technique when helping a customer decide on which wedding collection to go with. Give it a try. You will be surprised how well it works!

> Mrs. Jones, do you prefer to go with the Heritage Collection that includes four hours of coverage, or do you prefer the Elite Collection that has six hours of coverage plus the two parent albums?

The McAddon Close. Did you know that when McDonald's first starting asking, "Would you like a Coke and fries with that?" in the first thirty days they generated an additional 180 million in sales? *180 million* in sales! It seems like this technique, which I call the McAddon close, is all over our world now. (Would you like a muffin with

It can get them off of the fence and can **add dollars** to the order if done correctly.

your coffee? Would you like dessert tonight? Would you like to purchase the extended warranty? Would you like a shampoo with your haircut today? Would you like some lottery tickets with your gas purchase today?) To you, this should mean that if you are not suggesting frames with your wall portraits, you are missing the boat. If *you* don't sell them, they will have to buy them from someone else, so that's some of the easiest money you will *ever* see!

Creating Raving Testimonials

Testimonials make the sales game much easier. When you say something about yourself it's bragging, but when

somebody else says something about you it's *proof*! That is the bare-bones essence of a good testimonial. So, do you have a file folder with testimonials? Are you using them on a regular basis in your marketing, literature, web site, and direct mail pieces?

I want you to think about the last time you saw a testimonial on a marketing piece. Did it make you want to run to the phone and make a call? Or did it sound like every other testimonial you have seen? Let me give you a couple of examples:

> "WOW! What a tremendous experience! Way beyond my expectations. You guys are the best!"

So, good or bad? Very bad. This statement is way too general. To be effective, testimonials have to have a specific message and an "act now" feel to them. Great testimonials should 1) show action or make a call to action, 2) overcome an objection, 3) reinforce a claim, and 3) have a happy ending. Now, here's a testimonial with some real selling power:

> I'm so glad we decided to have our portraits done before our daughter left for college.

Remember, your customers can outsell you up one side of the street and down the other. Nothing is more powerful than one customer who loves you telling others to *just do it*! Are you going to believe the car salesman or your next door neighbor who just bought a car like the one you want?

Conversion

The key to a successful sales system is conversion—turning prospects into customers. It's in your telephone skills, your presentation techniques, and your follow-up procedures, so try these techniques out right away. The sooner you try what you have learned, the faster it will become part of your process.

Marketing doesn't have to be limited to printed materials or the Internet. Here, Sarah Petty shows her signature t-shirts and lip glosses, featuring colors, artwork, and slogans that coordinate with other items in her marketing arsenal.

Power Corner

Focus on . . .
Doug Box

Besides being a dynamic writer and speaker, Doug Box is also a man who enjoys life to the fullest! This interview was done on a sunny day in Canada, sitting outdoors with a cold drink in hand, resulting in an interview with a relaxed, informal tone. His laughter is contagious, and spending too much time with him can put a permanent smile on your face. His vigor for life and for sharing his techniques with other photographers has made him one of the most sought-after instructors across the country.

The originator of the revolutionary concept of "prime time" and "minimum orders," he is a pioneer of marketing in the age of digital imaging. For years, Doug has been inspiring photographers of all levels to go beyond the normal and create a more successful and creative business. He is the publisher of the Photographic Success *newsletter and has written several books, including* Professional Secrets of Wedding Photography, Professional Secrets for Photographing Children, *and* Professional Secrets of Natural Light Portrait Photography, *all from Amherst Media®.*

For more information on Doug's seminars and educational materials, visit www.simplyselling.com.

Mitche: **What do you feel is the biggest challenge that faces our industry in the future?**

Doug: To me, it's charging for your time. Photographers are notorious for undervaluing their time, and they tend to give it away or do extra things just because they want to. Down the road, I see that being the biggest problem with going digital. Of course, photographers are going to get better with the equipment and the software, but they're still going to have that opportunity to do a lot of things. As long as they charge for their time, they'll be okay; if they start giving it away, it's going to just kill them.

It's almost like the digital revolution is the core problem, but one of the side problems that develops is that you spend too much time in front of your monitor. And that's okay, if you feel it rejuvenates you. I can't argue with that. Maybe at some point more photographers will be better able to delegate things. Of course, with any business, being able to delegate so that you don't have to do every single thing, whether it's digital or film, is the end goal.

What's your marketing philosophy in a nutshell?

For me, it's a referral business. I've been studying this and I've realized that there's a great difference between a word-of-mouth business and a referral-based business. In a referral-based business, we have systems in place to do things—to get referrals and to thank people for their business, for instance.

Our business is built on referrals. We talk about it with our clients ahead of time, telling them that I can only earn new referrals if, at the end of the whole process, they still like and trust me, and I have delivered above and beyond their expectations. I ask them, "If I do all of those things, will you send me your friends and family?" and then I just wait for a response.

Saying this to the client is almost like raising your hand and promising those things. I'm saying to them, if I fill my end of the bargain, I expect that you'll do your part too. And they all say, "Oh, sure. . . . in fact, I've already told two people about you." That's typical.

When I get referrals, I sell the benefits of hiring my studio, not just **the features.**

When I get referrals, I sell the benefits of hiring my studio, not just the features. The benefits should be carefully worded, though. A good example of that is, "I've been in business for thirty years." Well, if you're not careful, it's going to sound like you're just old. But if you can tell them the thirty years' experience is good because you can handle any situation, because you've seen it all, and because, if they run out of time, you can still get them good images, then that experience is a clear benefit. So, you have to talk in benefits, not just features.

What do you feel is the most important attribute of a Power Marketer?

I think it's the ability to make the time to do it, because it's so easy to put that type of thing off.

You mean mapping out a time in your schedule to sit down and work on your business?

Yes! You should schedule a time to work on your business. Otherwise, it's too easy to just put it off. You can say "Oh, I'll do it next week," or "I'll do it tomorrow," then something happens tomorrow. Schedule time where you're working *on* your business, not just *in* your business. And stick with it. Don't give that time up. That's as valuable a use of time as your photography itself.

You should also schedule recharge time, which for me is like getting away from everything and just recharging my batteries, so to speak. So that I can come back into it clear-headed. If you work twenty-four hours, seven days a week, you're going to burn out so much quicker. Most photographers have never taken a two-week vacation. Maybe they get to go to a school and take a couple extra days off, and they call it a week's vacation. A vacation is totally different than that. So, at the beginning of the year I think it's important to schedule time off for yourself and for your family and to use that recharge time.

You mentioned family. What are the most important things to you in life, and how does your marketing help you accomplish your goals?

My family. Of course, they're very important. My kids are grown, so I don't spend as much time with them as I used to. Right now, quite honestly, I've bought this motorcycle, and I'm having a ball on it. I never thought I could retire until I bought this motorcycle. I could retire this afternoon and just take off on the bike. Teaching is fun for me, too—I'd like to take a week and just ride to some destination, teach for a week, and take a week getting home. Make a three-week deal out of it!

How do you balance the professional and the personal life that you crave so much?

I try to work in two-week blocks, because if you don't, all of a sudden, you have no time. But if you schedule yourself out two weeks at a time rather than three days at a time or two days at a time, you're able to include time for yourself and your business. And then having the willpower to stick with it and just saying, this is the time for X. On my answering machine, instead of just saying, "Leave your name and number, and I'll call you back as soon as I get back," it says, "Leave your name and number and I will return my calls on Friday between the hours of 2:00 and 3:00PM and 5:00 and 6:00PM." This makes your job more efficient and helps clients, since somebody might leave you a message saying that in the morning they are at this number, and in the afternoon they are at this number. If you're not specific, they don't even know—you're not giv-

Schedule a time to work on your business. Otherwise, it's **too easy** to just put it off.

ing them any parameters. If I'm going to be away at a seminar, I let them know. I'm going to be at a seminar for a week and I'm learning new customer service ideas to be able to come back and serve you better. So, I'm not just saying I'm off at a conference—because they'll think I'm just goofing off.

What about somebody who's just getting into the industry or who has been around for fifty years— what one or two things can you recommend that they do to take their marketing and their business to the next level?

One of the things, I think, is education. Going to schools and seminars. For twenty-one years I've been going to schools and it advances you. One of the things I would tell people is when you take the time to go to a school or a convention, schedule some time afterward to implement some of the ideas. So many times, you get home and you're so far behind that you don't have time to even try any of the new things you just learned. If you don't try them immediately, the new skills are gone. By scheduling a week for the school and then two or three days afterward to start implementing these things and get caught up . . . I think it helps you to actually use the things you learn.

I voraciously read marketing books and listen to audiobooks. I drive a lot, so these work for me. I've got a bookcase that's three feet wide and six feet tall that's full of nothing but marketing and sales things. I get as much enjoyment and excitement out of making a new marketing plan and writing a marketing letter as somebody else would out of sitting in front of Photoshop and doing pho-

If you want to be a leader, you have to **offer something** unusual and different.

tographs. It's exciting! Quite honestly, it's more fun for me to book a wedding than it is to shoot a wedding. I love booking them.

What is your most successful marketing philosophy or campaign that you've done or that you do on a regular basis?
You know, because my business is referral-based, I don't have to do much marketing anymore!

So, having a referral-based business is your main focus?
That's exactly right. I did an analysis last year and about 25 percent of my business came from past clients. About 25 to 30 percent came from other photographers who referred clients to me. About 20 percent of the referrals come from the trade. The other part comes from different areas. Almost none of it comes from yellow pages, our web site, or anything like that. I get a lot of calls from those places, but they don't turn into business. So, we're cutting our marketing effort in those areas.

Another important thing is to stand out. Some years ago, my studio brought black & white photojournalism into our area. We certainly didn't invent it, but nobody else in the area was doing it. It was huge—I mean, there was a real buzz. The next year, though, everybody was doing black & white—and so, to the untrained eye, they all looked the same. So I'm always looking at ways to stand out. Everybody is following. If you want to be a leader, you have to offer something that is unusual and different.

How about your favorite book or author?
Louis L'Amour. I love reading him.

Have you read all of his books?
Not all of them, but a big chunk of them.

What about the best experience you've ever had?
As corny as this sounds, the birth of my kids. They're good kids. Also, I was teaching at a school one year, and my son was in a really bad accident, but he came out of it okay. That was a miracle. It turned his life around. It really made me stop and think a little bit about life.

Who are your biggest inspirations?
Brian Tracy is a big one. I'd like to meet him. Also Dan Kennedy. I'd have to say for me as a speaker, Don Blair. I remember watching him years ago, thinking, "I want to be like Don Blair." And it was a goal that I set, to be recognized as a good photographer, to be respected as a teacher, and to have the staying power he did. He was also a fun, well-liked guy—the whole package.

I think you've got to do what you love. And that's the beauty of our business. For the most part, I love everything about it, and if you don't, get out of it. Do something else. Life's too short!

11. Mitche's Power Selling Tips

Now it's time for Mitche's Power Selling Tips—a series of quick-hitting, fast-paced ideas that can revolutionize your business literally overnight. Grab a pen and paper, a hunk of cheese, and open up your mind to some new ideas—and maybe some old ideas that you forgot about.

Study Advertising Trends

Study your competitors' advertising as well as advertising of other industries. Pick up your local paper, or magazines, or mailers. See what trends are hot, what fonts are in, what styles are cool. The more you learn, the more you will earn!

Educate Yourself and Implement New Ideas

Reading about marketing and sales will often remind you of things that you already know but have failed to put into action. Did you know that the average business person uses only 12 percent of the available marketing resources to promote their business? What would happen to your

You don't need to reinvent the wheel in your marketing—study the ads in magazines and the marketing materials used by other photographers, then use their ideas to inspire your own designs. This piece is from Chatsworth Portrait Studio.

From the moment they walk in the door, every element in Christa Hoffarth's studio presents a coordinated look. Even her product packaging (see facing page) meshes with the overall design.

business if you could find a way to add some new techniques on a regular basis and get your studio using even just 25 percent? You would do twice as well as you competitors, that's for sure! So . . . do you want to be average or successful?

Invest in a Top-Shelf Business Card

Get the best that money can buy! This is your number-one tool in creating your image. It only takes five seconds for a prospective client to decide how much they feel you are worth and if they want to do business with you. Are you willing to risk that on a business card that you printed with your inkjet printer on paper from the half-off bin? I certainly hope not. If you look at your business card and it doesn't give you a "wow" impression, get rid of it! Any other response is not enough. If you aren't sure, ask several other people what they feel about it. If the response is lukewarm, take my advice and start from scratch. Put foil on it, emboss it, get a new logo designed, use multiple colors—do whatever you need to do to elicit an over-the-top reaction.

Hang Around Successful People

Stay away from hockey pucks that are always trying to bring you down. You deserve everything life has to offer. Sharing ideas with other like-minded people can reinvent your business all by itself!

Have Some Fun

Go to a movie with your spouse or a friend and eat popcorn until you are sick. Watch your favorite movie again—for the hundredth time. Get on the ground and roll around with your kids. If you don't have kids, your dogs. And if you don't have dogs, a big fluffy pillow will do!

Get Some Perspective

Take a day off and visit some art museums or galleries. Give yourself a fresh new perspective on your place in the photographic universe. Continue to challenge your intellectual brain cells with ideas from outside the box.

Rearrange Your Office

I bet your office looks the same as it did the day you opened your studio. Give yourself a clean start by going

through and completely overhauling your work area. If you don't have the guts, have your spouse or an assistant give a helping hand. You will notice a new-found energy as soon as this project is finished.

Embody Success

Dress and look like where you want to be tomorrow. If you want to eventually be known as *the* photographer in your market, then you better start acting like it today! Remember that perception is reality. What people think is true, *is* true. Start creating the impression you ultimately want everyone to have.

Study The Big Boys

Study the success of the big boys, companies like Starbucks, Domino's Pizza, Nike, Turner Broadcasting, Microsoft—the list goes on and on. Read books about business success and figure out how you can adapt their business models into your own business. Hey, Ray Kroc started with a single hamburger store, and Bill Gates started in his garage.

Invest in the Best Packaging

Spend more on your packaging than you do your prints—the mount board, the box, the tissue paper, the bow, and everything else that goes into making your prints look their best. If you can raise the perceived value of your prints, guess what? You can charge more! Do you think that Victoria's Secret just tosses your purchase in a cheap plastic bag? If you are not going above and beyond, customers will go elsewhere. Always be looking for ways to deliver value-added service to your customers' experience.

Christa Hoffarth's packaging materials are neatly arranged and coordinate with the rest of her image (see facing page).

Have a Complete System

You must have a complete system for running your business. This will eliminate most problems before they occur and will return you higher profits—and a better quality of life.

Practice Talking About Benefits

As we've already discussed, people buy benefits, not features. Get in the habit of playing the feature/benefit game throughout the day—driving in your car, sitting in your favorite chair, at the store. The more proficient you become at selling the benefits of your products, the higher your sales will be.

Don't Stop Learning

Continue to invest in your education—seminars, workshops, tapes, DVDs, books—anything you can get your hands on that will make you a better businessperson. It requires a lifetime commitment to truly be the best you can be and attain every goal you have ever dreamed of.

Learn to Say No

Accept the fact that not everyone can afford you and not everyone is meant to be your customer.

Make a Top-Ten List

Why you? Why should customers spend their hard earned money with you instead of any other photographer in your market? If you don't know why, how can you expect them to know why?

Regard Your Business as an Art

Just like your photography, start thinking about your business as an art. True success will come when the two are blended together into one amazing creation that can be nurtured and developed over time.

Manage Your Time

How you spend your time is more important than how you spend your money. Money mistakes can be corrected, but time is gone forever. I did a survey recently, asking photographers from all over the world to give me their input on how the digital age had affected their business and their life. I was absolutely blown away by what I

How you spend your time is more important than how you spend **your money**.

found out. The average photographer works 67.5 hours per week, and an average of six days a week in their studio. That is 291 hours per month, and 3494 hours per year. And do you know where that time has come from? Our families, our hobbies, our personal lives—that time came from our lives! The only way we can get that time back is to take control of our businesses instead of letting our businesses control us.

I don't expect you to tackle all of these projects right away, but I do expect you to make a good college effort to accomplish a good number of them over the coming days and weeks. Don't let your enthusiasm wane and your energy level subside. Begin to make changes as soon as you show up for work tomorrow—or else you run the risk of everything going back to the way it always has been. Don't let that happen. Embrace the idea of a new day, a fresh try, one more start, with perhaps a bit of magic waiting somewhere behind the morning. That's what keeps life exciting!

12. Power Pricing

There is an intimate relationship between the three different areas of your business that go into what I call the Power Triad: marketing, sales, and pricing. They each are interconnected with each other in such a way that it is impossible to attain a high level of success if any one of these three areas is weak. They are all connected at the hip. On that note, I would like to share something that has become very special to me; it appears at the bottom of this page.

Believe it or not, this poem was written back in the 1800s by a man named John Ruskin, and it's as appropriate today as it was nearly two hundred years ago. My favorite line is, "There is hardly anything in the world that someone cannot make a little worse, and sell a little cheaper."

If you are like most other professional photographers, you didn't get into this profession because of your love of business. Little did you know, when you chose to become a professional photographer, that you would be expected to be not only a top-rate photographer (with an intimate understanding of posing, lighting, composition, Photoshop, etc.) but also a proficient salesperson, marketing and

Our sense of what something is worth is not derived from its **intrinsic value** . . .

branding expert, accountant, manager—oh, and you'd have to try to figure out what to charge people for your products and services. This last task, in particular can be a very daunting task unless you have the tools to build effective, profitable, and incentive-driven price lists.

What Determines an Acceptable Price?

Our sense of what something is worth is not derived from its intrinsic value but from the demand that has been cre-

Ode to Pricing

It is unwise to pay too much, but it is worse to pay too little.

When you pay too much you lose a little money.

That is all.

When you pay too little, you sometimes lose everything because the thing that you bought was

Incapable of doing the thing that you bought it to do!

The common law of business balance prohibits paying a little and getting a lot.

It cannot be done . . .

And if you deal with the lowest bidder, it is well to add something for the risk that you run.

And if you do that, you will have enough to pay for something better.

There is hardly anything in the world that someone cannot make a little worse and sell a little cheaper.

And the people, who consider price alone, are this man's lawful prey.

Tasteful displays of your awards and accreditations, like these in Christa Hoffarth's studio, can increase your perceived value in the minds of customers.

ated *for* that something. The basic rule of supply and demand makes something worth a higher price if that product is in demand. For example, I remember when the PT Cruiser came out a few years ago. My best friend had one on order for nearly six months because everybody wanted one. I would venture to say that he didn't get much of a discount (if any) on his purchase. There may have even been some dealerships that were charging more than the sticker price, *because they could!*

The other thing that allows you to charge more is that your client wants the product emotionally. We have all heard the terrible stories of the bride who hired Uncle Bob to photograph her wedding, only to be totally disappointed in the results. The price may have been right (in many cases as a free "gift"), but the true "cost" was very high. If we only had a way of shaking that bride upside down and convincing her that her wedding deserved to be photographed by a true professional, she would have been much better off.

The key comes down to whether or not we can create value for our clients, giving them something that has perceived value and benefits their life in some way. A classic example is in the auto business. You all have seen the television commercials from car dealers that say, "Sunday! Sunday! Sunday! Noon 'til midnight! ALL CARS MUST GO! And we are prepared to sell you a car for a dollar over invoice—no tricks, no gimmicks, no kidding!"

As a potential customer, that has very little no value. At least very little perceived value. What happens after I drive the car home? What kind of service will I get?

I'd be more likely to buy if the commercial said, "Our prices are $100 more than anybody else's, but our service is guaranteed to be 110 percent better than anybody else's service." Underneath that are pictures of their customers telling you why they paid an extra 100 bucks and that the service *is* wonderful. They would probably grab a fair share of the market, don't you think?

Of course, not everyone will buy value; 30–40 percent of all people will buy based on price. That's the bad news. The good news is that 60–70 percent of all people will buy value if you provide it to them.

The Power Pricing Self Test

Before we get too much farther, I want to clear the cobwebs out of your brain. We are going to start with the Power Pricing Self Test and see where you are with your understanding of pricing strategy. This will take only about five minutes, so grab a notepad and a pen, sit down in your favorite easy chair, and jot down some ideas as we go along. Here we go.

1. How do you feel about your current price list (or, as some prefer to call it, your investment sheet)?
2. Do you know your costs on each of your products and services? If so, what are they?
3. Do you offer à la carte pricing as well as packages or bundles? Whether you do or not, what were the factors that you considered when making your decision?
4. What is your mark-up factor, or how did you decide what to charge for each of your products and services?
5. How much does it cost you *per month, per day*, and even *per hour* to keep the doors open at your studio, regardless of whether or not you have any business coming through those doors?
6. Do you raise prices at least once a year to cover the additional expense of operating a business? If not, when was the last time you did change your prices?
7. Could you raise your prices 5 percent on January 1st and 5 percent on July 1st without giving your customers a heart attack?

8. Have you done a competitive analysis of other studios in your market to find out where they stand with their pricing structures? Where are you in the pricing hierarchy?

9. If you could create a life that had everything in it that your heart desires, what would that be?

10. Do you feel that your current pricing structure will allow you to get there someday?

11. What changes would have to be made in order for you to be able to attain your dreams and goals?

Well, how did you do? Many of these questions may require you to spend some time crunching numbers and doing some calculations. That's good! Make the time to get this accomplished as soon as possible—I would recommend today. There's no better time than *right now* to improve your business.

Addressing Pricing Issues

Your ability to handle pricing questions relies heavily on your belief in yourself and your products and services. Before you can address price issue with your clients, you need to address it with yourself. If you don't have an unshakable faith that your products are worth the price, you will not be able to sell them. Your work may be better than your competitors, but without the skills required to be able to price and sell your work, all will be for naught.

Three Methods of Pricing

There are basically three different methods that photographers use in order to determine what the price should be for each of their products and services.

Overhead (or Cost-Based) Pricing. Using this strategy, your pricing is based on what it costs you to produce a print. This number is then multiplied by a factor in order to come up with the selling price. This multiplication factor must cover all the costs of running your business— your payroll, utilities, lease, cars, taxes, your compensation, and of course profit.

The first order of business is getting your arms around the cost of operating your studio. You must have a complete grasp of these numbers in order to be the best businessperson you can be and price your work correctly. The

first expense category is your capital expenses or your investment costs, things like real estate, vehicles, equipment that your purchase, props, furniture, etc. The second category contains your general expenses, things like your pay and benefits, employee pay and benefits, lease payments, electric, phone, trash, insurance, taxes, advertising, education, bookkeeping services, etc.—things that have to be paid every month, whether you have any business or not.

The third category consists of your cost of sale (COS). This is what it actually costs you to produce a product from beginning to end. This can be tricky. If I were to ask you what it costs your studio to produce a single 8x10

As this display by Christa Hoffarth shows, you can display tear sheets of your published images alongside wall portraits. It's another great way to boost your perceived value.

A simple table display might be an attractive addition to your studio's decor. Images by Christa Hoffarth.

the tissue paper that goes around the print, the stickers, bows, and ribbons . . . and ultimately the delivery of that image to your client. Oh my!

Now. Based on that, if I asked exactly what it costs you to produce a single 8x10 print, would you have a different answer?

If you don't know what your cost of sales (COS) are, I want you to spend some time with your nose in your books coming up with a real number. You will also need to identify how much time you spend on each client from start to finish *and* you have to assign a value to that time. Yes, you heard me correctly. I said that you have to assign a value to your time. Just because you enjoy your work, doesn't mean that you should have to do it for free. Sitting in front of the television on Saturday night after you get home from a wedding while you download and edit your images is not time off. You may think, "Oh, this doesn't really count because I'm sitting here laughing at *Saturday Night Live*." I hate to tell you, but that time has to be accounted for.

The industry standard ratios for COS in today's market are as follows:

- 10-20 percent for a high-end boutique studio
- 30 percent for a home studio or residential gallery
- 40–50 percent for a retail studio that has high volume and lower pricing

So if you have a residential gallery and are working with a 30 percent COS, of every dollar you bring in, about .30

The first order of business is getting your arms around the cost of **operating your studio.**

cents should go toward producing the end product. There's some wiggle room here, of course. I've seen studios that have their COS down to around 10 percent, and I have also seen other studios that do very well with a COS up around 50 percent. If a studio has their COS down in the low double digits (meaning only about ten

print, ready for delivery, what would you say? You can't simply say, "Well, the lab charges me $2 for an 8x10, so if I sell it for $10 I'm making $8 in profit!" It doesn't quite work that way. Let's think about this question for a minute. In addition to the lab bill, there was the time that you spent talking with the client on the phone, conducting their consultation, and shooting the actual session. There was the digital media that the image was stored on (or, if you are a film shooter, the cost of the film, processing and proofing). There was also the labor and time required to manage that image from capture, to download, to editing, to backup, to selling. And let's not forget the commissions paid to get the order, the cost of retouching and image manipulation, shipping expenses for getting that file to and from the lab, and the costs for mounting and laminating, and stamping the print. There were also costs for boxing, bagging, or framing the image,

percent of each dollar goes toward producing the product), it is more than likely what we would call a "boutique" studio—one that focuses on providing a true experience to their clients. This allows them to mark their products up substantially. Studios that are located in a mall or other high-traffic area tend to provide a low-cost product with less refined and personalized service. This means they cannot mark up their products as substantially, so they focus on volume. A typical COS for this kind of business is anywhere from 40–50 percent.

Just because you enjoy your work, doesn't mean that you should have to **do it for free**.

So, if the COS accounts for only a small percentage of the actual price of the product, where does the rest of the money go? Well, after the COS is subtracted from the selling price, that leaves you with what we call margin contribution or gross profit. That is the amount that is used to pay the overhead (the investment costs and general expenses discussed on page 117–18). Whatever is left over is, of course, your profit. Let's say you have a COS of 30 percent. That will leave you 70 percent of every dollar coming in to cover your overhead and your profit. When it comes to profit, a good goal for at the end of the year is at least 10 percent. This is how you grow your business, afford new equipment, and give yourself a nice raise. And wouldn't that be nice?

Some of you will get to the end of this exercise and realize, for example, that your COS on an 8x10 is $40 but you have them priced at $35. That mean that if someone comes in and orders only one 8x10 you will lose money. If you have a rock-solid sales system in place at your studio, the one 8x10 order will probably never happen, but your à la carte pricing should take this into consideration.

So how do you determine the right selling price for your products? Let's say you have a COS of 30 percent, and you sell your à la carte 8x10s for $100. If you divide 100 by 30, you come up with a factor of 3.3, which is what we call your markup factor.

If you have a 20 percent COS, then your mark-up factor would be 5 (20 into 100).

If you have a 40 percent COS, your mark-up factor would be 2.5 (40 into 100)

If you have a 50 percent COS, your mark-up factor would be 2.0 (50 into 100)

Get it, got it? Good. This is not graduate-level trigonometry, but it's important you understand this concept. So, if your markup factor is 3.0, you multiply your COS by 3.0 to come up with your selling price. For example, if your 8x10s have a COS of $40, multiplying that by 3.0 gives you a selling price of $120. For some of you, that may be way out of whack with what your market will bear, so let's see if there is any other way for us to come up with a different selling price.

Factor in Your Time

With digital now part of our everyday lives, we now have a new item that we must figure into our calculations: time. This is the biggest mistake I see photographers make all over the world: they don't put any value on their time and don't incorporate their time into any pricing calculations. How much is your time worth? Remember, customers need to pay for your expertise, knowledge, and experience, not just your products.

Let me take it a step further. If you were to hire someone full-time to be your "digital" guy or gal, how much would you pay them to handle all of your editing, workflow, retouching, artwork, and uploading? $10 per hour? $15? $20? $25? Are *you* willing to work for that? Actually, most photographers must be, because that's exactly what they are doing.

I do understand that if you are the only staff in your studio, it may be difficult to justify hiring someone. It probably seems much easier to just handle the work yourself. But what is the real cost of that time you are giving up? Has anything suffered because you now find yourself glued to the computer twenty-five hours a week? Are you noticing that your list of hobbies has been reduced to watching the FTP status bar as your order is being uploaded?

There may not be a short-term answer for this, but I want you to at least spend some time really thinking about this question. In fact, there is someone out there right now that can do just about all of this for you. They don't need any training and they can start today. This person is called your lab! Give them a call and talk with them about how they can help you. You may be pleasantly surprised.

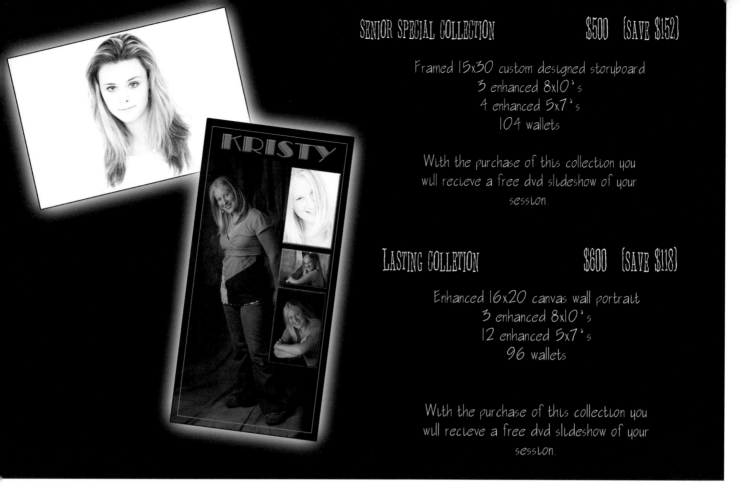

SENIOR SPECIAL COLLECTION $500 (SAVE $152)

Framed 15x30 custom designed storyboard
3 enhanced 8x10's
4 enhanced 5x7's
104 wallets

With the purchase of this collection you
will recieve a free dvd slideshow of your
session.

LASTING COLLECTION $600 (SAVE $118)

Enhanced 16x20 canvas wall portrait
3 enhanced 8x10's
12 enhanced 5x7's
96 wallets

With the purchase of this collection you
will recieve a free dvd slideshow of your
session.

If you want people to make a real investment in your artwork, your price list cannot be a cheap photocopied sheet of paper. These pages from the senior portrait price list at Chatsworth Portrait Studio show how simply and attractively prices can be presented.

What if we used a session fee in our calculations? The print costs us $40 and we have a 3.0 markup factor, giving us a selling price of $120. But we have also collected, say, a $50 session fee. If we subtract that $50 from the $120, that leaves us with a *new* selling price of $70. Is that more in line with what your market would be able to bear? Remember, these are only example prices I am using here, so you have to use real numbers from your studio in order to come up with the right data.

Packages (volume sales) can also come into play in these calculations. That first unit sold bears the biggest burden of cost (we have to capture all of our expenses in that first unit). But how much does the *second* identical 8x10 cost? You have the actual cost of the print, a little bit of labor to get it ready for delivery, and you have some packaging materials—let's say $5. That's it! The rest of the costs associated with that print have already been captured in the sale of the first 8x10.

Now, for the *two* 8x10s you have a COS of $45, the original $40 from the first 8x10 and the $5 for the second

8x10. Are you starting to see the picture a little clearer now? There is much more profit on that second 8x10 (or the third or the twentieth). This is why packaging or bundling can be so successful if done correctly, and we will talk about that a little later.

So, the cost-based pricing model basically says that once you figure out what it costs you to produce a print, you multiply that number by a predetermined factor to come up with a suggested selling price for an item.

The biggest problem with this type of pricing is that it does not effectively maximize your profits or take anything else into account other than what it costs you to do business. However, it's where you have to start. The value you determine using this method is basically the lowest price that you will sell an item for.

Competitive-Based Pricing. Unlike cost-based pricing, competition-based pricing takes into account what your competitors are doing with their pricing strategies.

As you are very well aware, some products are more price sensitive than others, so you must be aware of what

is going on in your marketplace. I'm going to ask you the price of some everyday items and I want you to come up with the price. Ready?

1. A gallon of milk
2. A pack of gum
3. A gallon of gas
4. A new digital camera
5. A can of pumpkin pie filling
6. A soda
7. A movie ticket
8. A car wash
9. A Japanese dwarf maple tree
10. An all-you-can-eat buffet
11. A gallon of bleach
12. A drive-through combo meal
13. A pound of morel mushrooms
14. A nice bottle of wine on Friday night
15. A hanging plant basket
16. A desktop computer
17. A Lamborghini sports car
18. A box of Kleenex
19. A ream of printing paper
20. An electric dog fence

Most of these items probably assigned a value instantly in your brain. Other items—like a can of pumpkin pie filling, or the Japanese maple, or the Lamborghini, or the electric dog fence—may have stumped you just a bit.

If you were to go into five different grocery stores to compare the price of a gallon of milk, they would all be within a fairly tight range. You probably wouldn't find one store that charged $1 and another that charged $100, would you? Same with a gallon of gas, or a car wash, or anything that is considered a commodity. The prices must be perceived as at least being in the ballpark or, as consumers, we close our minds. If the local gas station was charging $45 for a gallon of gas, would we even think about stopping in? I don't think so.

What items in the photography industry are considered "commodities" and need to be at least perceived as being in the ballpark for competitive reasons? How about sessions? Or 8x10s? Or wallets? Or the price of your entry-level package? In looking at your pricing from a com-

petitive standpoint, you need to be aware of what your potential clients will gauge your worthiness on—how they will determine whether or not you are in the ballpark. So wouldn't it make sense to make sure that your pricing, or at least the perception of your pricing, was viewed as being competitive?

You may actually be the most expensive studio in town because of all the little things you do to add perceived value and to provide your client with a luxury experience, but the way your pricing is *presented* must still show your client that you are in the ballpark.

Should I Put My Prices on My Web Site? Should I Hand Them Out?

That's a great question and causes many photographers quite a bit of grief. My view of web sites is that they should exist to create excitement for your photography and to entice a prospect to either send you an e-mail—or better yet, pick up the phone and give you a call. The job of your web site is *not* to sell, which is what you are doing when you post your prices on the Internet. A web site can't build a relationship, create a rapport, or even ask questions. That all must be done by the human element. However, the sales process can be made easier by a professionally designed web site that has good content and helps educate the client. As a professional photographer, though, you cannot sell anything from your web site.

Now, if you would like to post ranges, that is perfectly fine—but remember that you don't want your web site to be your "screener." It should not decide who gets in and who doesn't. That should be up to you or someone on your staff. If you are a few dollars more than the other studios in town, posting those prices on the web will definitely not be a good idea; you won't be able to show people *why* you are a few dollars more, or *why* you would be the perfect photographer for them.

The exceptions to this are for things such as photographing school dances, or sports teams, or when you want to advertise certain special promotions. Other than that, your regular bread-and-butter pricing should always be given out by a warm-blooded human being.

Once you have established a connection with a good prospective client on the phone—and once you have established your value to them—you can make an educated decision about whether or not you want to send them something in the mail. The best solution, of course, is to have them come into your studio, but we all know that sometimes that just isn't possible. Just use your best judgment.

Lifestyle (or Demand-Based) Pricing. Lifestyle or demand-based pricing is perhaps the most important element to consider when determining prices. It's a combination of everything you have ever done to create a high perceived value for your products and services with the lifestyle you want for yourself and your family—the car you want to drive, the home do you want to live in, where you want to go on your vacations, the toys you want to own, the type of clothes you want to wear, the hobbies you want to enjoy. All of these things must be determined before you can decide on what price to charge, since the money that you bring in to your studio is directly related to what dreams you have in your life.

So, how much will your market bear? Unfortunately, I don't know that answer. That's something only *you* can determine.

What's Best?

Have you been able to figure out which method would be best for your business? Actually, the best method to use is a combination of all three.

First, figure out what it costs you to open your doors in the morning, what it costs you to produce your products, and then assign a markup factor to come up with a price for each product. This is the absolute *lowest* that your pricing can be, unless you plan on losing money and not being around in a year to answer your phones. Then, do a competitive analysis to see where you are compared to the other players in your market. Finally, determine what kind of demand there is for your products and services and what lifestyle choices you have made for yourself and your family. Put all three sets of data together and you will be able to come up with a pricing structure that is both profitable and well thought out.

In previous chapters, we looked extensively at how to create value for your products and services, how to position those products in the mind of your perfect client, how to build a positive image in your community, and how to create a sales atmosphere that compels clients to invest more money with you. All of these things must go into your calculations, as well. The goal is to create a high level of desire long before you talk about price. It's like building a house—the foundation must be poured before you can put up the walls, or the windows, or the big-screen television.

For some of you, that may be way **out of whack** with what your market will bear.

Again: marketing, selling, and pricing are all connected at the hip and create the Power Triad.

Will your method of doing business appeal to everybody? Of course not! Are there people in the world who will always be looking for ways to get things on the cheap? You bet! They are the kind of people who will go to Sears and buy their own oil filter, then go to Wal-Mart for the oil, because it's on special. Then, convinced they have saved seven whole dollars, happily crawl under the car to change the oil and filter themselves. This person may get their oil change for less, but they'll spend three hours doing it. The price may have been right, but the cost was very high indeed.

Cheap things are not good and good things are not cheap.

Mitche: **What would you say was the biggest change that faces our industry?**

Michael: The major thing is providing a product and service that consumers cannot create for themselves. We no longer have the magic hand—there are kids out there who understand Photoshop very well, and consumer cameras provide some pretty good images. I think that for the industry to survive as we know it, we will have to provide an exceptional product and service.

What kind of products?

The photo book is going to be very big; it is here to stay and grow. The pre-pressed products are also emerging—calendars and personalized products with your work displayed and personal data displayed can be produced fairly economically. This is not something that is going to go away. These products will help out tremendously.

If you were to wrap up your marketing philosophy, into a nice little package, how would you describe it?

Personally, our philosophy is to educate our customers, by moving up the food chain rather than down the food chain. If you go down, the only difference is price, whereas going up there are a lot of perceived differences. At NuLab, we work very closely with our clients and I consider them my focus. We help them by educating them on sales, marketing, product development, and technical support. The last two years we have worked on providing them with work recognitions for the customers.

I have been photographing professionally for over thirty years in the portrait/wedding industry. I was the photographer who arrived in a Fiero or Porsche with two assistants. It was a choreographed performance. We charged accordingly and the studio was ahead of its time.

It all started with my education—I started right out of high school. I was overseas for ten years and spent all my money on education. I was lucky to meet people who changed my outlook on photography. I studied with Monte Zucker and spent some time shooting weddings with Rocky Gunn. Frank Cricchio, Don Blair, and Phil Charis all taught me the value and worth of photography.

I operated several studios in Australia until around 1989. In 1990, I started developing a market in Asia, which was mainly in portraits. I spent all day photograph-

Power Corner

Focus on . . .
Michael Warshall

I met Michael a couple of years ago after one of my programs at WPPI. After spending some time with him in Australia on a speaking tour I did last summer, I can say without a doubt that this man is the most successful photography marketer I have ever met! He not only is known as one of the most successful photographers in the entire world, but also as a savvy lab owner who has revolutionized the Australian photographic industry. Everything about this man is top-rate and you can't help but walk away from a conversation with him a better person. For more information on Michael Warshall's workshops, products or services, log onto www.nulab.com.au.

ing the rich and famous. With the average wedding budget about $150,000US, it was easy to make lots of money. We did that until I decided I didn't want to travel anymore—plus my kids wanted to see their dad more often.

What do you see happening in our industry today?

It's all about automation today. The companies that can automate and stay ahead of their competition will be the ones that will survive. It's also about education, and we provide a tremendous amount to our customers. The more we can help them, the better they will do, which means the better we will do. It's all part of the same game.

For a new person in the industry, what are the most important things you can recommend to them?

First of all, you have to have some skill sets in sales and marketing. Photography is secondary. I have seen people all around the world who were average photographers but had great sales and marketing skills and did very well. On the other hand I have met some exceptional photogra-

phers who are broke. The key is to understand what the client wants and then figure out a way to give it to them.

What do you see as the future of photography?

The problem with that is that the consumer can take the same photographs as we do because it doesn't take a lot of skill to follow someone and take thousands of pictures and have a few reasonable photographs. The ones that will make it are the ones who understand lighting control, both indoors and outdoors, and the art of good posing. This is something that the "happy-snapper" can't produce.

Can you learn how to be a Power Marketer?

Yes, but it helps if you already have the right set of skills. You need to like people and be able to get along with many different types of clients. It's easy to teach the technical aspects of sales and marketing, but you have to start with the personality and build from there. If you don't like talking to people, it's very tough. If you don't like people, then hire someone who does.

Tell me about your family.

I've been married for over thirty years to the love of my life, Barb. I have two kids who grew up around the studio. We traveled all over the world—a month in Australia, a month in the Philippines, a month in Australia, a month in Borneo, etc. After doing this for a long time, we wanted to just be back in Australia and tried to retire. That lasted an entire three days! I didn't know what to do. I was sitting on a beach in Borneo one time, just itching and wanting to get back to work—new products, new promotions . . . my mind wouldn't shut down.

How do you balance the professional and personal?

I think in my case my personal and professional lives are intermingled. I'm a socializer. I love people, I love to travel, I love good food and good wine. I also love running workshops for our customers, which is part of the marketing strategy for our lab. You can't help but get the two lives mixed up with each other.

How many days a week do you work?

On average, probably a little bit every day. I might go to work and spend ten hours, or go to work and spend two hours then go for a drive and lunch with friends. I'm a car fanatic. I use to race cars when I was young and restless, but now I'm a bit more mature. One of my great joys is to take my car and go driving with my wife or son, and sometimes I will even rent a race course and go driving on weekends..

What other kind of hobbies do you have?

I like to sit by the pool and read, and listen to good music. I used to play jazz in Latin America, so I'm particularly fond of the bossa nova, rumba, samba, and salsa. I could be sitting there drinking a nice glass of wine, or a single-malt, which I have been known to enjoy, and listening to good music.

Who are your biggest inspirations?

The people who probably influenced me the most were Monty Zucker, Frank Cricchio and people like that. Photographers like that allowed me to separate myself from the masses. From the business world, people like Richard Branson and Lee Iacocca from Chrysler. Even Richard Miller from Miller's Lab in the states taught me quite a bit about running a successful lab in today's competitive environment. I'm always open to suggestions and I'm not afraid of change. If someone can show me a better way of doing something, I will change. Many photographers today don't want to change with the times, and are afraid of change. Those are the ones who will go out of business.

What do you think is the biggest reason for failure among photographers starting out today?

The biggest key to success is perseverance, so the biggest key to failure in not trying hard or long enough. Keep trying until you get it right!

Do you still feel like there is money to be made in professional photography?

There's a load of money to be made! It all has to do with being able to understand what the customer wants, and then providing it to them. If you want to be in this industry, your main job is to get bums in seats for the rest of your life. That's all there is to it!

13. The Myths and Realities of Pricing

Do you believe in the Loch Ness monster? What about Bigfoot? Or UFOs? Or how about this one: you can eat everything you want, as much as you want, and still lose weight? These are some pretty good myths that have been perpetuated for quite some time—and it seems as though there will always be a group of people who will buy into them. Well, there are also some pricing myths that I would like to dispel once and for all.

Myth #1: People Buy Because of Price

Wrong! If you insist on selling based on price, your customers will buy because of price. Sure, price is important, but it doesn't have to be *as* important as a lot of other factors—that is, unless *you* believe in this price myth. There have been many studies over the years, and price usually comes in fifth as far as the reason that people make purchasing decisions. Other factors like quality, experience, level of service, and referral usually place higher than price on the importance scale.

Myth #2: Lower is Better

Let's talk in broad terms about the impediment of discounting. Let's imagine there are 100 units of a product that you sell in your studio. If you give a 10 percent discount on these, you would actually need to sell 11 additional units to make the same amount of money as selling 100 at full price. At a 15 percent discount, you'd need to sell 118 units. You'll have to do more work to earn the same amount and you actually make less, on a percentage basis, because you have more time and overhead invested.

On the other hand, if you add 10 percent to your prices, which you should be doing once a year anyway, you only have to sell 91 units to generate the same revenues. Add 15 percent and you're down to 87 units.

The point is that your customers may not be as price sensitive as you fear they are. They may tolerate a price increase much better than you think. Additionally, they may not even respond to a decrease in price as enthusiastically as you need them to in order for that decrease to be profitable for you.

Myth #3: Price is What Matters

When we think about how to price our work, we assume that our focus should be on the price. But there are many other factors that go into determining profits and cash flow, as I have mentioned. Price will only matter if you allow it to matter. Don't fall into this death trap! You need to charge what you think you are worth. An increase in price will increase a prospect's perception of you; a decrease in price will decrease the perceived value. Many people assume that price equates to quality, which means they won't buy your products unless your price is *high* enough. You may remember the story about a riding lawn mower that I tried to sell several years ago (see page 34). In my initial ad, I set the price so low that people figured there must have been something wrong with it. As a result, I didn't get a single call. When I raised the price to $200, on the other hand, I sold it instantly.

If you insist on selling based on price, your customers will buy **because of price.**

Factors That Really Do Effect Pricing

There are several major factors that will affect your ability to have a successful pricing strategy in today's competitive marketplace. These include the quality of your photography, the branding and marketing that you are currently doing (or not doing), having a highly defined

Portrait Packages

(Two poses per Portrait collection)

Lifetime Collection :

842
(save $207)

.A framed 20x30 canvas in a 5000 series
frame with a lifetime guarantee on the portrait.

6 - 8x10's

6 - 5x7's

48 - Wallets

With the purchase of this package you will receive a
free 5'x4' fleece throw-- value $75.00

Prestige Collection :

512
(save $100)

A framed 16x20 canvas in a 5000 series
frame with a lifetime guarantee on the portrait.

4 - 8x10's

4 - 5x7's

32 - Wallets

Portrait Packages

(Two poses per portrait collection)

Memories Collection :

322
(Save $40)

16x20 canvas

2 - 8x10's

2 - 5x7's

32 - wallets

Traditional Collection :

215
(save $41)

11x14 canvas

2 - 8x10's

2 - 5x7's

24 - wallets

In Chatsworth Portrait Studio's price list, the portrait packages are clearly explained and there is a nice range of price points.

sales system that begins the very first second someone is exposed to your business and continues long after your clients order is picked up, having a complete understanding of your competitors' strengths and weaknesses, and having an unequivocal belief in yourself and your ability as a modern-day entrepreneur.

Price is where you get what is yours, where all those wonderful things you do for your customers is suppose to be reciprocated. When it comes to pricing, you have to be sure that your studio gets what it deserves—and nobody will pay you more than what you ask for, so be careful not to under price yourself.

So, how can you tell if you have poor pricing? If you constantly find yourself having to explain your price list, or if the price always seems to be an issue, or if you are always changing your prices, or—here's the big one—you always

seem to be busy but you don't have anything to show for it . . . those are all bad signs. If this sounds like you, it may be time for a price list makeover.

Something that will help you with some of these issues is to work on your image through marketing materials, refining your sales skills and techniques, and most importantly by putting more emphasis on building relationships with your clients. This will lead to a decrease of price sensitivity all by itself. The stronger your relationship with your client, the less important price becomes. This is the magic carpet that will take you to where you want to be.

Learn to answer the pricing questions confidently and professionally. If you educate your clients, price is rarely an issue.

Some other things that will affect your ability to charge what you are worth are having an identifiable style, hav-

Portrait Packages

(Two poses per portrait collection).

Basic Collection : **150**
(save $22)

2 - 8x10's
4 - 5x7's
16 - wallets

Add On Packages

(with purchase of portrait collection only)

Legacy Collection : **192**
(save $80)

4 - 8x10's
4 - 5x7's
32 - wallets

Deluxe Collection : **122**
(save $32)

2 - 8x10's
2 - 5x7's
24 - wallets

～ Portrait Pricing ～
Pricing is for Color, Black and White or sepia.

4x6	12
5x7	18
Set of 8 Wallets	18
8x10	32
11x14	65
16x20	150

～ Canvas Mounted on Masonite ～

11x14	120
16x20	190
20x30	310
30x40	430
40x60	650

Basic Retouching is included on all portraits purchased.

In Chatsworth Portrait Studio's price list, add-ons and à la carte items are clearly and attractively presented.

ing a wonderful atmosphere in your studio, your personal appearance and your professionalism, your ethics and business integrity, the presentation of your products, your customer service, your reputation, and your ability to build friendships with people.

Building an Effective Price List

What does your price list alone communicate about the value of your work or about your business? Is your pricing clear, concise, and easy to understand? When someone looks at your price list, does it make their head explode with confusion?

There are some simple-to-implement techniques that will help to make your price list a much more effective sales tool—and that will, in turn, increase your sales averages substantially.

Research Other Photographers in Your Marketplace. You don't need to reinvent the wheel. There are plenty of great price lists already in the market, you just need to get your hands on them. It may be as simple as picking up the phone, calling some other photographers in the area, and saying that you want to get everyone together for a planning session. Have everyone bring their price list, some marketing materials, and a business card. There really isn't any secret way of making money in our industry. The more we can share with other photographers, the better we can become. If this idea doesn't appeal to you, how about calling some of your photography friends from outside of your area and asking them to do an exchange with you.

The purpose of this is *not* so you can copy the prices, but rather so you can get ideas for graphic design, layout,

creative ways to bundle your prints together, or unique products that you can offer to your clients. It's part of the creative process.

Find the Best Paper Money Can Buy. The paper that your price list is printed on speaks volumes about the quality and value of your work, so don't cut corners with this part of your business. Once you have made that initial impression on someone, it's virtually impossible to change it, so do it right from the beginning. So, go down to your local print shop (not one of the chain office supply stores, but a regular old commercial printing shop). Ask to see their best line of papers. For prices that you present to your clients when they arrive for their sales and ordering session, how about placing them in a nice leather folio—like the wine list that you would get at an elegant restaurant. Talk about making a great impression!

If you insist on selling based on price, your customers will buy **because of price.**

Keep your À La Carte Pricing High. This will create value for your packages, bundles, or collections. We will talk about how to build packages a little later on, but putting a group of products together for your clients to purchase is a good thing. After all, the more decisions you ask your clients to make during the sales process, the more difficult it will be at the end when it comes time for the most important decision: how much to spend. The easier you can make it on your client, the higher your sales averages will be and the happier they will be.

Feature a "Most Popular" and a "Best Value" Collection. The reason for this is very simple. Human nature says that people like to belong to a group and feel safe when we know that others are doing the same thing as us. Even if you don't have a most popular package, make one up. Before long, it will become your most popular simply via the power of suggestion. Obviously, the package with the highest price will also be the one that has the best value because of all the savings that have been built in. Make sure to point out this fact right on your price list. If they believe in it, they will buy it!

How do you determine which package should be your "most popular?" Here's a cool little technique. Once you have determined what your averages are for each type of client—wedding, family, children, senior—your most popular package should be at a level that is higher than your average. For example, you have an average of $410 on your children's portraits. I would recommend having your "most popular" package at $499–$599. Then, everything you do should be with that package in mind. This will bring your averages up by nearly 20 percent and will give your client a great value at the same time. If your averages are higher or lower than this, you will have to adjust accordingly, but I think you understand the concept.

Have a Whopper Package on Every Price List. What is a "whopper package" you ask? It's something that appears to be so incredibly expensive that nobody in their right mind would ever invest in it. It's a package that has everything, including the kitchen sink. The purpose of a whopper? To make the other packages look and feel better. It's there only to create value for the other packages. A little later on there will be an exercise that will help you generate some ideas on what you could include in a whopper package.

Discount Your Session Fees, Never Your Prices. When you discount your print prices, you lower the perceived value of your work, which can have a long term effect on your ability to charge what you are worth. Photographers have, for a long time, used their session fees as a tool to get more clients in the door, and to keep current clients coming back more often. Giving something away for free is *always* better than giving someone a discount. Add value, but don't discount.

Close the Gap with Your Pricing. There is no way that a 5x7 should be half the price of an 8x10, or a 4x5 half the price of a 5x7. You spend the exact same amount of time and resources on the smaller print sizes. In fact, the only difference is that they get printed on a smaller piece of paper, which is the least expensive part of the entire process. Your pricing for your 4x5s, 5x7s, and 8x10s should be fairly close together, if not exactly the same. It's very easy to tell a customer that your price for a gift portrait is X, and they can select any size that meets their specific needs. Regardless of whether that need requires an 8x10, a 5x7, or a 4x5.

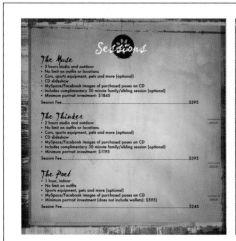
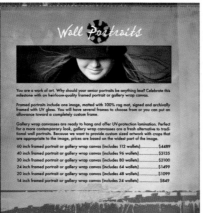
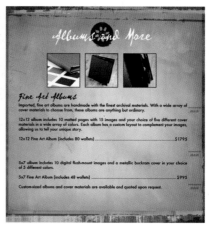

Sarah Petty's price list is simple and beautifully designed.

Eliminate the Second Print Discounts. I have seen many studios that offer discounted pricing if a client orders more than one of the same image. Don't do this—that's what offering packages is for! If they want to save some money on their portrait package, show them the value that each of your packages offers, but don't offer to discount your à la carte prices. It will only cheapen your pricing integrity.

Pricing Strategies

When I go to one of the big retail malls in my area, there are a few stores that I love to visit. One is Bath and Body Works, because it seems they always have some incredible deals on their products—and the deal is always the same. For many years, it was buy three get one free. Even if you planned on only purchasing a single item when you went in, you rarely could get out of there without stepping up and buying two more so you could get the fourth at no charge. In fact, 84 percent of all shoppers at Bath and Body Works end up purchasing three to get one free. Isn't that incredible? The last time I was in there, the deal had been changed to a buy two, get one free—and I bet this strategy will be even *more* successful!

Victoria's Secret is another store that does an incredible job of packaging and bundling. A couple of years ago, I took one of my workshop classes to the mall so they could see how the big boys do things, and we stood there and witnessed a magical moment. A woman had taken one pair of panties up to the cash register to purchase. There,

she was greeted by a friendly sales associate who enthusiastically supported the lady's choice of style and color. She then said the following, "If you purchase one pair, they are $7, or you can get five pairs for only $5 each." They lady almost jumped out of her dress as she quickly rushed to select four more pairs so she could get them for only $5 each. When she was ready to check out, the sales associate then said, "If you would like to open a Victoria's Secret charge account today, I can give you 90 days to make your first payment, no interest for a year, plus give you a $25 gift card. Are you interested in signing up today?" Well by now, the lady thought she had won the lottery and happily filled out the application, received her $25 gift card, and went back into the aisles to pick up several other items. By the time she was done, she had spent over $200 and walked out as happy as a spring chicken. She had originally planned on spending $7.

There are also companies like Amazon.com that will pay freight when you order $25 worth of books. And guess what? Most books are less than $25, which means you need to buy a second book in order to get the free freight—which is exactly that the majority of people will do. The same things happens when you are in the airport terminal and want to buy a pair of sunglasses. You can buy one pair for $12, or two pairs for $20. It works, or they wouldn't do it!

It just goes to show, you can make people buy what *you* want them to buy if you can make the alternative unattractive! This, my friend, is exactly why you should offer

Chatsworth Portrait Studio Inc.
88 Northpark Dr. Chatsworth Ga. 30705

706.695.1501

The time has come again...

This year Chatsworth Portrait Studio is proud to be donating a percentage from each session to Operation Smile. A non-profit organization that funds operations for children with facial deformities. Help a less fortunate child and create and unforgettable memory.

Give the gift of family portraits...

Schedule by August 30th and receive 10% off your order.

Braddt Parker
Photographic Artist / Owner

John Waldron
Photographic Artist / Designer

October 28th - November 1st
Limited sessions available. Schedule your session today!

A percent-off discount for booking by a certain date can motivate customers to pick up the phone.

packages in addition to your à la carte images. This is the subject of the next chapter.

Special Offers

To discount or not to discount? That is the question. When you offer some sort of special at your studio, what are the main reasons for doing so? Usually it because you want to:

1. Counteract something that one of your competitors is doing.
2. Experiment with the price of a product in order to find out where your customers' price sensitivity is.
3. Introduce a new product that you expect clients, once they experience it, will continue to want at full price.

There is a problem with this sort of mentality. If you get too focused on offering slashed prices and special offers,

you can flood your customers with price-based promotions. This can eventually outweigh all the brand building you do. It can increase your customers' price sensitivity and attract price switchers, people who are not really loyal to any brand. Over time, this can reduce your loyal customer base and increase your fringe customers. What does all this mean? It means that special offers have the potential to erode brand equity, reduce customer loyalty, and cut your profits. It's a very slippery slope, and losing your footing is easy to do, *unless* you have an intimate understanding of the global picture.

How much of a deal should you offer? The answer depends on how much attention you want. Most offers in our industry fail to motivate customers to buy because the offer does not appear to have what is probably the most important element to having success: it must be totally irresistible!

Mitche: **What do you feel is the biggest challenge facing the industry?**

Bill: I don't see as many challenges as I do opportunities. I hate to use the cliché "the digital revolution," but it made a huge difference in terms of how people see the world and consequently how they take pictures—on every level, amateur and professional. In terms of professionals, it has made a huge difference in the potential creativity and I think that converts into dollars and cents in the long run. In terms of obstacles, I see fewer obstacles than challenges. I think that is going to continue until the day that video starts to override still photography.

How do you see it changing?

HD Video is a very basic prosumer camera and very affordable. You can cut a high resolution 7x10 still from an HD video, so this is just the beginning of that technology. Provided it is lit and composed correctly, you will be able to pull a nice quality still out of video, which will have a remarkable impact on the world of still photography.

Do you see a there being some resistance to that transition just like there was for the digital?

Yes, maybe even more so. The still guys don't like being on the same bus as the video guys. The feeling is mutual. The technology is going to be the overriding factor here. I think it is coming and it is not that far off.

What is *Rangefinder's* marketing philosophy?

In a strange way it is kind of like a small company. We have 60,000 readers that you might think of as our clients, and we do try to take care of them, respond to them, and give them what they want out of a good magazine. And we maintain them in terms of our circulation program, which in this day and age is tougher and tougher to do—but that is one of the things that we do and that is why we have been in business for over fifty years.

Everything you do in life, everything you have, what are the most important things to you and how does marketing for the company you work for play into the priorities that you have?

I tell my kids this all the time: a job is a job, but a profession means that you love what you do. If you are good at

Power Corner

Focus on . . .
Bill Hurter

Bill Hurter has been involved in the photographic industry for the past thirty years. He is the former editor of Petersen's PhotoGraphic *magazine and currently the editor of both* AfterCapture *and* Rangefinder *magazines. He has authored over thirty books on photography and hundreds of articles on photography and photographic technique. He is a graduate of American University and Brooks Institute of Photography, from which he holds a BFA and Honorary Masters of Science and Masters of Fine Art degrees. He is currently a member of the Brooks Board of Governors. Early in his career, he covered Capital Hill during the Watergate Hearings and worked for three seasons as a stringer for the L.A. Dodgers. He is married and lives in West Covina, CA.*

it, and you are intent on getting better at it, there is no greater joy. Family, of course, is obviously important and financial rewards and so forth, but the biggest thing—and I think the reason that so many people in the business live so long—is that they are passionate about what they do.

How do you balance your personal life with your professional life?

It helps to be married to someone who likes to work all the time, too.

What common threads do you see that attaches top level marketers together?

Oddly enough, this year I have noticed that the successful marketers have a kind of built-in "give back" clause. Just this year, Tero Sade from Tasmania told me that half of his sales go to the Make-A-Wish Foundation—the booking fee and the shooting fee go to Make-A-Wish

Foundation and he charges for only the prints. So if you look at it, it is kind of a silver-lined mouse trap; it's beautiful in terms of its marketing simplicity, yet he really is a believer that you have to give back. I have noticed this so many times. Kathleen and Jeff Hawkins, Jeff Lubin—they have all built a charitable wing or platform into their business. I think that this actually makes people better human beings, but it also aids in their marketing programs because, honestly, people like to do business with people who are thoughtful and caring about other people.

Tell me about your background.
I grew up in New Jersey, I went to school in Wake Forest in North Carolina and ending up graduating from Amer-

I don't think enough people stretch themselves creatively to reach that **next level**.

ican University and worked for a news agency. I had a White House pass, a Senate pass—and this was during the Watergate era, so I got to know a lot of the notables on Capital Hill. It was a fun job, but I wasn't learning anything about lighting and color, so I went to Brooks for the full program.

What would you tell someone who is starting out?
One of the things that people who are starting out do is imitate someone else. You see a lot of successful imitators. What you don't see is the second tier, after they have discovered who they are. I don't think enough people stretch themselves creatively to reach that next level. I think that education and the application of that education is an important tool. I am a big believer in reinventing yourself, finding new outlooks to keep it fresh.

Has *Rangefinder* become a designer brand?
It appeals to the younger photographers, the ones that are eager to learn. That is a large part of our appeal. We have to walk both sides of the bridge, though, because a lot of our readers are older and have subscribed to us for thirty or more years. We have to honor the traditions as well as

being cutting edge. With *AfterCapture* we can be more on the edge of things—technology and imaging.

What has been the most successful marketing campaign that you have ever seen in the industry?
Among photographers, one of the things that has been extremely successful is teaching other photographers. It doesn't have an immediate effect on dollars and cents income, but what it does have is an elevating effect on their careers. Mentor-type photographers are more in demand.

Where do you see the trends headed in the future?
I think since 9/11, family has become huge—family photography and seniors, relishing the time in a kid's life that just won't exist in five years. That has gotten huge. Weddings are going to continue to grow, but I don't know if the budgets are going to continue increase like they have. There is so much competition. Right now, they seem to be holding their own.

When you're not working, what do you do for fun?
I take pictures. Whatever strikes me. My daughter was telling me about some bridges down in Long Beach, so we went out about a month ago and just drove under all these amazing bridges in her VW convertible. I enjoyed shooting them with the 10.5mm. It is pure enjoyment.

Who is your biggest inspiration?
Within the business I would say a couple of people. Paul Farber at Petersen's was huge in terms of getting me to understand the importance of what I was doing. He was an editor and publisher. He was brilliant and I loved working for him. And Emmerit Lawson, who was the head of the portrait department at Brooks. He wasn't about formulas, he was about learning life from the inside.

Final thoughts?
The industry is healthy. The way I can tell that is because there are a lot of great young minds coming into the business. Also, there are a lot of new companies emerging to meet the demands of the new technology. These are start-up companies forged on good ideas and fortitude.

14. Designing Irresistible Packages

Packages appeal to clients because they reduce the number of ordering decision needed and offer good value. They can also boost your bottom line by giving the client strong incentives to spend a little (or a lot) more. But how do you create packages that are irresistible? Let's do an exercise and generate some ideas. We'll start with some brainstorming, then talk about how ways to implement these ideas into your product mix.

Adding Benefits

Let's start with weddings. What are some things that you could offer your clients that would be so irresistible that people would have to be fools not to respond? I want you to remove all obstacles and allow your mind to wander just a bit, okay? Don't worry about cost, or price, or anything like that for now. We will get to that soon enough. For now, just let your mind create. What would compel a potential client to want to do business with *you* instead of anybody else in your market? Here are just a few ideas to get you started:

1. A complimentary limousine rental when someone books one of your Premiere Collections.
2. A day at the spa for the bride, and perhaps the bridesmaids too—maybe even Mom or Grandma. You could include a massage, a facial, manicure, or pedicure.
3. A complimentary night for two at the finest local resort, including dinner and champagne.
4. A two-volume album set for the bride and groom, an album for Mom and Dad, and a nice 4x5 album for Grandma.
5. Unlimited time not just on the wedding day, but on Friday night at the rehearsal dinner, and Sunday morning when they are opening their gifts in front of friends and family members.

Sara Petty's marketing piece for her baby portraits ensures customers will pick it up and interact with it—not just give it a glance and forget it.

6. A hot air balloon ride complete with a champagne breakfast.
7. Unlimited gift wallets for all guests to send with their thank-you cards.
9. A signature matte for all the guests to sign at the reception.
10. Thank you cards for every single guest, with envelopes *and* postage
11. A DVD slide show of all their images—not just for the bride and groom, but for Mom and Dad, and grandparents, and the wedding party.
12. Here's a big one. What about including their files? At what point are you willing to give your client a disc containing all their images? Is it $1,000, $2,000, $5,000, $10,000? At what point will your client not be ordering any more photographs from those particular files? Or can these files be used as an incentive to get your clients to step up to the next package?

Should I Sell My Files?

This is probably the question that gets the most amount of debate in our industry these days. For anyone who has been in business for more than a few years, the initial answer to this question has to be absolutely not! But because we now have a new breed of shooter in town, we need to analyze this question much more deeply than we have in the past. Start by asking yourself these two questions:

1. Is it possible for me to use their files as a sales incentive to get them to invest more money with me?
2. What is the true likelihood of my client coming back in and ordering more from those files?

Now, one thing I don't agree with is simply giving the files away with every package for no apparent reason. If you are going to go this route, make sure they earn it! Require an investment in one of your premium collections or a certain minimum investment in portraits. They can't just be handed a disc because they spend $100 with you. That wouldn't make much sense.

Using the files as a sales tool, however, may not be a bad idea. We all have to do what we are comfortable with; if you are not comfortable, don't sell your files. If, however, you are looking for ways to maximize your sales and give your clients a great value for their money, this may be a no-brainer for you. Today's photographic world forces us to, perhaps, do some things that in the past may not have even been an option.

I'm not saying to do it. I just want you to make sure that this topic is well thought out before you make a decision. And try not to let your ego get in the way of making this decision. It will only cloud your thinking.

What about portraits of families, children, and seniors? What kinds of things can you offer your potential clients that will entice them to jump up to the next bigger package or come to you in the first place?

1. A $50 coffee card for all new clients that come to you during the month of February.
2. A complimentary small wall folio for any order over X amount
3. A movie pass for the entire family
4. A new iPod.
5. Free oil changes for a year with a minimum purchase
6. A complimentary twelve-way portfolio for all senior sessions during the month of June
7. Complimentary Christmas cards for all orders placed before a certain date
8. A free stuffed animal from a local children's store for all sessions during the month of December.
9. A gift card to their favorite store.
10. A free cart of groceries from a local store (with a dollar limit, of course).
11. A complimentary DVD slide show of their entire sessions
12. Or, as we discussed before, their files on a DVD.

Any of these items can be used as an incentive to get them to come to you in the first place or enticements to get people to step up to the next package or collection. If Mrs. Jones sees that the difference between package A and package B is $200, but she receives and additional $350 of value . . . well, what do you think she's likely to do? If your price list has built-in incentives and enticements, it will be your number-one salesperson, which can take some of the pressure off you. Wouldn't that be nice?

The Whopper Package

In a perfect world, your whopper package—your top-of-the-line, fantasy package—would include all of these

items, right? How much would that cost for you to build a package that included everything on this list? I'll tell you one thing: it won't be cheap! But, it will show your client what *can* be done, if money isn't an issue. As noted in chapter 13, the whopper package will also make all of your other packages look much less intimidating in comparison, and probably encourage a large enough purchase to get at least some of the "whopper" perks.

Take-Away Selling

When selling, you should start with this top-dollar package, then work your way down the list. This is called take-away selling (the smaller the package, the fewer things included in it). Because it appeals the emotions—that sense of "wanting" in our clients—it can be extremely effective if done properly. We all know that weddings, in particular, are very emotionally-driven events that people will spend money on simply because they *want* to. It may not make sense to spend $25,000 on a hand-woven bridal dress flown in from Italy, but by golly they *want* it!

When selling, you should start with the **top-dollar package**, then work your way down the list.

One you have described in detail what is entailed in your whopper package (which you'd want to call something like your "Elite Collection"), the bride will *want* all of the features—and she'll have already taken mental "ownership" of them. As a result, when you drop down to the next collection that doesn't include the image files, or the romantic getaway, or the balloon ride, or albums for the grandparents . . . well, it almost feels like she is giving up something that she already bought. And the next collection down includes even fewer items that she has decided she just absolutely *must* have if she is to have the perfect day.

The Smallest Package

So, what does the smallest collection include? Not much. In order for a package or bundling strategy to work in your studio, there must be a reason for a client to go up

Adding incentive items like photo jewelry, ornaments, or DVD slide shows can create an incentive to upgrade to a larger package purchase—especially if those items can't be purchased à la carte. Top photo by Christa Hoffarth. Bottom two photos by Sarah Petty.

into the next larger package. If you give them everything they want in the smallest package, there is no incentive for them to invest more.

If your bottom senior-portrait collection includes a session, some gift wallets, one of those big ol' 8x10s for the wall, and an eight-way portfolio for Mom, that's going to

Have a Few Laughs

Don't get so bogged down in the nuts and bolts of selling that you forget this should all be enjoyable for both you and the client. All things being equal, people want to do business with their friends—and all things being not quite so equal, people *still* want to do business with their friends. Throughout this process, it's okay to make your clients laugh and have fun! Humor is relaxing and it creates a more open atmosphere. This is what will begin to breed friendship and respect.

satisfy the needs of many people—and that bottom package is all you're going to sell. Instead, if they want an 8x10, make them earn it. If they want gift wallets to give to their classmates, make them earn it. If they want the 8-way portfolio, make them earn it.

The idea is to create a stepping-stone concept in your packages. Each package increases in small steps, with more and more bonuses and enticements along the way. This technique can be applied to just about any category of photography.

Each package increases in steps, with more and more bonuses and enticements **along the way.**

You have a blank canvas. It's up to you to determine what is included in each collection you offer your clients. Obviously, there are costs associated with building irresistible packages like this, and you need to identify those costs, include them in with your calculations, and make sure that there is sufficient profit built in. I think it goes without saying that if you are going to give away an iPod, you will have to have some sort of minimum package or investment level associated with it in order to qualify. You and I know that these items aren't really free, someone has to pay for them, but if you position it correctly, the perception will be exactly that.

Added Value in Your Presentation

You also need to make sure you are adding value in the way your packages are literally *packaged*. This will allow you to charge a higher price—after all, you can't sell gold from a paper bag. Without proper packaging, the best products in the world will lose some of their appeal and their value.

One of our high-value products is called First Edition Prints. The name alone suggests prestige and importance. We increase this by placing the prints in a beautiful velvet-lined box. When a wedding client comes to pick up their set of First Edition Prints at our studio, we also add to the magic with a special presentation routine. As we walk out of the back room with their image box filled with their First Edition Prints, we wear white gloves, and say:

> Mrs. Jones, before you see your First Edition Prints for the first time, I want to go over a couple of things. Although we can always make more for you, there is something very special about the first printing, so I encourage you to treat all of these prints with the utmost respect at all times. I have taken the liberty of making a personally monogrammed set of gloves for you, and also a pair for your husband. Before you handle these prints in any way, do me a favor, put your gloves on and only handle the prints very carefully. Try not to handle them by the corners or edges as you may increase the change of damaging them, and I wouldn't want to see that happen. Now, each of these beautiful prints comes with a lifetime guarantee, so if anything should happen to them—including a damaged corner or an accidental spill—we will replace them at no charge to you. But we still don't want to run the risk, do we?

I then present their box to them along with the pairs of monogrammed gloves. By now, the anticipation is so high that they can't wait to get see what magical creation is waiting for them inside the box. I have had husbands reach to pick up a print without their gloves on only to have their wives slap them and say, "Didn't you hear him? He told you to put your gloves on before you touch any-

Our lifetime guarantee add extra value to each purchase.

thing!" I have even had brides call me months later in a panic because they have somehow misplaced their gloves and need another pair—or brides will call and ask if we can make a pair of gloves for their mothers and grandmothers.

Over the years, we have positioned our First Edition Prints as something that is nearly irresistible! To our clients, these prints have so much value that they would do just about anything to keep them protected; they have a very high perceived value.

How Many Packages Should I Offer?

I once knew a senior photographer who offered *forty-seven* packages in his price list. The entire things was about twelve pages, and must have had at least five thousand words. By the time most people got to the good part, they were probably so tired and fatigued that the last thing they wanted to do is spend any money. All the emotion had been frittered away!

A good number to start with is five. With this scenario, you would have your whopper (see chapter 13), then what we call the "drop package" (the one that, according to the "take-away" selling philosophy, we anticipate people will skip over on their way to a happy medium), then what is called the "target" package. This is where you want your clients to end up. It should be a combination of products and services that will motivate people to buy, and it should be priced at wherever you want your average sale to be. For example, if you are currently bringing in an average of

$750 on your senior portraits and you would like to raise that average to $900, your target package should be priced at $899. It's that simple.

So you have your whopper, your drop, your target, and then two other packages that bring up the rear. Obviously, the more they invest, the better the packages become. And, again, you don't want to include all of the things they want in the lower packages. Otherwise, those are all you will ever sell!

Stand Out from the Crowd

What type of enticements would work in your marketplace? Spend some quality time and come up with your own list of irresistible offers that you can use to beef up your studio's reputation as providing things that your competitors *do not*. In today's highly competitive world of professional photography, you must do things differently than your competitors, or people will have no choice but to compare your price—and in that scenario, the true professional will lose out every time.

Conclusion

When it's all said and done, the only thing that will separate us from the rest of the pack will be the amount of passion we have invested into our life—our family, our hobbies, ourselves, and our work. It has been rightly said many times that if you don't absolutely love what you do for a living, do something else. Life is way too short to not do the things that bring you happiness and a sense of fulfillment.

You are one of the fortunate few who have been blessed with a passion for the wonderful world of photography, and hopefully you wake up each and every day full of excitement and looking forward to going to work. My dream is that this book has rekindled, or sparked for the very first time, a vigorous desire to bring that same kind of passion and conviction to your business.

If you are committed to making the necessary changes that are required to drive your business to higher and higher levels, then you will be well on your way to becoming a Power Marketer and a Power Seller. The road to success is definitely less traveled, but well worth the extra effort. Your new-found enthusiasm will allow your cre-ativity to flow like never before, and will catapult your life to new heights.

I applaud your initiative and your willingness to work *on* your business for a little while, instead of working *in* your business. Initiative is that exceedingly rare quality that prompts—no, *compels*—a person to do what needs to be done without being told. It's also a commodity upon which the world places great value. Initiative will immediately set you apart from your competition.

The road to success is definitely less traveled, but **well worth** the extra effort.

That does it for me this go around. I hope that our time together has been a worthwhile investment for your business and, more importantly, for your life. Keep your focus on what is truly important, do the best that you can with everything that you do, and the rest will fall into place.

Contributors

Without the expertise and generosity of the following photographers and industry professionals, this book would not have been possible. Thanks go out to each of them for contributing their time, knowledge, and images.

Douglas Allen Box
2504 County Road 235
Caldwell, TX 77836
www.dougbox.com

Bambi Cantrell
940 Tyler Street
Benicia, CA 94510
www.cantrellportrait.com

Skip Cohen
Wedding and Portrait Photographers International
6059 Bristol Parkway, Suite 100
Culver City, CA 90230
www.wppionline.com

Rick and Deborah Ferro
Signature Studio
(904) 288-6464
www.ferrophotographyschool.com

John Hartman
1416 Clark Street
Steven Point, WI 54481
www.jhartman.com

Jeff and Kathleen Hawkins
327 Wilma Street
Longwood, FL 32750
www.jeffhawkins.com

Christa Hoffarth
2042 Fifth Street
South Lake Tahoe, CA 96150
www.christahoffarth.com

Bill Hurter
Rangefinder magazine, *AfterCapture* magazine
6059 Bristol Parkway, Suite 100
Culver City, CA 90230
www.rangefindermag.com

Charles Lewis
Creativity International
4930 Cascade Road
Grand Rapids, MI 49546
www.cjlewis.com

Don MacGregor
1545 West 75th Avenue
Vancouver, BC V6P 6Z7 Canada
www.macgregorstudios.com

Bradd Parker
Chatsworth Portrait Studio
88 Northpark Drive
Chatsworth, GA 30705
www.chatsworthportraitstudio.com

Sarah Petty
2920 Plaza Drive
Springfield, IL 62740
www.thejoyofmarketing.com

Michael Redford
(800) 227-7901
www.michaelredford.com

Tim and Beverly Walden
3229 Summit Square Place, Suite 100
Lexington, KY 40509
www.waldensphotography.com

Michael Warshall
8-12 Venture Way
Braeside, Victoria
Australia, 3195
www.nulab.com.au

Index